**Eduardo Chillida a**nd Pilar

**Memories of** a Daughter

Eduardo Chillida and Pilar Belzunce

Memories of a Daughter

Susana Chillida

Hauser & Wirth Publishers

For my parents

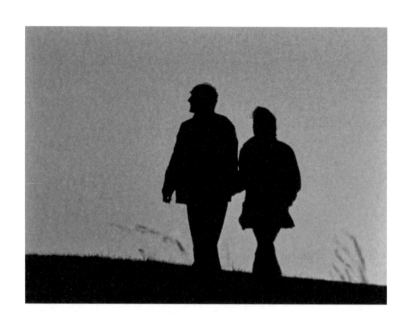

The writing of this book began, in a sense, when my vision of the world emerged. A world that, from the very beginning, was peopled by those iron objects that appeared all around my home. A home with a father, a mother, some siblings—I was the fifth of eight, which meant I was always anxious to figure out where I belonged, to understand my place in the pecking order.

But the place of those iron objects also interested me. They were so mysterious. Many of the adults around me when I was a child seemed to cherish them, almost too much, while others just laughed at them—which meant they were somehow also laughing at me. Later, the questions began: What is that? What does it mean? What is it trying to say? People assumed I would be able to answer those questions, but I could not: I was dumbfounded. It took me a while to understand that those questions were worthless. All I knew was that the artworks around me, the art I experienced up close, were the fruits of the endless toil of a man who solemnly devoted his life to making "that stuff." A man whom I loved as a caring father. For the poet José Ángel Valente, the word "abstract" misses the mark completely; it distorts reality—and I agree. What could be more concrete than a sculpture you can touch, an object you can walk around? It is a silent but fully present material entity, not an abstraction. It is something that viewers can connect to.

Be it writing or film, all my production about my father, including this book, has gone through a great many phases. Along the way, and whatever my original motivation might have been, many—though not all—of my demons in relation to the art world and artists have vanished. Subjects that had once felt necessary to confront lost importance upon being written. Water under the bridge that, I promise, won't splash any reader of this book. Something new gradually settles in, and from it the writer draws sustenance. The book is what remains after a long journey. "At dawn I discovered the piece. I could have encountered it in a thousand ways but only one. Its place between perception and

freedom. Its motive, necessity. Its end, agreement." That "dawn" of which my father spoke always comes to me after years of work guided by both intuition and doubt, which turn fertile when the light finally hits them.

It all began in 2009—at the height of the age of the DVD. Who could have imagined that such a solid system would soon meet its demise? In an attempt to increase the sales of my two documentaries about my father, I wrote "Chillida's Places" to be included on the well-designed DVD case. What do the places shown in my films teach us about my father's life? We know so little—almost nothing—of them. Mere glimpses of his home in San Sebastián, his old workshop that would later become my home (and also the place I recorded my first interview with him), his studio adjacent to the house, the industrial forging workshop, the river on whose banks we see him walking at night . . . Writing is as different from filming as seeing images is from reading words. Each medium has its own set of possibilities, its advantages and drawbacks. It was my hope that, through writing, I could round out the topic I had dealt with in images. But once the DVD format reached its end, everything was put on standby.

In 2015, when my mother died, I took up writing again to cope with her loss. I saw her all around me, but I still wanted more, I needed more. That's when I rummaged through her belongings and came across a bunch of photographs of her life together with my father. It felt like this book had been waiting for her. And the photos, some of them very simple, accompanied me as I wrote. For me, who once considered the path of the photographer, the images speak of details that are almost imperceptible but profound and important if you know how to "read" them. Once I had finished my mourning, however, my motivation died out. Until, a couple of years later, in 2017, when my children, who had read both versions of the manuscript, expressed their desire to get to better know that grandfather—a man of depths, subtleties, and unpremeditated teachings, a humanist, a creator of spaces, an architect of emptiness, an engineer of dreams— who had gone too soon for them. For the sake of my children,

I decided to continue to focus on his thought and his work. More photographs began to become indispensable. I imagined the reader learning with me about Chillida, in a way similar to how I myself had learned his story, his life. I enjoyed it and made a lot of progress—but other professional work prevented me from finishing. And that's how I got to December 2022. I had, at that point, a jumble of disparate writings on art, my father, and my mother. They had been written in fits of intuition and emotion, but also of reflection. I read them over, and they seemed worthwhile. At that point I decided to write a joint biography of Eduardo Chillida and Pilar Belzunce, my parents. For me, it is an act of historical justice to include her alongside him. I now had motivation to see my project through.

But putting that jumble in order was no mean feat. My first step was to add titles; they helped me make sense of so much text. I then decided to group the topics by decade in a chronology of not just Chillida's works but also the places they have inhabited over time. The reader will still detect in the narrative time jumps, thoughts, and pieces of information that reflect the flow of associations and feelings that accompanied my work.

Speaking of the process, I must mention one final step I took when the book was almost finished. I had written so much about "my" father and "my" mother that I felt the need to reach out to at least two of my siblings, a sister and a brother. I wanted to find out to what extent they could see "our" parents in my account. It turned out that they could see them clearly. Each one of us kids appears in at least one of the book's anecdotes—our father was a real family man. I was sure that all my siblings would feel the same as me. But were there other memories, nuances, and emotions that, because they were part of *their* lives, only they could offer? Unquestionably. That is why I ended up asking all seven of my siblings to share some of their experiences. I have scattered them throughout this volume.

I have done my very best to offer a broad vision of a universal artist. In the end, I still believe that art, and not only "abstract" art, is a great unknown. And whether you read this book because you like art and

want to learn more about one of its major figures, or because you love Eduardo Chillida's work and want to delve into it, or because you are interested in the role of the artist's wife—topics one and all found in this book—it is my hope that you will come away convinced that art is truth. As a writer, I would settle for nothing less.

This is, for me, a love story. A family story. And a story of the love of art.

Madrid, March 2024

# Stories of a Daughter

A delightful bird alights on a low branch. I watch it flutter. I look down at the smoldering cigarette in my hand. When I look back up, I sense a silent movement, an absence before me. The bird has gone, flown off. How fleeting, but also how permanent. Is there some connection between the absence of that bird—the void it leaves amid the branches of my consciousness—and the emptiness I have felt inside since my mother's passing? Is it connected to the void captured in my father's art?

"How wonderful," I remember exclaiming to him, looking at how my sleeping newborn moved his tiny fingers. "It is," he answered, "because you know how to see it."

The back-and-forth between seeing and not seeing, the act of looking—that was something alive between us. As were sculptures.

## The Junk Dealer and the Sculpture

A story comes to mind that I have, until now, told only in passing. An incident that received a lot of coverage in both Spanish and foreign newspapers at the time: the theft in 2010 of a group of artworks on their way back to Spain from Germany. One was a sculpture by Chillida. Its owner, the gallerist Nieves Fernández, was always reluctant to loan it out for exhibitions, but this time she had agreed (I doubt she was ever inclined to do so again). Paintings by Picasso, Tàpies, Botero, and others were in the truck along with my dad's sculpture. Back in Madrid, the drivers parked in the transport company's lot. They left the keys in the ignition, and someone seized the opportunity and made off with the vehicle.

In all likelihood, the police know much more about what happened than we do. It's also likely that, in their reporting on the theft and its resolution, the newspapers provided only the information that best suited their purposes, be they sensationalist or political. Personally, I have learned to take what the media reports

with a grain of salt. But let's get back to the theft. Today, I'm the one recounting it, and I take full responsibility for wherever that takes us.

Chance would have it that, after the incident, my father's work was immediately sold to a junk dealer. Perhaps because it was so much harder to move around than the rolls of canvases, the thieves got rid of it quickly. What was a kilo of iron going for at that time? Whatever it was, that amount times 150 was what they got for the sculpture. That was the first thing to come out in the investigation, and the press ran away with it.

I could dwell on how the laughter occasioned by the sale of a Chillida to a junk dealer made me feel. But I would rather focus on the sculpture itself and what happened between it and the junk dealer once the thieves had left and they were alone together in the junkyard, surrounded by so much scrap metal.

I can imagine the man looking at my father's work, but—oddly— I can also imagine the work looking at him. I suspect that he observed it for a long time. Because of his extensive experience working with iron, the junk dealer would likely have been struck by the skillful blacksmithing and how harmoniously the material expanded and contracted. My father's strange form would have stared right back at him in a soundless conversation. When the sculpture started talking, I imagine it said, "I am not just a piece of iron." The man must have been unsettled, perhaps even frightened or bewildered—that's how I see him in my mind's eye. I imagine him being unable to stop looking at the new arrival that was, little by little, revealing itself to be quasi-human. The thing is—though not everyone knows it—art is truth, and that work was not just "a Chillida" but, in a sense, Chillida himself. It took a long time to understand that myself. The next day, the junk dealer went to the police and reported what had happened. The perpetrators were soon found and the rest of the stash recovered.

That is just a simple story, probably no more or less accurate than all the others I will tell in this book. In fact, I later learned that the sculpture in question was not the one I thought it was. But who cares? It changes nothing about the story. To narrate is to voice in the

first-person, to bring facts to life, to sound out emotions in need of transformation.

### The Girl Who Would Run Away to Keep from Saying Her Name

There were, between my parents and me, not only sculptures but also cameras—and that was the case for as long as I can remember. The photographers who streamed through the house were what first made me understand how important my father was for the world. Francesc Català-Roca, an extremely sensitive man, would come by with his son. I would venture to say that for all of us, for my parents as well as my siblings, his presence was something special. The same was true of the beloved Waintrob brothers—Sidney and Budd, who had a studio in New York. They had met my father through James Johnson Sweeney, the director of the Solomon R. Guggenheim Museum, and soon added my father to the list of artists whom they photographed on their annual trip to Europe (the list also included Giacometti, Duchamp, Calder, Moore). They would arrive—always right on time—to a house ringing with shouts: "It's the Americans! It's the Americans!" They

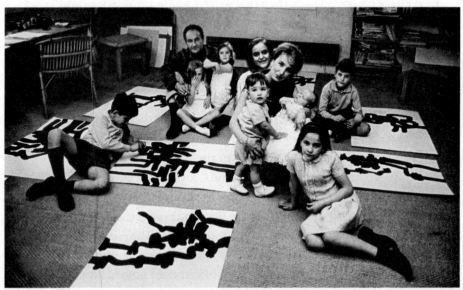

The entire Chillida Belzunce family in the artist's studio at Villa Paz, San Sebastián, 1964

would photograph my father not only with his works but also with Pili and us kids. The fact that Chillida was such a family man seems to have struck them as odd for an artist.

The first photograph by the Waintrob brothers in this book provides an opportunity to introduce my child self. I am the one on my father's lap, next to my sister, María. Her upright and playful stance is somewhat theatrical—a hobby she has remained dedicated throughout her life. My pose is no less telling. There I am, serene with legs crossed, sheltered by the two of them. Just one of my eyes can be seen in the image—the other one is covered by hair, just as my mouth, is covered by my hand. But what captures my interest here is the expression in that one visible eye. As a psychology student, I learned about cross laterality. Apparently, my left eye is dominant—that is the one I would later use to take photographs and shoot film. My mouth, which, at the time the photo was taken, still had little to say, is covered by my right hand, the one I have used to write this text over the years.

For me, the visits from those photographers with their Leicas were a breath of fresh air. My drab life was, at that time, limited to a Catholic school just a few steps from our house, Villa Paz. I could never have imagined back then that when I was in my thirties—and Sidney and Budd Waintrob, as well as their sister, Lilly, in their eighties—they would become such close friends of my husband and mine during the years we lived in New York. The first time I saw them there—we had not laid eyes on each other for years—they surprised me with an anecdote my parents had told them about me not long before. It really captures the three of us, my father, my mother, and me.

I must have been around five. My parents were driving the seam-stress, who would come to our home to alter the hand-me-downs passed from the older to the younger kids, back to her house. A bunch of us hopped in for the ride. On the way back, my father asked us a question. "Kids, do you know what to do if you ever get lost?" For peace of mind, my parents made my older brothers and sisters solemnly repeat their full names and address. "What about you, Susanita. Do you know what to say?" "If I get lost, I'll run straight home," I replied.

Dad tried to explain why that wouldn't work, but I would not give in: I would run home.

Eduardo and Pili must have exchanged a glance before deciding to teach me a lesson. "Do you really know the way home?" We were pretty far away, and on the other side of the Urumea River, which had only a low parapet wall at that section. It was nighttime. "Okay, then, run home!" They opened the car door and let me out. My parents must have thought I would stay put, petrified. They took a quick spin around the block. By the time they got back, I had dashed away.

It's impossible to convey how scared I felt, no matter how fast I was running. My mother got out of the car and ran at least as fast as me to the house of one of her sisters who lived nearby. She was going to call the police. It's funny now to imagine my mother and me in a sort of parallel race that night, each of us moved by our pigheadedness. The price my parents had to pay for testing my youthful assertion was undoubtedly a bit excessive: they were overwhelmed with fear and guilt.

My scraps of memories of that night are still vivid. Only God knows how relieved I was when I reached the street Alto de Miracruz and knew our home was just a stone's throw away. I soon heard a car hit the brakes and my father's voice calling out to me. I remember him holding me close. Apparently, I told him that if it had taken them only a little bit longer, I would have made it all the way home.

I remember not only the exact spot where that happy ending occurred but also my father's legs, bent so flat they were almost against the ground, and his wide-open arms—a precise visual, postural, and spatial arrangement. Come to think of it, it was like the stance of a goalkeeper—which he had been—or like the concave and receptive forms of his *Monumento a la tolerancia I* (Monument to Tolerance I, 1985).

### Binoculars to Better See What You Have Already Seen

Thirty-seven years later, before a loose-rock landscape on the shores of the Aegean Sea, my father handed me a pair of binoculars.

"Here you go," he said. "They will help you better see what you have already seen."

Acts like that forge a life. Words that would be with me forever. We had just gotten through a rough experience in the Greek islands. I felt the need to come clean to my father in a way I never had before. The year 2000 was upon us. On what would be our final family trip, we all realized that our father was not himself anymore. I needed to let him know that I sensed the end of a long period of my own life. Though I didn't tell him so, I wasn't sure he would be around to see my next chapter.

That day, I realized that my father had used weight to rise up against weight, and I was using time to rise up against time. I had gotten a bachelor's degree in psychology at a young age. In my thirties, I made two documentaries about my dad. In a week's time, I was heading to New York to finish up my doctoral dissertation at Columbia University. My father was proud of me. But I hadn't yet published any books or run an educational program. "One never knows," my dissertation would eventually begin, "at what moment something will arise that may affect one's entire life." Coming up with those first three words, the ones that would set the tone for my thesis, was not easy. But once I had, the writing flowed forth smoothly. Is it embarrassing to admit that the thesis I defended at the dawn of the year 2000 was dedicated to my father? A little. It almost seems that without him I am nothing. The strange thing is, for the Family and Community Education Department at Teachers College, Chillida was not an artist—or, at least, not primarily an artist—but the father of a woman who, at the instigation of her mother, had made a few films about him. And this instigation had prompted a turning point in my life.

Since I ultimately decided not to pursue an academic career, I sometimes think that all that effort was just a child's wild escapade to get the attention of a father and a mother who were completely devoted to art.

### "If you follow me . . ."

Right before my eyes, traces of my parents' life. The hydrangeas in their yard look at me as if my mother herself had painted them. I go outside and cut one, then put it in a vase, just as she would have done. I relish

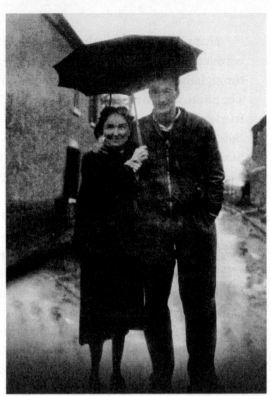
Eduardo and Pilar in Villaines-sous-Bois, France, 1951

the moment of solitude. I look at a photo of them that they had
enlarged and put in their bedroom. At that very moment, I remember
something my father said to my mother years earlier, when he was
thinking about dropping out of architecture school to become
a sculptor. "If you follow me . . ." He was twenty-three and she was
twenty-one. Eduardo's parents, my grandparents, opposed the idea,
and they asked Pili for help. "You may be young, but you are the only
one who can get that idea out of his head." Of course she was afraid.
She did not want him to drop out—she loved the idea of an architect
boyfriend. My mother might have been young, but she was brave. She
listened to Eduardo's arguments with her head and her heart. And
she sided with him. Pili was a gambler at heart. She placed a bet and
she won. She knew her beau, and intuition told her that, whatever he
ended up doing, Eduardo Chillida was a winning horse.

That photo was taken the year after their wedding. Standing between two houses, they almost look like a single body that cuts through the image vertically; they stand under a tiny black umbrella. The photo must have been taken by the painter Pablo Palazuelo, their friend with whom they shared a home and studio in Villaines-sous-Bois, a small town on the outskirts of Paris. My father had lived with him the year before. He always spoke of how important Palazuelo had been for him when he was getting his start. He was older than my dad, and had more experience.

Were it not for Pili's sparkling eyes and the smile she flashes at the photographer, the picture might be mistaken for a still from a sad Resnais film. The two pairs of feet emerge like shadows from a luminous mist. Bits of sky reflect in the mud below. To the right of Eduardo, in the distance, is a streak of white sky.

What strikes me about this photo is my parents' hands, and the story I read in them. Everything—everything to come—is written in them. Pili is already turning into Eduardo's pillar.[1] Her two hands, so bare and white against the winter clothes, are at the center of the photograph. We see them perform an act as trivial and as meaningful as sheltering them both from the rain. One of those small hands props up the other, grasping onto its wrist to get a solid hold on the umbrella. Together, her hands make up a single mass. Pili plays the strong one, looking after herself to look after him. Next to her is Eduardo. One hand buried in his pocket and the other resting on his wife's neck, he exudes calm. We get the sense he protects and is protected. And yet, because of his stature and the small size of the umbrella, one of his sides is exposed to the storm.

My father's one visible hand is blurry—undoubtedly because he moved when the camera clicked. Ingrained on the photo is a trace of that hand pulling Pili toward him. A rough gesture that is also full of tenderness for her, a gesture that provided security but also demanded it. I saw him do it so many times. It was, by pure luck, captured in one of the scenes of my documentary *Chillida: el arte y los sueños* (Chillida: Art and Dreams, 1999).

---

1   TN: The Spanish name Pilar is also a common noun that means "pillar."

Eduardo needed the sense of security he got from having Pili next to him. At the same time, his helpless side, the one left all alone with no coverage from the rain, was undoubtedly where his art came from. That hand buried in his pocket is, I feel, where the tension lies. It is expectant, waiting for the right time and place to jump into action. That was the hand my father made art with.

To show what kind of artist Chillida would become with this woman at his side—the only woman he was ever with—I look to another photograph, a well-known portrait of an artist. This image could not be more different. At the center of the photo Robert Capa took of Picasso and Françoise Gilot on the French Riviera in 1948 is a large beach umbrella, as opposed to the tiny one in the photo of my parents. The beach umbrella is not stuck in the sand but carried by the two powerful hands of a grinning Picasso. From behind, he shelters from the sun both his beloved and himself. Gilot is smiling, as is Picasso's nephew, who looks on from the background. The scene is festival-like and hedonistic—and clearly a bit staged. The woman—Picasso's fourth wife and forty years his junior—appears to bask in the flattery.

Both photos were taken in France, only three years apart. The photo of Pili and Eduardo is in a rainy town on the outskirts of Paris; the other, on a sunny beach on the French Riviera. The attitudes, settings, and moods could not be more different. Each image speaks of a way of being, a way of inhabiting the world—and it is from there that each of the men's art springs.

Françoise Gilot, a painter in her own right who never stopped making art, left Picasso after having two children with him. Pilar Belzunce, meanwhile, would be a pillar for Chillida his entire life. They had eight children together—four boys and four girls. It was only after she was widowed that we discovered my mother was also a passionate painter—and she would be until the very end.

# Where Do the Waves Come From?

**The Story of Eduardo Chillida's Family**

My father's family was crucial to his development as a person—in that, he is like everyone else. In his case, both his mother's and his father's sides were perfect breeding grounds for art. For an array of reasons, both families passed down to him a certain inner tension that would also prove important to his maturation as an artist.

Eduardo Chillida Juantegui was born in San Sebastián on Thursday, January 10, 1924. The sea was rough that day. At dawn, the *Mamelenas*, the city's famous fishing boats, were washed up on the bay. I remember that extreme weather also marked the day of his death on Monday, August 19, 2002. At dawn, the bay was enveloped in a thick mist—you couldn't even see Santa Clara, the little island across the water. At midday, it cleared. And he died.

From the beginning to the end, the sea—*la mar*, as he used to call it[2] —was important to his life. From a balcony of his house on Zaragoza Plaza, you could see it through the gap between the old Hotel Continental and the beachfront property next door. He recalled how on the days the surf was up, he would skip school and walk to the edge of the city, where his work *Peine del viento XV* (Comb of the Wind XV, 1976) is today. He would stare out into the sea, asking himself where the waves came from.

I found a photo in the family album where my father is in the center, flanked by his grandmother, Juana Eguren, and his two brothers. He and Gonzalo each hold one of their grandmother's arms—though she hardly seems to need their support. Dressed in black, the only trace of color is in her collar—it appears to be some sort of jewel or accessory. Ignacio, the younger brother, is somewhat disconnected from the other figures. His stance is self-assured and composed. My father is the one who looks somewhat tense. His free hand seems to be searching for—and not finding—a comfortable position. His tie and the length of his pants set him apart from his younger brothers.

2 TN: In Spanish, "sea" can be either masculine, *el mar*, or feminine, *la mar*. Usually, the feminine form is used to express a deeper and poetic connection to the sea.

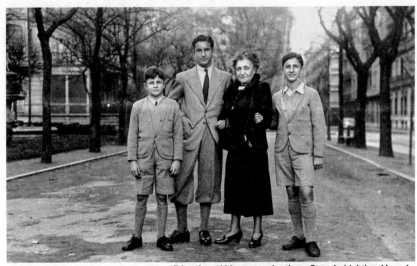

Eduardo and his younger brothers, Gonzalo (right) and Ignacio, with their maternal grandmother, Juana Eguren, 1930s

Known as Juanatxo, that woman, the boys' maternal grandmother, was a force to be reckoned with. She had a lioness's face and sparkling pale eyes. They say that when she was about to turn ninety, she lamented how she lacked the energy she had had in her seventies. She died at ninety-six. She was the most important figure in my father's life from the time he was a boy until well after my birth. He used to tell me that I looked like her—I took it as a compliment, since he held her so dear. She was born in a *caserío*—a Basque farmhouse, usually in the mountains—in Urretxu, near Zumarraga. She lived there until, one night at dinnertime, a fight broke out between her parents and one of her children. Afterward, she gathered all her kids and her husband—whom she called by his last name—and left for good. "Juantegui, let's get out of here!" I was always struck by how many times dad told us that story. He clearly respected her sense of dignity and courage. She worked at an inn in Zumarraga. Thanks to her many talents, someone took a leap of faith with her and she was able to prosper: she ended up opening two hotels in San Sebastián, a coastal city overlooking the small and beautiful Bay of La Concha, with its two beaches separated only by a small rocky outcrop. The Hotel Biarritz was torn down when my great-grandmother died, and

the Hotel Niza, right on the bay, is still up and running, thanks in no small measure to my mother.

In an interview with the journalist and writer Martín de Ugalde, my father remembered his grandmother as "a powerful woman of remarkable strength and kindness . . . but don't believe for one second that that meant she was soft or malleable, like something you can easily shape. Her kindness was shielded by a detached, almost haughty, dignity that came with the stubbornness it took to get by in the tough hotel business."

No matter how much *abuelis* Juanatxo—that's what we kids called her—loved showing off her long pearl necklaces, her *caserío* background never left her. She would do the shopping for the two hotels herself, riding to market in horse and buggy and bargaining with the various merchants in their mother tongue, Euskera.

My father's ability to mix with so many kinds of people came from that grandmother, whom he saw every day. A secret door attached the house he grew up in to the Hotel Biarritz, the more elegant and larger of the two she owned. And that grandmother, determined and modern as she was, ended up becoming his first patron. She helped my parents out financially for a few years at the beginning of their marriage. She even wanted to install one of my father's sculptures in the Biarritz lobby. Eduardo affectionately dissuaded her, since it didn't match the rest of the decor. Chillida was always picky about where his work was installed.

From a very young age, my father understood that the world was large but, with some effort, accessible. The hotel's guests would bring news of other countries and speak other languages. During the war, a gentleman from Argentina who was staying at the hotel fell in love with one of my great-grandmother's daughters—there was no shortage of time to lose his heart, since the border had been closed and he was stuck in the country for a number of months. Before he left, the smitten Argentine told Doña Juana—the other name my great-grandmother was known by—that he wanted to take his beloved with him. She told him that if he loved her so much he would have to show

it by heading home alone and coming back for her. And he did, one year later. That is the origin of the branch of my father's family that lives in Argentina. Many years later, my father's beloved cousin Chicha was born. She became a leading golfer in Argentina—a source of great pride for my father. Oddly enough, something similar happened with another one of my great-grandmother's daughters. She ended up in Uruguay. These stories have always brought to mind the film *Casablanca*—that moment of maximum tension when people were waiting for safe passage or devising all sorts of ruses to travel freely. The only of her children left in San Sebastián were one daughter, Carmen—my grandmother—and one son, Antonio, who, like his father, Juantegui, worked in the Hotel Biarritz. Together with Antonio, Juanatxo promoted skiing in the Pyrenees before there were any ski resorts. Not long ago, I had a chance to see postcards in French advertising the modern Hotel Candanchú, which they ran there.

Looking through papers after my mother's death, it saddened me to see that all the documents related to the hotel businesses were in the name of Juan Juantegui, my great-grandmother's husband. The name Juana Eguren did not appear once. No matter how powerful and brave a woman was back then, she could not sign a document. So much remains to be done to right that historical wrong.

My grandmother, Carmen Juantegui, was very close to her mother. She died at a young age from kidney disease. From the time he was little, my father would accompany his mother to a spa on the outskirts of Madrid. That was where he acquired a fear of contagion that would continue to the end of his days. Carmen passed before I was born, but I know how dearly my father held her beautiful and dramatic soprano singing voice. He remembered one song— "Aurtxo polita" (Pretty Boy)—in particular, which the revered soprano Ainhoa Arteta would perform at a gathering we held in the Zabalaga *caserío* at the Chillida Leku museum, on the tenth anniversary of my father's death. It was very moving. Eduardo remembered his mother as a caring woman who passed on her love of music to him. What she did not pass on to her children, though, was the Euskera language that her

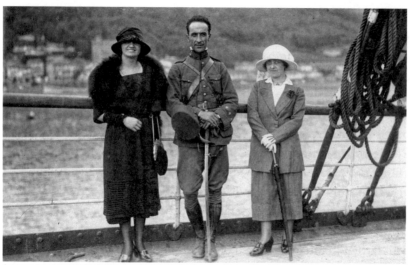

Carmen Juantegui (left) and Pedro Chillida, Eduardo's parents, with a friend, 1920s

ancestors spoke. Apparently—even before Franco banned the Basque language from schools—it was already becoming less common in Basque cities. Spanish and French were starting to replace it, and all the more so in an aristocratic and Francophile city like San Sebastián.

My father's father, Pedro Chillida, was a career soldier. He was not ambitious, though, and he refused to move to Valencia for a promotion. He was very religious and conscientious. He loved art, along with sports and religion, and he passed those loves down to his children. Eduardo recounted how, at the very end, his father confessed to him that what he truly wanted was to be a painter. "When, as a second lieutenant fresh out of the academy, he was stationed in Vitoria, he would walk by a large garden with peacocks every morning on his way to the garrison. It was the home of the painter Fernando Amárica. He had the urge to run inside and say, 'Mr. Amárica, would you take me on as an apprentice?'"

Pedro Chillida's sensibility left its mark on his children. He would come up with clever games to entertain them when they were small. For instance, he would ask them to take careful notice of all the details of a room, explaining that he would later ask them a few questions. He

then would ask them to leave the room while he changed a few things around—he would move a book, hide a lamp, shift a rug, that sort of thing. My father recalled how excited he was when they were let back into the room. He was convinced that this early training in the perception of space later came to play a role in his art.

I do not know how grandfather Pedro met grandmother Carmen, but I do have some sense of the impression Pedro left on anyone who crossed his path. One day, a burly Basque man seated at the bar in a place I used to frequent exclaimed (he must have overheard my conversation), "*Chillidaren alaba?*" (Chillida's daughter?). He went on, "I knew his father, Colonel Pedro Chillida. He was in my regiment when I was in the service. Never had a better commander. He was a good man."

After my mother's death, we found a carefully kept bundle of the many letters Pedro wrote to his three sons during the war. In one of them—I have not read them all—he gives each of them advice. He tells the youngest, Ignacio, to keep calm and think before acting (evidently, he was overly gung ho). Too bad he was too young to heed that good advice. My grandfather had also already detected his son Gonzalo's many talents. He was a sensitive painter, a loyal friend to many, and a lover of nature. To Gonzalo he wrote, "Any artistically inclined child could be the next Murillo or Velázquez. Practice and broaden your horizons—you have more than enough natural talent to make it in art."

The advice he gave Eduardo is key to helping me understand my father's persistent inner struggles. "You, Eduardo, are impulsive and fiery—such wonderful traits to have, so long as they are accompanied by reflection. I cannot expect you, at your age, to analyze and weigh every last trifle, but I do recommend that you choose your friends wisely—hopefully you will have many, more than one or two, who will inevitably end up influencing your character and spirit. You must always stay true to yourself, without pride or arrogance—no need for those. There is, though, a need for persistence and constancy, for faith in what you believe right . . . I am so pleased that you apply yourself to

your studies—you didn't always, and seeing that you now do so shows me you are capable of bettering yourself. You know how to care for yourself—stay that way. Congratulations, Eduardo. I am so proud to see your name and my last name on the honor roll. [ . . . ] Keep at it, Eduardo!"

Despite what my grandfather, who had also studied at the Marianistas school in San Sebastián, said, my father was never a great student—he was a rebel. In fact, he ended up getting expelled. But he was capable of bettering himself. When he left that school, he started studying at a private academy, and that was where he discovered a love of knowledge. He would often speak of how much the school's principal, Ignacio Malaxecheverría, had influenced him. He considered him a true mentor, an important figure in his life. In a book by Martín de Ugalde, my father says, "I immediately took to Don Ignacio, a patient and sincere man who surrounded himself with books. He was not stiff or formal—he wore sneakers—and he was extraordinarily kind. For all those reasons, an image of culture, knowledge, books, and so forth began to take shape in my mind. I sensed that the open-minded world that surrounded Don Ignacio was a good thing, that there was something in it for me."

I have been told that my father's youngest brother, also called Ignacio, was very charismatic. He honed his many natural talents with great passion. When he saw how artistically gifted Gonzalo and Eduardo were, he told them not to worry about anything—he would take care of them. Ignacio's life was short, but full. He would come up with clever business plans, as well as cockamamie schemes, to keep that promise to his brothers. Once, he tagged along with a Basque delegation heading to Ireland, hoping to sell one of his ideas there. He was also a field hockey player. One day, at the age of just twenty-six—he was engaged to be married—he took his brother Gonzalo's motorcycle without asking to go to a game. He was killed in an accident. My father remembered how wrenching it was when he and Gonzalo had to identify the body of their beloved brother, who had departed far too soon.

Something I valued about my parents was how permissive they were with us when it came to motorcycles. They never objected to us having them, and most of us did at some point. In fact, three of their younger children—myself among them—could have been killed (fortunately, none of us was). But that's another story.

### The Story of Pilar Belzunce's Family

My mother's family background has everything to do with the choices she would make in her life and with her total commitment to my father and his project. Pili, like Eduardo, also understood from a very young age that the world was large but, with some effort, accessible. However, she was faced with a unique set of circumstances from the get-go.

Her father, my grandfather Román Belzunce, was a tough and peculiar character from Navarre province. He had a taste for mathematics, sports, women, the piano, and gambling. He had shares in a mining interest in the Philippines as well as a sugar plantation there. Life on the plantation was still largely feudal. Román was *el cachila*—the head honcho—with everything that came with it. For every three years he lived in the Philippines—sometimes alone, sometimes with my grandmother María and some of the kids—he would spend two in Estella at the family home. On October 9, 1925, during one of those long stays abroad, during which most of the older children had stayed behind in Navarre, my mother, Pili, was born in Iloilo, the Philippines.

When my grandfather was in Estella, he loved spending time with his friends. He would challenge them to races, on land or in the water, or to play fronton, a type of handball. He was very competitive, and he usually would win. He often recalled how his friends would say, "What a star you are, Román! You come here all the way from the Philippines to beat us at fronton, to outswim and outrun us . . . You are a well-oiled machine!" Pili's father was a bit of a show-off.

My mother's mother, María de Carlos, died when I was still quite young. I vaguely remember her tossing crumbs to the sparrows from her balcony or sitting at a brazier table in the living room. I learned not long ago from a cousin of mine that she was a very creative and skilled

woman. When my grandfather's plantation was going under, she and one of her sisters helped keep the family afloat by designing and sewing clothing.

Back then, getting from Spain to the Philippines meant a four-month voyage with a stop in New York, among other places. I doubt my mother remembered anything about her first trip to Spain—she was just a baby. When she was nine years old, she returned to the Philippines, leaving half of her siblings behind in Estella. She went to boarding school on an island near to the one where her parents lived (there were no good schools anywhere closer). She spent the Spanish Civil War in the Philippines, entirely oblivious to what was going on.

At least three languages coexisted in my mother's young mind: Spanish, her mother tongue; Tagalog, the language spoken by the plantation workers; and English, the language of her education. (Actually, French might have been in the mix as well, since the school was run by French nuns.) That set of circumstances, that multicultural and transoceanic background, proved very handy when, years later, the time came to promote my father's art. But those were not the only circumstances that marked Pilar's life and prepared her for her future role.

One of my mother's younger sisters had an incurable disease that prevented her from attending school or leading a typical childhood. To give you an idea, the doctor told her she could never cry—or laugh, for all I know—because her weak heart might give out. During her early years in Estella, my grandparents treated my mother as if she, too, were sick. They wanted to keep that other daughter, who was actually ill, from feeling any worse. Pili, like her sister Rosita, was instructed at home by a governess rather than sent to school with kids her age. She was not allowed to sing or dance in the presence of her sister, to keep from overexciting her. Everyone felt sorry for my mother. On holidays or when her sister was resting, my mother's aunts and the servants would help her slip outside to enjoy some fresh air, like the healthy girl that she was.

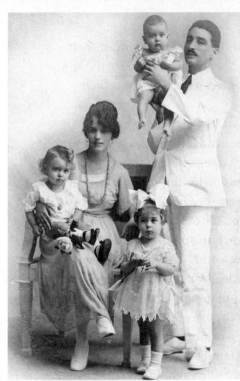

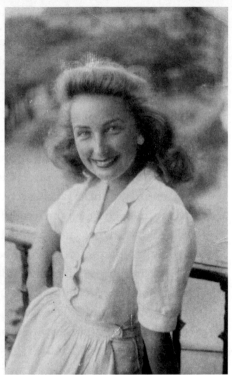

Pilar's parents, María de Carlos and Román Belzunce,
with their three oldest children, the Philippines, 1920

Pilar Belzunce, 1940

Over time, my mother's sad situation got worse, because that
perhaps overindulged sister turned into a child tyrant. If she saw Pili
going out, she threatened to cry and reminded her sister that that
might kill her. Finally, my mother got fed up one day and lost her
temper. I can only imagine how guilty Pili felt, all the more so since,
not long after, her sister died. Soon my mother, now nine years
old, left for the Philippines. From then on, self-sacrifice and guilt
avoidance were fundamental to who she was. Not until my father's
death, when my mother consulted a psychiatrist to treat her
depression, did she understand how important those early events
were to her life.

In any case, young Pili became a selfless and generous person,
qualities from which her future career with her husband undoubtedly
benefited. These aspects of her personality not only helped her to

support my father and to work tirelessly by his side (remember their pact—"if you follow me") but also aided her in understanding the gallerists and others they came into contact with, to support them as they pursued their own goals.

I was drawn to the film *1898, Our Last Men in the Philippines* because of its title. Amid wild palm trees and lush trails, a priest and a few Spanish soldiers stumble through war games in the occupied islands. The film shows greed, religious fanaticism, and colonialism on the one hand, and a Tagalog rebel's and beautiful sex worker's thirst for independence and freedom on the other. I was struck when I realized that on that same archipelago, not long after the film takes place, my grandfather would have been settled into the plantation where my mother, the sixth of his nine legitimate children, was born.

Thus far, I have recounted the facts of my mother's childhood. But how, I ask myself, did Pili feel when, at the age of eleven or twelve, she saw her father have his way with women of all ages? Apparently, my mother had been told that for Tagalog families, giving birth to a *mestizo*—a child made with a European, such as my grandfather, for example—would increase their chances of a decent life in the future. I never asked how my mother or my grandmother felt about all this. It might have been a taboo subject, something discussed only by the Tagalog plantation workers in the kitchen. In any case, my mother never returned to the Philippines after her time there during the Spanish Civil War. When I floated the idea of taking a family trip there, her answer was a resounding no.

When Pili returned to Spain, she was nearly thirteen years old. She had already lost two siblings—the second one during the crossing back to Europe. She had experienced a lot for her years. She spoke perfect English. She had seen hundreds of films that would not be released in Spain for years. She copied the hairdos and maybe even some of the progressive attitudes of movie stars. She knew countless songs and dances—indeed, they would stay with her for the rest of her life. The trunks with the family's belongings had been sent back to Estella beforehand, and by the time my mother arrived, her older

sisters had divided up all the clothes, including hers. Pili had never really experienced life with her full family. Her mother wanted her to understand her sisters: they had stayed behind and felt abandoned. Hard though it was, Pili had no choice but to accept the situation.

The Civil War had ended just a few years before, and my mother had no idea what living through it had meant. She told me that in Estella they called her *Coquitos* (little coconuts). Her parents had never bought her a bra, and she was keenly aware of the scandal that ensued every time she ran a few steps or rode a bike. It is likely that she, more than most other girls her age, perceived the passion that womanly curves aroused in boys.

Not long after their return to Spain, the family moved to San Sebastián, as if they were a traditional Spanish family that had always lived together. Pili delighted in the change. For the first time, she felt like an equal among her siblings.

### My Parents' Love Story

In my mother's telling, my parents' love story might have begun the very day she and her family moved to San Sebastián. Grandmother María gathered all her daughters on the balcony. "Look at those kids from the circus," she said, referring to my father and his brothers, Gonzalo and Ignacio, who were climbing up the facade of the house across the street. All three of them were very fit, and they often challenged one another to perform some physical feat. It appears they had decided to never take the stairs up to their fourth-floor apartment. Sometimes they would climb up the facade, other times the elevator shaft or the banister—but never the stairs. It is entirely possible that the Chillida brothers also checked out their lovely new neighbors that same day.

Very quickly, Pili and her sister Cecilia fell into my uncle Gonzalo's crowd. They would often meet up in Zaragoza Plaza to go skating around the city. My mother recalled that the first day Eduardo came along, he struck her as a bit cocky—but maybe she liked that. Apparently, my father would try to stand out, to differentiate himself

from the other kids. He would go off to one side and stare out into the horizon to make himself seem interesting.

The day Eduardo mustered the courage to invite Pili to the movies was a major event. By then, she had seen him staring out at the horizon many times. When they arrived at the movie theater, she discovered that Eduardo had no money on him at all—that would prove a pattern—and she had to treat. But she was not discouraged. They kept seeing each other, and Cupid's arrow struck, even though they were just a couple of kids—Pili only fourteen, and Eduardo sixteen.

I can imagine how my father tried to seduce her with deep conversation. My mother had always attracted the admiration of many people. She liked it when people liked her, and she loved to dance at parties—both of which horrified Eduardo (he was the jealous type). But he had no choice but to tag along to dances and parties to make sure he did not lose her. Pili soon saw that Eduardo was a "Doric dancer," slender and stiff like a Greek column. Maybe that's why she declined when he asked her to go steady. She had suffered enough with her sister who had died—she did not want to miss out on any fun because of a sulky boyfriend, which he seemed to be. She told him that they were still very young, but she had no doubt he was the man of her life. My lovestruck father had no choice but to wait a few more years.

As her daughter, I celebrate my mother's decision. It was one of the few times Pili prioritized what she wanted over what others wanted. The years went by, and when the time came for my parents to formalize their relationship, nobody could say that my mother did not know what she was getting into. She gave up some things she cared about, but intuition told her that life beside this man, whom she loved very much, would be very special.

What can I say about the years when my dad, at the age of nineteen, was the starting goalkeeper for San Sebastián's Real Sociedad team? If dancing mattered to her and not to him, the opposite was true of football. Pili could not understand why Eduardo's parents let him play professionally. His legs were covered with scars—evidently, the rules back then protected goalkeepers less than they do today. A bad knee

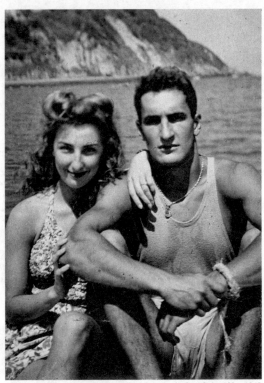

Pilar and Eduardo at the Bay of La Concha in San Sebastián, 1943

injury at the end of his first season is what led him to quit. Crushed, my father never again set foot inside Atotxa stadium, though the team would forever be close to his heart. Short though his career was, it was enough to gain him recognition from the team's subsequent goalkeepers as well as fans who had seen him play.

"Chillida, the goalkeeper?" a shopkeeper once asked my mother when she gave her name (by then, my father was already a well-known sculptor). "Who knows how far he would have gone if he hadn't gotten hurt?"

"You ask how far?" Pili replied, proudly. "Today, he would be the coach for the Elche team."

My father went to Madrid to study architecture at his parents' insistence. He was by no means pleased about it. But my mother was—just imagine, an architect boyfriend! They endured the separation the

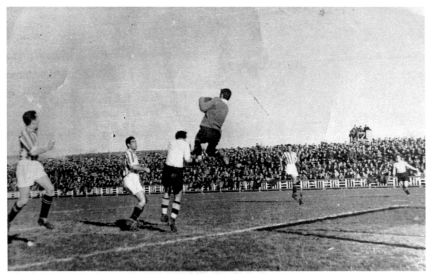

Eduardo as goalkeeper for Real Sociedad de San Sebastián football club, 1943

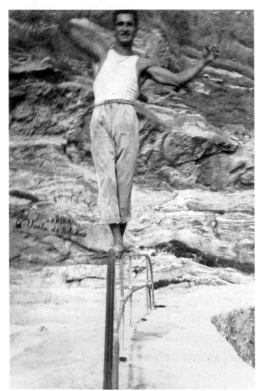

Eduardo walking on a slender rail on Santa Clara Island,
San Sebastián, 1944

way everyone did back then: by writing letters nearly every day. Though he was now more engrossed in intellectual concerns, my father kept in shape and continued to enjoy sports. When he came back to San Sebastián to see Pili, he would ask her, as they were strolling down Paseo Nuevo, a very high waterfront walkway where the waves hit hard: "Do you think I can hop up onto the handrail in one clean leap?" The sea was roaring below, but Pili's faith in him was boundless. "I am sure you can do it." Eduardo upped the stakes by not only jumping onto the slender rail, but then walking along it. "I'm going to break my neck one day."

The telephone was a mixed blessing. It produced a false sense of closeness. My father would always say that hearing Pili's voice but not having her by his side only heightened the sting of her absence. In any case, through telephone calls and letters, he was able to convey to his girlfriend the rough times he was going through at architecture school. With Pili's support, he finally decided to drop out and become a sculptor. That was when they made that "if you follow me" pact. His parents had no choice but to accept his decision.

Despite their displeasure at his choice, they put Eduardo in touch with a sculptor from Madrid, who gave him a piece of clay. My father hated touching that soft material. Some said that if he did not like molding, he would never be a sculptor—he proved them wrong.

He went on to study live-model drawing at the Círculo de Bellas Artes in Madrid, and that was where he had his first strokes of intuition about his vocation. Apparently, in the time it took other students to make one drawing, he would make three. His classmates asked him his name, and my father was pleased. One evening, he laid all his drawings out in his room. After observing and analyzing them all night long, he reached a conclusion: "This cannot be art—it comes too easy." So he decided to do something unusual. "Tomorrow at the Círculo," he said to himself, "I'm going to draw with my left hand instead of my right. That way, my mind and intuition, or my emotions, will take the lead. My hand will do what I tell it to; it will obey me. Not the other way around."

He and Pili burned almost all of those truly skillful early nude drawings in the chimney of my grandparents' house in San Sebastián. What those drawings showed was mastery. But mastery is not the same thing as art. In fact, it can sometimes keep art down. My father sensed that, and he helped my mother to understand it as well.

When, in October 1948, he set out to study in Paris, he had yet to make a single sculpture he considered worth keeping.

The stories of that second period that my parents spent apart were told often, and by them both, when we were growing up. They remembered how he bid her farewell at a steamy train station in Irun, on the other side of the border from Hendaye. They were enveloped in the night, in darkness, in a first taste of the longing that would accompany them throughout their separation, but also in the understanding of how necessary this was. Alone and determined to be true despite all the restrictions that came with being an unaccompanied woman back then, my mother remained in an oppressive culture from which my father needed to escape. And he headed to Paris—the Mecca of the art world at the time—as an unmarried man with nothing to hold him back in his search for light.

### The Start of a Winning Team
Some of my parents' peculiarities became glaringly evident soon after their wedding in 1950. For their honeymoon, they decided to go to the Parque Nacional de Ordesa y Monte Perdido in the Pyrenees, when most couples of their social class opted for Paris. They stayed in a shelter, and got there in a bus that left from the street they could both see from their respective balconies. "Can we ride in the *ahi-te-pudras*?" they asked the driver, who, overlooking a rule or two, agreed. He was undoubtedly touched by the newlyweds' youthful excitement. The *ahi-te-pudras* was a small outdoor seat for the person charged with keeping an eye on the passengers' luggage—my parents' first convertible!

They would often tell us stories about that trip to the mountains they took early in their life together. I can just see my mother with

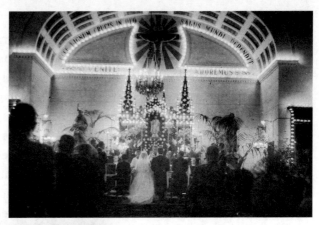

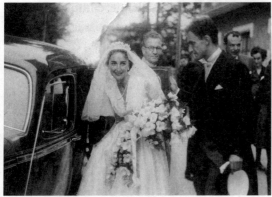

Eduardo and Pilar's wedding, Church of Ayete, San Sebastián, 1950

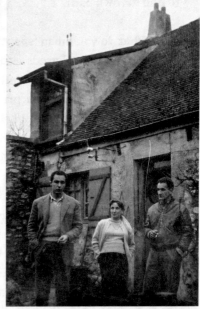

Pablo Palazuelo, Pilar, and Eduardo,
Villaines-sous-Bois, France, 1951

a wildflower pinned in her pretty blonde hair. I can also imagine my parents looking hard for an edelweiss—a flower usually found on mountain peaks, which might be why they climbed up Cotatuero. They would remember how the men who saw them make it up there laughed at what Pili was wearing—namely, a pair of *topolinos*, a fashionable style of wedge-heeled shoe. I know that, even though the onlookers laughed, those shoes were comfortable: I wear the same shoe size as her, and I can state as fact that she never wore an uncomfortable shoe. They had the climbing pegs they needed to make it up—a feat that eluded many of the men who had laughed at her. With my dad's encouragement and advice—"never look down"—my mother rose to the challenge, climbing from one peg to the next. I can imagine how pleased she was; he was not the only competitive one in the couple.

Instead of wedding gifts, my parents asked for money to make ends meet in the small town on the outskirts of Paris where they would head after their honeymoon. Eduardo did not want to stay in Paris proper. He had been living there for almost two years, and he wanted to take some distance from the dominant artistic influences to be able to find his own path.

**"What do you mean 'spent'? You haven't even gotten started!"** By the time the newlyweds settled in Villaines-sous-Bois, my father had gained a degree of recognition as a sculptor. The French press wrote that, while Spain was primarily known for its painters, a very promising Spanish sculptor had been featured in the Salon de Mai. While Eduardo had delighted in the acclaim, he expected much more of himself. Pili had made a wager on him. The last thing he wanted to do was let her down.

But his big break was not around the corner. During the first year of their marriage, my father was not very productive and even quite depressed. Pili, who was pregnant, handled the situation as best she could with the help of Pablo Palazuelo, who had declared himself her "official doctor." He pampered her. They called Eduardo's studio "Pompeii," because it was a ruin. It was freezing in there, and his

fingers became covered in chilblains. No matter how hard he worked, he could not cast off the Greek influence. He felt he was repeating himself.

It was during this period he wrote what would become his celebrated phrase: "I have yesterday's hands; I'm missing tomorrow's." He told my mother he was "spent." And, with characteristic fearlessness, she replied, "What do you mean 'spent'? You haven't even gotten started!" She could well have said, "No worries, dear, you can go back to architecture school"—he had completed three years—but she didn't. She had latched onto his dream of becoming a sculptor. So they decided to return to the Basque Country to find out if he had anything to contribute to sculpture. "If not," my mother said, "the sooner we find out, the better." Helping my father understand and get over his bouts of uncertainty and discouragement would prove a lifelong task, one of the many that she discovered came with "following" Eduardo.

### The Black Cantabrian Light

Back in the Basque Country in 1951, the black light of Euskadi—as Chillida termed it, as opposed to the white light of the Mediterranean—enveloped them in its dampness. At a forge in Hernani, the small town close to San Sebastián where the Chillida Leku museum is now located, an aunt had lent them a house. And there Eduardo forged a novel work in iron that he titled *Ilarik* (1951). That was the beginning of the Chillida we all know. He was just twenty-seven years old, and all he had to his name was the unconditional support of one woman. Come to think of it, the name of that first nonfigurative sculpture was marking the end of a certain path.

### Historical Justice

I open the window and the light that comes pouring in shines on my gratitude. I am endlessly thankful to all those—family and others—who have worked for years at Chillida Leku and the Fundación Eduardo Chillida y Pilar Belzunce. All the materials my mother accumulated during her life with my father have been catalogued, transcribed, and

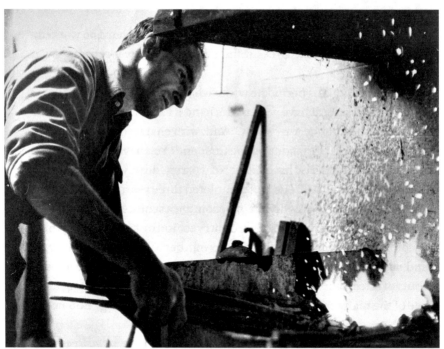

Chillida working at the forge of Manuel Illarramendi, Hernani, 1952

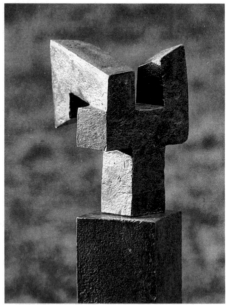

*Ilarik* (1951). Anchored in the earth like traditional Basque funerary monuments, this work marks the end of Chillida's figurative phase.

readied for use by scholars of Chillida and his art. I consider myself a privileged student of that rich life they shared. The letters my father wrote my mother, first from Madrid and then from Paris, sometimes make even me—their daughter—blush. I find this material, which is new to me, full of so much potential, and segments of it are included in the coming chapters. Others I have set aside for the documentary I want to make about my mother. Making a film about Pilar Belzunce after having made two about my father is, for me, a poetic act of justice.

When I was making those two films, I took continuous notes on my thought processes and motivations, the various elements at play in making a portrait of my father. I also wrote down my decisions about the filming, the team, and so forth. This was early and important ethnographic data recorded at the urging of my thesis supervisor, Professor Hope J. Leichter. For the first time in the history of Teachers College at Columbia University, a documentary film, *Chillida: el arte y los sueños* (Chillida: Art and Dreams), was presented as an integral part of a doctoral dissertation and not as an appendix. The written section of the thesis is a reflection on biography as a genre: the role of narrators, the differences between first-person and third-person perspectives, between filmed and written biographies, and so forth. It also includes an exhaustive personal account of the process of filming my father's biography, of being his biographer. My dissertation was translated into Spanish and published by the Editorial Service of the University of the Basque Country at the request of Father Antonio Beristain, SJ. It came out in 2002 under the title *Chillida, el arte y los sueños: memoria de las filmaciones con mi padre* (Filming the Biography of an Artist-Father: Representation of Self and Other in *Chillida: Art and Dreams*).

It seemed a bit grandiloquent, even excessive, to refer to myself as my father's biographer. And yet the visions of Eduardo Chillida that I captured as best I could in writing and film have proven enduring. This book is one more facet in the story, only this time it includes my mother in her rightful place. Would Pili have liked to share the spotlight, for the curtain to be drawn back on that anonymity in which she seemed so comfortable? Maybe, but maybe not.

I remember what she said when she read my dissertation (I sent them a dedicated copy). "My Eduardo"—as I used to call my husband in front of my mother, since our husbands shared the same name—asked Pili: "Have you read Susana's book?" Then, almost theatrically, she blurted out, "Oh boy!" She thought I was putting on airs.

My mother had always remained in the shadows and never received credit or public acknowledgment for her hard work. My text struck her as brazen simply because it was written by me, a woman. Bear in mind that, no matter how modern and unconventional she was, Pilar Belzunce was nevertheless a woman from another time.

### Madrid, 1944–48: Pili, Eduardo's Confidant

I have often wondered about my father's life in Madrid and Paris in the years leading up to his marriage. I knew the things he had chosen to tell us and that he had published in books, catalogues, and so forth. But the correspondence with my mother sheds more light on what their lives were really like back then. In addition to their great love, which is palpable in the missives, I sense his concern about her health and weight. On a bike trip to Orio, a small town about twenty kilometers from San Sebastián, my mother suffered a bad case of sunstroke. She then developed Ménière's disease and lost hearing in her right ear; furthermore, a constant whistling sound produced vertigo and headaches. She lost her appetite and, subsequently, a lot of weight. One day her doctor told her, "Pili, science has not yet come up with a treatment for what you have, so you best get used to it"—and so she did. The disease stayed with her her whole life, though you could never tell from the outside. That explains why she was so hard on herself—and on us kids. I can barely remember a time when she was sick, and all of the little ailments we kids got seemed to her like trifles—or "small potatoes," to use her term—compared to what she was putting up with every day.

What strikes me most about the letters, though, are the details my father shared with her about every move he made in his work and career, every discovery and cause for excitement. Whatever he learned, she learned as well. Pili was his confidant and friend.

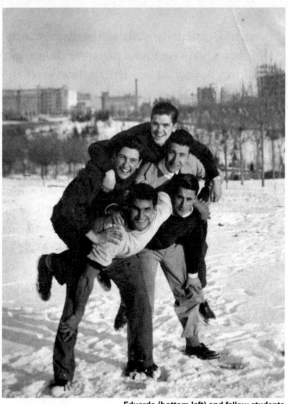

Eduardo (bottom left) and fellow students
at Ciudad Universitaria, Madrid, 1944

From the letters, it's clear that as soon as he arrived at the Jiménez de Cisneros dormitory in Madrid, where he would live while studying architecture, his fellow students wanted him for the football team. My father said he couldn't, but they begged him to at least be the coach. They were sure he would be able to organize them and get them riled up for the games. The next year, he took part in the dorm's "Olympics." Despite his bum leg, he was awarded first prize in discus and shot put, and second in javelin.

As I mentioned earlier, when Eduardo dropped out of architecture school and began exploring sculpture, he did some modeling in clay, but he did not like that material in the slightest. Nonetheless, it appears he modeled clay in the morning, drew at night, and from three to six in the afternoon went to a quarry to help a sculptor work

on a monument. "If you could only see the state of my hands . . . " He wrote to Pili in a number of letters about a personal clay work he was making. At play was my father's interest in the unexplored, in the qualities of matter, and in the addition of different elements to a single mass—all interests that would remain with him for the rest of his life. "I started work on something new in the studio this morning: the figure of a man falling onto a clay mound. It's almost as if the two formed a single mass. I like the idea, and if it turns out well, I'm going to try to make it in stone. Thanks to the work at the quarry, I'm gradually mastering stone, so I think I'll be able to make it work." "I really want to get to work with stone. Because of its resistance, the person who handles it develops a clear idea of what the sculpture should be—in other words, he has to have a solid understanding of what the form can and cannot do. It sets before the person who sculpts a terrain—the qualities of the matter itself—little explored at a time when everyone models and no one sculpts."

I know nothing more about that stone piece he was so excited about. Perhaps he never got a chance to make it. I never saw the clay sculpture either.

Letter from Eduardo to Pilar, sent from Ciudad Universitaria, Madrid, 1946

## Paris, 1948–50: Coming Out of the Dark

Moving to Paris in the late 1940s was an act of courage and a cornerstone of my father's life as an artist. He left behind the darkness that enveloped Spain, as well as the Basque Country, during the Franco years.

After receiving a fellowship, Eduardo lived at the Colegio de España of the Cité internationale universitaire de Paris. It was there that he met, among other artists, Pablo Palazuelo, José Guerrero, and Eusebio Sempere. He studied drawing at the Académie de la Grande Chaumière, which struck him as worse than the Círculo de Bellas Artes in Madrid, and enrolled in the École nationale supérieure des beaux-art, where he majored in sculpture. The letters to my mother suggest that his studio was close to Palazuelo's, and they became good friends. They helped each other muster the courage to visit the artists they admired, among them Brâncuși, whose understanding of materials taught my father a great deal. Picasso also agreed to see them, but he didn't show—though that ended up being its own lesson for my dad.

What he liked most of everything he saw in those first days in Paris was Egyptian art; he was also taken with African and Asian art, though evidently that interest pre-dated his time in Paris. "It was after seeing them [the Ancient Egyptian works] up close or, really, touching them that I understood their enormous importance . . . " That part about touching the work amuses me: I remember him telling us about the lengths he would go to in order to keep museum guards from noticing he was touching objects in the gallery. Once he spent quite some time waiting for the right moment to touch the *Head of Gudea* (2090 BCE). When he lay his hand on the dome of the head, he felt it was resting on the entire globe.

He also soon understood it was possible to get a lot out of modern art if you were able to distinguish between what was worthwhile and what was not. "As you can tell from all the impressions I've been sending you, I am caught up in a whirlwind of ideas. I have no idea where they will take me. I am sure that when I settle back down, I will

be blamed for having been swept away by things that are, in all likelihood, useless and unenduring. That is why I want you, if nobody else, to know that everything I make from here on, like the little I have made so far, comes from the heart. All I hope is to be able to find myself." Eduardo realized that ancient art nevertheless had a greater impact on him than modern art—though, in fact, they were often not that far apart. Yet he was not convinced by the avant-garde movements he had encountered. That said, he did realize that the modern artists were right about certain things. "Some of them are, in their art, more honest than that endless roster of artists who mindlessly paint what they have before them."

Knowing how close he and Miró would soon become, it amuses me to read the impressions of the first Miró show he saw. In a letter to Pili, he wrote, "I went to the Miró show (Miró is a world-famous Spanish artist who, in tandem with Picasso, revolutionized the art world). The exhibition was extremely interesting. Even though what he does is not what I am after, there is no doubt in my mind that his work is worthwhile."

He also wrote to her about his own work. "Work has been going quite well, and the reclining figure I started a few days back is pretty far along. Even at this early phase, I can tell it's better than the torso I just finished. Due to the arrangement of the forms, it can stand firm in three positions." This comment is particularly striking for me because my father was always intrigued by the number three. *Yacente* (Recumbent, 1949) was one of the few works that survived my parents' move from Paris to the Basque Country in the spring of 1951. My mother had just given birth, and my father had gone back to Paris to pack up his works and arrange their shipment. Evidently, he didn't do a very good job. When he saw the damage while unpacking, he said, unfazed, "No use crying over spilled milk." And he got right back to work.

He first met Bernard Dorival, the conservationist at the Musée national d'art moderne de Paris, in 1949. "After visiting a number of studios and gathering his impressions—favorable in some cases

*Forma* (Form, 1948) and *Torso* (1948),
the first two catalogued sculptures by Chillida

(Palazuelo) and somewhat less favorable in others (Muxart and
Mercadé)—he came to mine. He was very interested in my production,
both the drawings and the sculptures." Dorival wrote my father
letters of introduction to two sculptors and a dealer by the name of
M. Caputo, who had an important gallery in Paris. This is what he said
about Chillida's work in one of those letters: "I was stopped short
before some of his things. I think he has remarkable talent." Thanks
to that, my father started showing his work in exhibitions like the
invitation-only Salon de Mai, the most important group show in Paris
at the time. My father was unquestionably very lucky that his art
aroused such interest from the time he was so young. His determina-
tion, and the work itself, must have been truly exceptional.

I find it heartwarming and consistent with his romantic nature
that his first two sculptures, both made during those lonely months in
Paris when he was twenty-four, were of the body of a woman, titled

*Forma* (Form, 1948), and the body of a man, called *Torso* (1948). "I have changed my mind about what I'm going to do. I came up with a better idea. I'm going to make a male torso, but according to a new concept that is much better than the one I used for the female torso I made a month back. If I keep on track, I think it will turn out quite good. I have to finish up something on *Yacente* before I can leave, but as I said I think I will be able to make it at the end of the month. [ . . . ] I am pleased; I have made three sculptures (the one I am working on now is not finished, but anyway . . . ) and plenty of drawings. All three of them are much better than the ones I made last year, and so far each one is better than the last (in my opinion)."

*Forma* won critical acclaim at the Salon de Mai in 1949, as did *Metamorfosis* (Metamorphosis, 1949), which evidences Chillida's intention to go a step beyond figuration. We lived with *Forma* at home all our lives. Some of my siblings call it "the butt," and when my mother shows the work in one of my films, everyone can tell that that "form" is hers. At the risk of saying too much, I would say—and my mother confirmed—that Eduardo was quite passionate; holding off until they got married was hard for them both.

It was right before returning to San Sebastián in July 1950 to marry Pili that the most important event of Eduardo's time in Paris took place: Louis Clayeux, the artistic director of the Galerie Maeght, saw Chillida's work (he had already visited Palazuelo's studio). He asked my father if he would be interested in a show at the gallery.

"A true artistic vocation is no cup of tea," my father told my mother. "It is a destiny, a compulsion. No telling where it might lead us." I understand that "us" to refer not only to other artists, but also to both members of the young couple. My mother's love of art deepened through Eduardo's words. She admired artists' creativity and talent and experienced it through her man, even from a distance. She was always, and from the very beginning, his rock in good times and in bad.

### Inner Tensions: Back in the Basque Country for Good

I have the sense that, throughout his stay in Paris, my father naively set out to forget his origins and tried to play the part of the artists of ancient Greece, whose work he so admired. That was why he chose to work with white plaster, which resembles, at least in color, the marble used for so many of the magnificent artworks created by that Mediterranean civilization. But Eduardo was neither an ancient nor a modern Greek. He was a young Spanish-Basque artist with some unresolved issues surrounding his identity.

"With a light to see how I do not see, I was placed between the no longer and the not yet" That sentence expresses how, as an artist, he positioned himself before the unknown. And that limit between what had already been done and what had yet to be done was what he came up against when he moved back to San Sebastián—and it proved a great motivator. The light he sought, as a sculptor, consisted of questions about matter, space, and limits.

Eduardo would often recount how, on the train back to his homeland, especially when he was finally able to make out *la mar*, the sea, he was overcome by an emotion he had never experienced before. No less new was the situation he would find in the Basque Country. I have believed for some time now that the inner tensions that are part and parcel of his work—the source of its grandeur—have a lot to do with the tensions he went through back then and with his way of dealing with them.

One of those tensions—and by no means a minor one—was tied to the fact that his father, as per the family tradition, was a career military officer who had to fight for Franco. While that fact might have gone unnoticed, or almost unnoticed, when he was younger, feigning ignorance was impossible upon his return from Paris, now an adult. The political situation in the Basque Country at the time affected not only him but everyone he came into contact with. He would always say that the only way to get to know yourself is by leaving home and coming back with new eyes.

The conflict of loyalties that he was confronted with as soon as he found himself in the grip of historical consciousness was very strong. The repression in the Basque Country under Franco was intense. It affected all aspects of life, and my father, despite his upbringing, found the situation unjust. Besides, from the time he was a young man, he was aware that his father had been saved by a *gudari*, a Basque soldier. Apparently, the soldier opened the door to the cell in the Bilbao prison where grandfather Pedro was being held; he covered him with a trench coat and then let him out, along with many other prisoners, before the Republicans arrived to slaughter them. As a result, my father felt a debt to the Basque Nationalists, one that he would continually try to settle in a thousand different ways.

I am convinced that the difficulties my father faced in a Basque Nationalist milieu were intimately tied to the inner tensions that would ultimately enrich his art.

The fact that he did not speak Euskera—his mother had not passed it down to him—affected him more than anyone might imagine. It was one of his life's great sorrows, and it left him at a disadvantage in the eyes of many. He was a Basque who greatly valued the Euskaldun character—and *Euskaldun* literally translates to "the one who has the tongue." I remember how in the 1970s he made an earnest effort to learn the language. He encouraged some of us kids to study it, as well. I was thirteen, and I remember how from one day to the next we went from calling our parents Mom and Dad to calling them *Ama* and *Aita*. Unfortunately for him, Euskera is an extremely difficult language, and he did not have the time it took to learn it. For my dad, his art always came first. His works, he would often say, already spoke Euskera, which explains why from the beginning he appropriately gave many of them titles in that language.

Another drawback that burdened my father from birth was that impulsiveness that grandfather Pedro spoke about in his letter. That trait was particularly evident in the visits he and my mother made to Estella after they got married. Pili's old friends wanted to spend some time with her, but Eduardo made that impossible. He would get

frighteningly angry, and my mother had to calm him down by saying no one had even laid an eye on her. Reining in that intense character must have taken time and effort. But I'm convinced that learning self-control also had a direct relationship to his work as a sculptor. Forging hard material, pounding it with a mallet, was a good way to release energy and move inner tensions into his work—a model case of artistic sublimation.

He knew a great many Basque artists over the years, some of them—like the painter Rafael Ruiz Balerdi—became close friends. Indeed, he was like a brother to my father. That is why, upon Balerdi's death, Chillida would dedicate a sculpture to him: *Estela a Rafa Balerdi* (Stele to Rafa Balerdi, 1992). It is located on the Pico del Loro promontory, which divides the two beaches of the Bay of La Concha in San Sebastián. With other artists—mostly sculptors I never met personally—the relationships were strained and confused. Art got mixed with politics, and the personal with the social. I remember hearing my parents recount how one of those Basque sculptors, Jorge Oteiza, had chided my father early on. "You have abandoned man," he said to Chillida, who was the first artist in the Basque Country to venture into abstraction. I think the mix of love and hate Oteiza felt for my father only intensified over time. At a certain point, he even spread rumors and published false information that my father did not dignify with a denial. He would not let baseless provocations distract him.

Chillida loved the Basque Country the way he loved his children— with their virtues and their flaws. My father was a freethinker with a keen sense of decency and morals. He believed in and loved peace, and he always followed his conscience.

As I said before, he felt eternally grateful to the Basque Nationalists. But when it came to art, he did not believe in groups or flags. He held that each artist had to find their own voice, which is why he looked askance at art education. For that reason, he refused to claim member- ship in what is called the Basque School, even though his work, starting with the innovative iron gates he made for the Sanctuary of Our Lady of Arantzazu in 1954, has always been an inevitable point of reference for

that movement. He was an individualist, but also a man of commitments, and that held true in all spheres of his life, including not just art but sports. His form of teamwork was always singular: not only was he the goalkeeper in football but he was also the bow hand when he raced rowboats in San Sebastián.

When I was a child, there were only two television stations in Spain, RTVE and UHF. In San Sebastián, we were also able to tune in to the three French channels, and we did so all the time. To get a better sense of what was really happening in the world, my parents would listen to Radio Paris. I remember some of the people who would stop by the house: Mari Asun Bergareche, a highly educated and well-informed woman, especially in the sphere of politics; Pepa Rezola, a no-less-cultivated woman from San Sebastián married to a businessman from Bilbao; Dr. José Mari Merino and his wife, Antxoni; and psychiatrist and writer Luis Martín-Santos, with whom my parents delighted in discussing thousands of topics. When Martín-Santos died in an accident not long after his wife had passed, my parents and other close friends of the couple became godparents of their children. In 1963, my father made a sculpture in homage to his deceased friend. One of the children, Luis, remembers Pili and Eduardo as people who took loving care of him and his siblings when they lost their parents.

I said that my father did not get distracted by the provocations of his fellow Basque artists—and that is true. But I would go further. I believe that the silence he vowed to keep to stay on course is another factor that helped make his work more powerful. That restrained tension, that force held back by sculptural form, spoke for him.

The Basque question was never as important for my mother as for my father, but still it must have been hard for her to keep quiet when there were things to deny. She did what Eduardo thought best, and time would prove him right. Pili's silence also turned into a source of strength. It kept them at a distance from milieus best not frequented and pushed them to pursue their artistic ambitions—and those had always gone well beyond the local scene.

# Under the Wing of the Galerie Maeght

### Le cosmos du fer—One-of-a-Kind Sculptures

It was in 1950 that the show Louis Clayeux had offered my father at the Galerie Maeght in Paris came to pass. Like many of the gallery's group shows, this one, *Les mains eblouies* (The Dazzled Hands), featured the work of emerging artists that had caught the gallery's eye alongside the work of well-established figures. Chillida showed *Torso* and *Metamorfosis* (Metamorphosis). A few years later, in 1956, the gallery held his first solo show. "The iron cosmos is not an immediate universe. To reach it, you must love fire, hard matter, might. It can only be known through creative acts," wrote the philosopher Gaston Bachelard in reference to the wrought-iron pieces my father showed. The essay was titled "Le cosmos du fer" (The Iron Cosmos).

The gallery's founders, Aimé and Marguerite Maeght, and their artists were like a big family. The gallery published a great many books and catalogues, and enjoyed introducing artists to the most important thinkers, poets, and literati of the day—figures like Bachelard as well as René Char, Paul Éluard, Samuel Beckett, Louis Aragon, and Jean-Paul Sartre.

By the time my father became part of that big family, he had had a solo show at the Galería Clan in Madrid (held in 1954). That was where he met Juan Huarte, a businessman from Navarre who would become Chillida's first collector. Indeed, Huarte bought work by a number of Basque artists. My father had also, by the time of that first Parisian show, produced the gates of the Sanctuary of Our Lady of Arantzazu and his first *Estudio Peine del viento* (Study for Comb of the Wind, 1952), now part of the Museo Reina Sofía collection in Madrid. He had received his first major prize, the Diploma of Honor, at the 1954 Milan Triennial. The titles of his sculptures suggested his love of nature, poetry, and music: *El espíritu de los pájaros I* (The Spirit of the Birds I,

1952), *Música de las esferas I* (Music of the Spheres I, 1953), *Elogio del fuego* (In Praise of Fire, 1955), *Elogio del aire* (In Praise of Air, 1956), *Tximista* (Lightning, 1957).

Something that would prove pivotal to Chillida's art and his approach to making it happened at that 1956 exhibition. Aimé Maeght explained it was advisable to make a number of bronze copies of each exhibited work, so as to be able to continue showing them around the world once the originals had been sold. All the artists who worked with the gallery—Giacometti, Miró, Calder, Braque—did this, he explained. Indeed, it remains a common practice today. My father, feeling he had no choice in the matter, agreed to have his works copied, but only the eight he felt best suited to reproduction, and he limited the number of copies to three or four.

Once produced, Maeght proudly showed my father the bronze copies. "What do you think?" he asked expectantly. At the risk of ruining his relationship with one of the top gallerists of the 1950s, my father told him exactly how he felt while standing before those identical works that he had never laid a finger on. "Want to know what I think? To me, they look like . . . an entire shop of beautiful shoes, but they're all for the right foot." He refused to repeat the experience because it went against his principles as a sculptor. That gained him Aimé's eternal trust. In that moment, the gallerist promised to buy all of Chillida's future sculptural works. Imagine what that meant to my parents—a young couple with four mouths to feed.

Thanks to the unconditional support of his gallerist, my father could produce all his sculptures just as he wanted. He would make them by hand at the forge rather than use molds; each of his works was one of a kind. He also never rendered another bronze copy— a peculiarity that increases the value of Chillida's work.

Gisèle Michelin, Maeght's personal secretary, would regularly come to San Sebastián to see to the logistics of my father's shows. With her would come the strong scent of Parisian perfume. She would stay with us, and I remember that, because of the cologne, I knew she was there as soon as I arrived home from school. She was the first working

woman we kids knew, besides the two domestic helpers who assisted my parents in running such a large household, especially when they were not around.

### "The value is up to me, the price up to them"

Part of Eduardo and Pili's pact was that Eduardo not be burdened by financial questions. He knew that money and art should not mix, and he helped my mother to understand that as well. "The value is up to me, the price up to them," he would say—and he was right. But the price was just one part of the family finances. Payments had to be made and money collected on schedule: supplies were needed for daily work in the studio, and there was the household to think about. None of that is easy, and my mother was the one who took care of every last detail.

From the time my father started working with the gallery, Aimé Maeght called him *mon petit*, since he was by far the youngest artist the gallery represented. He was used to dealing directly with his artists in all commercial matters, and at first Aimé didn't want to confer with Pili, no matter how much he respected her as a person. So when Chillida would go to see Maeght, my mother would arm him with little pieces of paper to remind him of everything he had to say and ask for. I can just imagine how nervous she would have been until Eduardo told her the results.

"Did you tell him we need to buy more iron?" "Yes." "Did he pay you?" "No."

Aimée finally realized it was much easier to deal with Pili when it came to money matters.

### The Blacksmith from Hernani

My father ventured into the world of iron and forging as soon as he and Pili moved to Hernani after leaving Paris. Across the street from Vista Alegre, the house that his aunt let them stay in, the blacksmith Manuel Illarramendi had his shop. Since my father was an admirer of Julio González's expressive iron sculptures, he enjoyed observing how

the blacksmith worked with this material. They became fast friends, and Eduardo soon asked Illarramendi if he would let him use his forge. They agreed that he could use it very early in the morning, before the blacksmith began his workday. Later, my father set up a small workshop in the garage of his rented home—a home in which babies were born at nearly the same rate as iron sculptures were produced. Of course, I considered those sculptures my brothers and sisters! The strange thing is how little I knew about them until I started working on my Chillida documentaries.

### My Siblings, the Sculptures

My parents' first child, a daughter, was born in April 1951. They named her Guiomar, the name of the woman that the great Spanish poet Antonio Machado loved—clear evidence, to my mind, of their shared passion for poetry.

Today it's normal for the father to be in the delivery room when his children are born, but I doubt that was the case in the 1950s. My father, however, was there when all of us were born. How could he possibly leave Pili's side at such a moment? Besides, there was no way he, a creator, was going to miss the most powerful act of creation there is. It couldn't have been easy, but they finally found an obstetrician-gynecologist up to the challenge of having an "intruder" at the birth. To make matters worse, it was a difficult delivery. The baby was suffocating when she came out, because the umbilical cord was wrapped around her neck. While my mother was resting, my father, who feared for the baby's life, snatched her up and baptized her in a sink in the hospital. It fills me with tenderness to imagine him undertaking that brave yet innocent act, overcoming his fear, and heeding his heartfelt beliefs. Those were different times.

Their first son, Pedro, was restless and curious—and a bit wild. He was followed by Ignacio, and soon after came Carmen. Those were my four older siblings.

"All set, mom, this one is walking. When can we expect the next baby?" seems to have been the question voiced every few years.

56

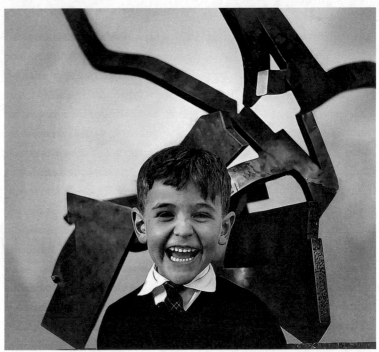

Ignacio Chillida in front of *Rumor de límites IV* (Rumor of Limits IV, 1960), 1960s

Among the photographs I gathered from my mom following her death, I found my brother Ignacio, their third child, grinning ear to ear (he still has his baby teeth). It made me happy. The co-star of the shot is one of our "sisters," the iron sculpture *Rumor de límites VI* (Rumor of Limits VI), born in 1960. I can almost hear my mother's voice explaining to me the importance of the small slits my father would cut into the iron to make it change direction and open up like a flower.

At first, the only form of contraception my parents used was breast-feeding, and Pili would drag that out for as long as possible. After the fourth child, they tried the rhythm method, but that did not work. After the eighth, my mother went on the pill. She stayed on it for years on end, never even taking the week of sugar pills. Years later, my eldest sister and I speculated that she may have been trying to avoid noticing when she entered menopause, a difficult stage for so many women.

Chillida (right) in Venice in 1958, the year he won the International Grand Prize for Sculpture at the Venice Biennale

### Wanted or Unwanted?

The mourning over the loss of my mother began before she died of Alzheimer's. That was when I began to think about the two of us, our particular relationship, and to try to heal any wounds before she was no longer around. I thought about my conception and birth. And I learned that something I believed—something my parents had made me believe—was only partly true: I thought I was the most coveted of her children. I was the first blonde girl with blue eyes, the child who looked like her, the one that she had always imagined. I lived for a long time with this illusion—which at the same time created a displeasing sense of injustice toward my siblings. But the fact is: I was also the first truly unwanted child. They had done everything they could to keep Pili from getting pregnant.

Born in May 1958, I was my parents' fifth child, and the first proof of the rhythm method's failures. If my mother was willing not to have what she supposedly wanted most—a child in her image—she must have been especially furious to get pregnant during what would be such an important year for my parents. At the upcoming edition of the Venice Biennale, my father would win the International Grand Prize

for Sculpture. He also was set to participate in the show *Sculptures and Drawings from Seven Sculptors* at the Guggenheim in New York as well as an exhibition at the Graham Foundation in Chicago, where he would also be awarded a prize. The burden of a fifth child when they were only just getting by, having her body change once more, and being forced to miss out on so much—it couldn't have been easy. I think I must have experienced in some way what my mother was going through during those nine months I spent in her womb. The doctor's exclamation was my salvation: "Such a blonde little girl!" My physiognomy was her reward. That said, she stopped breastfeeding when I was less than four months old—much earlier than any of her other children—to accompany Eduardo to Venice and the United States.

Today it fills me with equal measures of sorrow and tenderness to imagine my thirty-four-year-old mother trying to think of who might take care of her newborn. I know she looked hard for the right person. And I still remember in my bones the warmth and love I received from my auntie Ana Mari Cartes, my father's cousin who was to take care of me during those early absences. I can tell from all the photos I've seen of Pili while she was away that year that she felt miserable and she missed me.

Pilar and Eduardo in Chicago, September 1958

Villa Paz was our childhood home. My parents bought it after my
father received the International Grand Prize for Sculpture at the 29th
Venice Biennale in 1958. It was in Ategorrieta, at the foot of Mount Ulía
and across from Intxaurrondo, in San Sebastián. It was a large villa
with the red windows typical of the neighborhood. The house was
covered with ivy that would change color in autumn and then shed its
leaves in the winter. In a spacious area of the garden there was a jai alai
court for us to play Basque ball. We called the whole place, where many
family activities took place over the years, *el frontón*. It was our outside
playground.

I was the last child born while my parents were still living in
Hernani. My mother enjoyed remembering how she would take me
with her in the car when they were moving to San Sebastián, known
in the Euskera language as Donostia; not long after the move, María,
Luis, and Eduardo came along to round off the family. They did major
renovations to our new home, especially its ground floor, opening up
the space by removing all the partitions and doors they could.

The air flowed freely between all the rooms. My father loved
playing with us kids. Tossing a ball around the spacious living room was
more than just a game—it was an experience. We quickly understood
that what really mattered was precision and style in the toss—your hand
should snap like a whip—and the resonant sound that came when you
caught the ball with conviction in the hollow of your hand. We called
that game "blocking," which is what my dad would do as the goalkeeper
for the Real Sociedad football team. The game would often turn into
a challenge: difficult tosses and almost impossible catches, where style
always mattered. Just being with my father made you want to out-
perform yourself and relish the nuance of each and every thing. Life is
a continuum, and our father's philosophy and demeanor have been
passed down through us kids to our own children. When my husband
first walked into Villa Paz, he was riveted. He had never seen a house
like that before—and that was in 1979, when the open-concept home
*still* hadn't really made its way into Europe.

My father's sculptures were always around the house. We were quite wild as kids, and once one of his works fell on my head. If one of us got a cut, we'd try to hide it from my dad because he would always clean the wound with alcohol instead of hydrogen peroxide, and alcohol stings much more. For bad cuts and broken bones, we had the Clínica de San Ignacio nearby. No need for any adult to take us there—all eight of us had an open line of credit, so if our parents could not come along, we got the treatment we needed and my folks settled up later. They had the same system in place with Brito, the shoemaker.

Villa Paz had two chimneys, which Chillida designed himself: a wooden one in my parents' bedroom, and a granite one in the living room. Maybe my mother never again wanted to be as cold they had been in Hernani. In those early and uncertain years, they would turn off the heat in the house rather than forego the iron my dad needed to make sculptures. On sunny days, they would take whoever was in the cradle outside while all the older children played. One time, after everyone had gone inside because it had started to rain, someone asked where the baby was. They found the missing tyke outside, drinking raindrops and trying to dodge them, happy as a clam. I think the baby must have been me. Something similar could have easily happened to my children. I loved putting my babies' cradle under a tree and watching them delight in the way the light changed as the wind blew through the leaves.

Owning their own home and having the means to feed their eight children was my parents' greatest achievement as a couple. With that, they obtained true freedom and independence from their respective families. They were able to tell my great-grandmother Juanatxo, who often sent food from the hotel to Hernani and helped out with basic expenses, that they were very grateful but no longer needed her financial support. Before, one of the many things Pili had had to deal with was swallowing her pride and letting herself be helped.

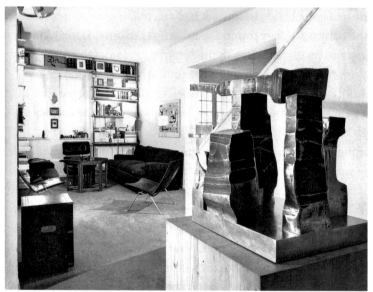

The open-plan combined hall and living room at Villa Paz, San Sebastián, 1960s.
*Leku I* (Place I, 1968) is on the right of the photographs.

### The Studio in Villa Paz

On the property a few steps from the main house was a second, smaller building that served as my father's studio. It was like the sort of house a child draws—a slanted roof and two simple levels connected by an outdoor staircase. The forge was downstairs, and the chimney upstairs (he had it added). The studio's doors and windows were also painted red.

The poet Gabriel Celaya, a close friend of Chillida's who was often at our house, drew a resounding and simple portrait of my father's workspace in words. He spoke of the "downstairs studio," where my father worked like a blacksmith with an assistant, and the "upstairs studio," where he turned into an engineer of dreams.

As his daughter, it was great to have my father always around. He would stop by the playroom on his way back from the studio and play some ping pong with us before settling down into his favorite armchair in the living room. One day, a little ivy leaf came through the window behind that armchair; my parents let it stay. With their permission, the leaf grew into a vine that eventually covered the bookshelf with green. Pili held it between the books, taming it, and when the branch grew too fat and felt it was suffocating, they opened the window to free it—surprisingly, the ivy died.

I can still see my sister María and me as girls walking into our father's ground-floor studio in search of chalk or oil for our skates. José Cruz, his assistant at the time, would always tease us, in his thick Euskaldun accent, before giving anything to us.

José Cruz Iturbe was a burly, down-to-earth, and somewhat sarcastic Basque man. He had been retired for years when he chided my father: "You have no idea how ashamed you made me feel, rooting around in mounds of junk metal like scavengers . . . What you should've done was smoke a good cigar with the junk dealer and have them load up a truck!" He was talking about the years when the pair of them went to junkyards to look for puddled irons. Of course, not all of them were what Chillida was looking for . . . He had a discerning eye. For my dad, perception was fundamental. It was thanks to these

qualities that he homed in on antique farm tools that connected him to the most archaic of his Basque people. By transmuting those artisanal forms, Chillida returned to a place already traveled and took it one step further through his art.

### Chillida's Chimneys

I remember the story my father would tell about the chimney he designed for his studio. Two burly Basque guys, father and son, who helped Pili out with a thousand things around the house over the years, built it according to Eduardo's instructions. When my father saw it, he was horrified. He told them to tear it down. They started over. Same result: my father saw it and told them to take this one down as well. When it came to the third attempt, the two guys, proud of their work, showed it to him: "So, do you want us to tear it down?"

In addition to the studio chimney and the two chimneys he made for our house, he built a last one out of refractory bricks years later at the Molino de los Vados, a water mill, a place very special to our family, nestled in the hilly province of Burgos.

One corner of the living room was on two levels, with the fireplace on the lower one (underneath it flowed the waters of the Arlanza River). One could access the lower level using some built forms, also made of refractory bricks, that worked both as stairs and as seats. They enabled us to choose our relation with the fire in terms of closeness and height—an effect that was reproduced years later in connection to the sea via a platform and steps in the work *Peine del viento XV* (Comb of the Wind XV, 1976) in San Sebastián.

### Pili: An "Architect-Builder"

Except for all those chimneys—which are authentic Chillidas, even if never signed—Pili was the one who dealt with the many renovations of the family home. Sometimes she consulted Eduardo, but sometimes she did not; sometimes she worked with an architect, but sometimes she did not. In these renovations, she heeded her intuition about the family's immediate needs, but also left open other possibilities, paving

My parents (left), husband, children, and I at the fireplace of Molino de los Vados during a break from shooting *Chillida: el arte y los sueños* (Chillida: Art and Dreams, 1999), Burgos province, 1998

The living room at Villa Paz, San Sebastián, 1960s. Visible on the fireplace mantel at the back are *Yunque de sueños XIII* (Anvil of Dreams XIII, 1962; left) and *Modulación del espacio I* (Modulation of Space I, 1963).

Chillida with *Forma* (Form, 1948), 1960

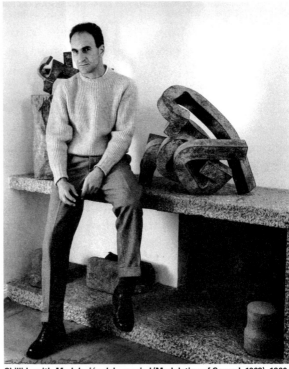

Chillida with *Modulación del espacio I* (Modulation of Space I, 1963), 1960s

the way for more than one future. My mother was bold, very bold—there is no denying that. If she had not taken on the couple's shared mission—my father's art and career—I believe that Pilar Belzunce would have been a very good architect. She liked math and calculations, she had a sense of beauty and style, and she was sensitive to what people needed. She was a hard worker, she enjoyed the company of others, and she was a team player.

There is an image of the living room of Villa Paz, with the granite chimney in the background. I see my father in the space's expansiveness, in its sturdiness and might. And I see my mother in its beauty and subtlety. Her way of decorating the house was nothing short of artistic. Vases with flowers she cut and arranged were scattered among my father's works. She was exacting in her selection of blossoms and of branches to go with them. Everything was chosen according to a natural intuition that I always admired.

Resting on the mantel are two old iron sculptures of my father's. With its large tree-trunk base, *Yunque de sueños XIII* (Anvil of Dreams XIII, 1962) suggests the forests around Villa Paz. With its curves, *Modulación del espacio I* (Modulation of Space I, 1963), now part of the Tate Modern collection, always takes me back to how I felt in the presence of the woman's torso in our house from the time we were small. Though the feelings the two works arouse in me are the same, their respective visual approaches could not be more different. The plaster sculpture of the woman is pure compact volume. The iron, meanwhile, seems penetrated and lightened by the space.

Not long ago, I heard my brother Luis tell a group of visitors to Chillida Leku that my father felt he returned to the same places in his work time and again, but always from a different angle. It's as if his work advanced in a spiral, digging deeper and deeper into the same themes. "Every work of art is, in the end, a query. A finished work holds some answers, but there is still some question left in it as well," he told me in an interview. As far as I know, Chillida's fascination with space was lifelong. And the first space that sparked his imagination was the hollow that emerged between the chest and the bent right leg

in *Forma* (Form), his first sculpture. That was the starting point for an inquiry that would last the rest of his life.

### Feelings of Abandonment

Some images make sounds. The gestures in them speak. Like in this one funny photo I was so pleased to find. Eduardo is looking back at Pili and I can almost hear him say, "You didn't forget anything, did you?"

How many times was that scene repeated in airports and train stations the world over? My mother knew how important she was to Eduardo, and she was by his side on all his trips, except a couple of times where circumstances made that absolutely impossible.

The trips were rarely long, but they were frequent. An overnight train ride in a sleeping car from Hendaye if they were going to Paris; a flight from Bilbao, with or without a stopover in Madrid, if they were headed elsewhere. All the kids stayed at home, awaiting our parents' return with bated breath. The farewells were always hard for me (I would often cry by myself in the bathroom), and the returns a relief. We would all gather around their suitcases, asking what they had brought back for us. Pili knew perfectly where each one of our gifts was. She would buy our clothes and other things we needed in Paris or wherever it was they had gone, and so as kids we got to wear the latest fashions. Sometimes it was cause for scandal: we must have been the first girls in San Sebastián to wear bikinis, and Pili the first woman.

Despite the clothes and other gifts we enjoyed so much, my mother and father's absence was a weight on my spirit. Without them, our house was not the same. It can't have been easy for the help left to take care of us to deal with so many kids. When I was little more than a baby, I had a terrible experience with one of them that I would rather not recall. Though my parents fired her as soon as my siblings told them what had happened, the lovelessness that prevailed in the house without them lingered on. The housekeepers would clean the living room rugs and sofa cushions when my parents were away; we were not allowed near them. I remember the darkness of a space normally so full of life.

Eduardo and Pilar at the Madrid airport, 1958

### Sometimes Extravagant, Sometimes Frugal

Taking another look at the airport photo, I see that hanging from Eduardo's shoulder is what looks like the Polaroid camera we had. He has a portfolio of prints in one hand, and some sort of case in the other. There is no way there was any money in it—he never touched money. That, and everything else that mattered—except for art— was Pili's department. She was peculiar about money. She resented spending unnecessarily on small things. However, she was able to buy expensive things all the same. For example, jewelry to adorn herself and be fashionable at the events she attended. She loved to look pretty for Eduardo. She might well don a fancy ring or necklace while weeding the garden. Nor did she skimp on cars. Our family vehicle

could take all of us kids to the beach as well as Pili's sister Ceci and her children. We sometimes even brought the dog along. Eduardo had his own car. He liked driving—fast. In all other things, they were both quite frugal. Except for a few transatlantic trips late in their lives, they always traveled tourist class.

A funny story involving money comes to mind. My parents had driven down to the bay to go for a walk. Before they parked, they realized they didn't have enough gas to drive home. To make matters worse, my mother had forgotten her bag (probably the only time in her life she left it behind). I can just see my father standing there, anxious, as my mother went through all his pockets. She would be looking for some of the spare change she usually put there in case something happened to my dad when he was alone. Not a cent. Perfectly composed, Pili walked over to the church they attended on Sundays. I cannot imagine how ashamed my father must have felt asking for a loan from the almsman at the church door to whom they would give an offering every Sunday.

Something else that happened years before shows what Pili and Eduardo were like when it came to money. A man named Fanjúl would come by Villa Paz every week to ask for something to eat; he would not accept money. We all knew him. One day on the feast of Saint Ignacio, he brought a cake to the house for my brother Ignacio. When Fanjúl came by the following week, my father asked him to join him for a chat in his studio, which turned into a long visit. I think they met on more than that one occasion, actually, and the relationship influenced my father in certain ways—my father knew how to learn from the most unlikely people and situations. One day, my father asked Fanjúl where he slept. "Wherever I happen to be when midnight strikes," he replied.

Practical woman that she was, our mother, seeing that he was a good man, offered Fanjúl work washing the cars or helping out in the garden. Solemn, Fanjúl looked her in the eye and said, "Why do you want to change me?"

### "Children, to the playroom"

As I got older, I learned a lot about my parents through the stories they would tell about their trips abroad. These journeys were always work related, whether for a Chillida show or an international exhibition of one of his friends from the Galerie Maeght. My father was not a big talker, but when he did talk, he mostly told stories—rarely to us, but rather to his friends and other people who came by to visit him. When guests came to Villa Paz, we would hear his voice say, "Children, to the playroom." But I liked to stay behind, sinking into a sofa and silently listening in. I remember in particular the poet Celaya, who would always come by with his wife, also a poet, Amparo Gastón, known affectionately as Amparitxu. I also remember the painters Marta Cárdenas and Rafael Ruiz Balerdi, who were somewhere between my parents' generation and mine. Seeing my parents with their friends was enriching. When I believed I was old enough, I dared to break my silence, if only for a second, to make myself useful: "Can I get you something to drink?" Then, mission accomplished, I would once again tune in to what would become the stuff of my own stories. Living was—and still is—watching.

### Chillida and Cioran

Spending time with my parents and their friends would be a habit of mine until the end. I remember a few anecdotes my father told about the philosopher Emil Cioran when he and my mother were living at Intzenea, the home where they spent their final days. Dad and Cioran were working together on an artist's book. Cioran sent my father the text, and Chillida illustrated it with eight lithographs in 1982. One night, in Paris, the philosopher invited my parents over for dinner. It seems he had cooked it himself. Upon opening the door to his small apartment, he immediately said, "I don't know how good the food will be, but the wine has been waiting for you for a long time." Though my parents were not big drinkers, I imagine they relished the reserve wine he served them.

Knowing what a skeptic Cioran was about the world and practically everything in it, my father asked him one day how, with his beliefs,

he managed to write. He replied, "Sometimes when I finish scribbling out a sentence, I feel like whistling." The original title of the book they were working on was *Aveux et anathèmes* (Confessions and Anathemas). In response to the questions my father asked him and—mostly—what he found himself saying in reply, Cioran decided to change the title to *Ce maudit moi* (That Cursed Me). Chillida had him write directly on the lithographic limestone. The final page of the book reads, in Cioran's handwriting: "A Saint-Séverin, en écoutant à l'orgue une fugue de Bach . . . je me disait et redisait, voilá la refutation de tous mes anatémes."[3]

Stories like that show me how my father engaged the world not only as an artist but also as a thinker. At the risk of sounding boastful, I must say that I was so proud of him on so many occasions.

### Learning from Their Stories

My mother, unlike my father, did tell us kids the stories she brought back from their travels. My sense of the world—and of my parents—changed with her anecdotes. The two of them seemed so different in those stories from how I knew them at home. It was odd to imagine them at the house of a painter by the name of MacDonald whom they had met through Hans Spinner, a ceramicist connected to the Maeght Gallery. Since MacDonald was Scottish, my mother explained, he answered the door wearing a kilt. All the guests ended up sitting on the floor. MacDonald wasn't wearing any underwear, so they could see "his parts"—which did not seem to concern the painter in the slightest. It's much easier for me to imagine an unfazed Pili in that situation than my father—he was so reserved!

Dad would come by our bedrooms to give us a kiss before turning in himself—something my mother never did. That moment was so special for me. Half asleep, I would revel in his warmth; he would tuck the foot I had uncovered to cool down back under the sheets. Later, when my sister María and I were older, he would find us still awake, going back and forth from the bedroom to the bathroom. Because we would be near naked as we got ready for bed, my father stopped

---

3  "In Saint-Séverin, listening to a Bach fugue for organ . . . I said to myself once and then again, 'Here lies the answer to all my anathema.'"

coming by to tuck us in. I never told him how sad the end of those goodnight moments made me.

Other stories our mother brought home showed her to be an open-minded and modern woman. She was always willing to help other women without judgment. She told us, for instance, how furious the wife of a friend became when she found out her husband had a lover. Since the woman did not know how to drive, she would ask Pili to take her to the house her husband had bought "that other woman." Maybe she wanted to catch a glimpse of her, maybe to bring the situation to a head, or maybe to cast an evil eye. For me, those anecdotes were not only amusing but also enlightening. They confirmed that the things I read about in novels were true. My world grew in size and interest beyond my hometown.

Through Pili, I got some sense of what the art circles they frequented were like. When they were in Paris—and they were there often, throughout their entire lives—they would dine at La Coupole along with the other Galerie Maeght artists who were in town. During dessert, Giacometti would often come by for a cup of coffee. Like a vampire, he avoided daylight, working only at night. What worried my mother was the poor nude model whom Giacometti would have in his rundown and poorly heated studio at all hours. Pili was aware of what women went through, of their place in society, and whenever she could, she would provide a sympathetic ear, a piece of advice, or a survival strategy.

### Special Occasions

Despite their frequent absences during our childhood, Pili and Eduardo knew how to create special occasions for us, many of which were repeated every year. I remember the Bonfires of Saint John in particular. We would spend days gathering firewood from the jai alai court area. Each of us would invite friends, and they were all allowed to stay the night in camping sacks by the embers. If it was cold, we'd move onto our living room sofas. We would make plenty of sangria, leap over the fire according to tradition, and put on music. It only

happened once a year, but what an exceptional day to remember and to get to know each other better!

New Year's Eve was no less exciting. We would usually spend it with my uncle Gonzalo, my father's brother, and our cousins. We would alternate—one year at their place, the next at ours. One year when we spent the holiday at Villa Paz, we brought the record player down from my brothers' room and danced in front of the chimney to the records Pili had brought us home from their trips. That day we saw with our own eyes how well our mother danced the waltz, and that my father really was a "Doric dancer"—though he did pull off some pretty funny boxing-inspired dance moves.

### A Wider World

Looking over the history of Chillida's career, I see that in 1959 he participated in the second edition of Documenta, a contemporary art event held in Kassel. With that, he began to gain recognition in the German art world. The German art historian Carola Giedion-Welcker wrote about his work in an array of publications, and even contributed a text to one of his catalogues. My father took great interest in German culture—the nation's thought, poetry, music, and art. I remember the Romantics who were always in his library: Friedrich Hölderlin, Novalis, Rainer Maria Rilke, Johann Wolfgang von Goethe . . . I remember how at a book fair he gave me Rilke's *Letters to a Young Poet*, which I've reread several times and enjoyed so much when I was younger. I also think of Martin Heidegger, with whom my father would later collaborate and whom he, rather surprisingly, classified as a poet as well as a philosopher. I think too of Meister Eckhart, who provided the basis for much of my father's theological and religious discussion with friends, such as the criminologist and Jesuit priest Antonio Beristain, SJ or Dr. Friedhelm Mennekes, a German Jesuit specialized in art. I think of the great artists Caspar David Friedrich, Albrecht Dürer, and Matthias Grünewald, whom Chillida admired so much. Of his favorite composer, Johann Sebastian Bach, and so many others . . . My father used to say that his art spoke German, and although it clearly spoke a number of other languages from around the

world as well, he always felt that German people had found the strongest connection with it from the beginning.

Chillida's career continued to grow, and it soon reached the shores of the United States. I'd always believed—undoubtedly because my mother did—that the fact that Aimé Maeght did not speak English affected my father's career on the other side of the Atlantic. Aimé did not feel comfortable in the United States, nor was he particularly well received by collectors there, with whom he could not converse. Nonetheless, when rearranging the books in my parents' house one day, I came upon the 1966 edition of *Who's Who in America*. The entry on Chillida mentions the numerous prizes he was awarded and the many exhibitions of his work held in the United States throughout the 1960s. Of the shows, one I would have particularly liked to see was *Three Spaniards: Picasso, Miró, Chillida* at the Museum of Fine Arts, Houston in 1961. Chillida would continue to show work in the United States in the 1970s, even as he was making his entry into England, Switzerland, Sweden, Japan, and other places with major exhibitions. Because he did not make multiples, the number of pieces available for exhibition was limited, no matter how hard he worked in the studio. European collectors and museums were eager to get their hands on everything Chillida made. A further disadvantage my father faced in terms of sales in the United States was that his works were incredibly heavy and hard to ship.

### Black and White: Graphic Work

When anyone pictures Chillida's art, what invariably materializes is an iron sculpture or a black-and-white graphic work—at least that's the first thing that comes to my mind. His first etching, *Glissement des límites I* (Slip of Limits I, 1959), looks like a *Hierros de temblor* (Trembling Iron) rendered on paper. He produced it in 1959, and from then on he made graphic work in parallel with his sculptures. Who could have imagined back then that, many years later, his son Ignacio would replace Robert Dutrou, the printmaker for the Galerie Maeght, with whom my father had worked for so many years?

Chillida and his son Ignacio working on a print at the Hatz studio, San Sebastián, 1992

*Glissement des límites I* (Slip of Limits I, 1959)

The rich relationship between my father and Ignacio was not only familial but also, starting in 1977, professional. Ignacio briefly studied biology, but soon dropped out. In addition to skillful hands and a keen sensibility, he had acquired technical artistic expertise in Madrid, Barcelona, and Paris. Our father would convey to him the precise shade of black he wanted for each print, and together they would figure out how to make it. They would also collaborate on the quality of lines and the thickness of ink splotches. My brother told me that for his prints of hands, for instance, Chillida wanted very thin lines, and achieving that was no mean feat. My father would draw them on the plate, but they could easily turn out thicker than desired when the acid did its etching or, for that matter, during any other phase of the printing process. And if that happened, the work had to be discarded. When it came to printmaking, my father's trust in Ignacio was absolute. If he could not finish up a print before a trip, for instance, he would call on my brother. The strength of the bond between them comes through in Ignacio's testimony:

> When I was young, I never thought we would work together—but I was wrong. We worked together on a daily basis. No matter how demanding a project was, he would make it easy.
> "Iñaki, how's the print coming along?" "Something doesn't look right, *Aita*." "If that's how it looks to you, get rid of it."
> The trust between us was vast.

Like Chillida's various sculpture series where one name is shared among many, several of the etchings, drypoints, lithographs, and block prints made over the course of his lifetime are "similar yet different." After all, they pursue a singular idea. All of them are compiled in the four thick volumes of the catalogue raisonné of Chillida's graphic work published from 1999 to 2005, thanks to the efforts of Aimé Maeght, Martin and Dorothea van der Koelen, my brother Ignacio, and a few others.

# Face to Face with Matter

Covering the stretch between the distant past and the near future. Resolving, veiling and unveiling, opening and closing. I feel the need to reach other shores.

The philosopher Víctor Gómez Pin held that Chillida was a *technites* of our times, that is, someone who joined art and artisanry. He writes:

> Delving into the exploration of a material with painstaking respect for its inner structure, density, resistance ... always heeding the range of its possible forms. On the basis of his observation of matter and his commitment to the essence of each material, he arrived at extraordinary conclusions about the bond between matter and space, conclusions that made him a sort of intuitive master of non-Euclidean geometry.

Chance episodes of the senses were how Chillida came to many of the materials he worked with. Something he had seen or heard would lead him to work with a particular substance. That was how the "conversation" between them—my father and the material, or *matter*, as Chillida liked to call it—would begin. He was interested in what he did not yet know, and wanted to know, about each material in relation both to himself as sculptor and to space. Through that approach, he honed perception—a cornerstone, in his view, of art itself.

### Wood: *Abesti gogorra*

Regarding his encounter with wood, my parents were driving around one day in the early 1960s when my dad saw an enormous tree lying horizontal in an open field. He was drawn to it. They stopped to get a better look, and my mother figured out how to take it back home. My father often told the story of how that abandoned trunk turned into

an *Abesti gogorra* (Rough Chant)—with an olfactory component. When he left his studio in the evening, my father would gather his things and turn off the lights. One morning when he walked into the studio, he had a strange sensation he could not pinpoint. Little things seemed to have been moved around. A few days went by before a nauseating stench revealed the mystery: a lone bird that, it seems, had not been able to find its way out lay dead in the heart of the work. Perhaps that work was the *Abesti gogorra* Chillida dedicated to his friend, the writer and psychiatrist Luis Martín-Santos, at the time of his death. Or perhaps it was one of the four or five other works in wood he made at that time and then quickly sold. Some details matter and others do not.

One thing that is for sure is that I lived with some of those wood pieces as a child. I was too young to remember now, as an adult, how they looked around the house, but what I do remember clearly is the impact of seeing one of those works during my first visit to the Museo de Arte Abstracto Español in Cuenca. The sculpture was standing in the lobby, welcoming people. I was overtaken by the feeling that my father, in the flesh, was greeting me with his characteristic warmth—a warmth he had conveyed to the material. I later had the opportunity to see other wood pieces in retrospectives (collectors would loan them on a temporary basis) at, among other places, the Palacio de Cristal in Madrid in 1980.

I found a photograph taken when Chillida was making one of those wood sculptures. My father appears cornered, trapped against the wall—and that was just how I knew he felt at the time. The work was enormous; it took up much of the studio, and he had trouble getting around to join the parts. He must have talked about that with the photographer—which was either Sidney or Abraham (a.k.a. Budd) Waintrob (it's not always clear which one was behind the camera, as the signature is always Budd Studio). They knew how to make the most of that moment, of what my father was experiencing with the work.

That bent leg up against the wall, that foot lifted off the floor, is what strikes me most in the image. It almost looks as if part of his leg is missing. His seriousness seems genuine, and appropriate to the

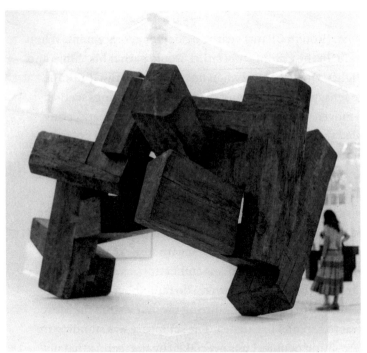

*Abesti gogorra I* (Rough Chant I, 1961), Palacio de Cristal, Madrid, 1980

Chillida in his studio standing behind an in-progress
wood sculpture, 1960s

moment the photo was taken. The year 1963 was a rough one for Chillida. He was embroiled in a crisis involving a sport that was not football—but I will get to that shortly.

### Chillida and Braque: *"Lequel des deux est le vôtre?"*

There is an official photo —which has been published many times— that documents an important event in Chillida's life: his exchange of works with Georges Braque. The French artist saw my father's 1961 solo show at the Galerie Maeght, and he wanted to buy *Yunque de sueños II* (Anvil of Dreams II, 1958), an iron work on a wooden base. Perhaps the work reminded Braque of the birds he himself had painted. Aimé Maeght called my father to tell him about Braque's interest, and my father refused to sell it to him. He said that gifting the work to Braque would be an honor, a cause for joy. My father was thirty-seven at the time. He then went to Paris, and Aimé told him that Braque expected him at his studio at six. He went, and the painter himself opened the door. All of his paintings were leaning against the wall except for two small ones, which were on plain view. "*Lequel des deux est le vôtre?*" (Which of those two is yours?), he asked. My father understood perfectly. "*Celui de droite*" (The one on the right), he replied. The dedication had already been made out: "*Á Eduardo Chillida avec mon amitié*" (To Eduardo Chillida, in friendship).

What I did not know until today is that a few more snapshots, apart from the official one, had been taken that same day. To either side of Georges Braque are Louis Clayeux, the Galerie Maeght's artistic director, and my father, both sitting comfortably on the floor. All three seem very engaged in their conversation. We cannot tell which sculpture has Braque riveted, but he is clearly engrossed. It's quite likely that it was *Yunque de sueños II*.

Though we don't get to see her, I know my mother was around that day—she always was. Maybe, knowing that her presence was not essential just then, she set out to take care of an errand in Paris, buying something for us kids—I'll never know for sure, but that's what I imagine. I was only three years old at the time.

Chillida and Georges Braque with *Yunque de sueños II* (Anvil of Dreams II, 1958), the sculpture that the painter received in exchange for one of his works, Galerie Maeght, Paris, 1961

Chillida, Braque, and Louis Clayeux conversing, Galerie Maeght, Paris, 1961

## Alabaster: Chillida and Greece

That exchange of works with none other than Braque might well have made my father feel that he had come into his own as an artist. But, by his own account, that did not happen until a few years later, when he realized he could now look at the ancient Greek art he loved so much without getting swept away by its influence. From the beginning, his attraction to Greek art had been overpowering. For that reason, he was careful to avoid the galleries displaying it when he visited museums, keeping well out of earshot of that tempting Greek siren song.

Chillida had reasoned himself away from the white light of ancient Greece. He considered himself the child of the black light of his land, the place from which his works in iron, steel, and wood came. And then one day in 1963, by sheer chance, he found himself face to face with a recently discovered hand from the Winged Victory of Samothrace. The palm, found nearly a century after the rest of the ancient statue, was installed in a privileged place in the Musée du Louvre. He stood by it for a long time and, while looking at it, felt the spell lift. He understood that he now had a world of his own. He could now dare to enjoy everything that appealed him, with no risk of getting confused or straying from his path. That was, for him, very important.

My parents then took a long trip to Greece with Louis Clayeux and the poet Jacques Dupin and his wife. The purpose was to confirm my father's intuition. They had a great time, and a few years later—in 1965—Chillida made his alabaster sculptures in homage to white light. The first one, *Homenaje a Kandinsky* (Homage to Kandinsky, 1965), is a sort of temple made from a single block of alabaster pierced by three columns that point upward. That work, currently at Chillida Leku, is sheer architecture rendered in a material that catches the light on its edges. Also in alabaster, a material I happen to love, are bas-reliefs like *Elogio de la luz I* (In Praise of Light I, 1965), *Elogio de la arquitectura I* (In Praise of Architecture, 1968), *Homenaje a Goethe* (Homage to Goethe, 1975), and *Homenaje a la mar I* (Homage to the Sea I). My father would often tell us that Goethe, at the moment of his death, had said: "Light, more light."

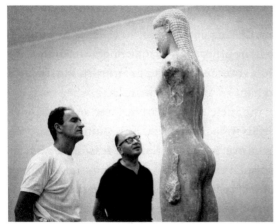

Chillida and Louis Clayeux in Delphi, Greece, 1963

Chillida with *Homenaje a Goethe IV*
(Homage to Goethe IV, 1978)

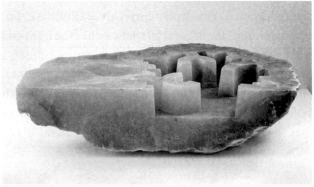

*Homenaje a la mar I* (Homage to the Sea I, 1979)

One particular photograph of the many I found of that trip to Greece stayed with me, and I kept it as a memento of my mother. Pili appears alone in front of a stone arch. I can feel that she was sad—not radiant, as I am used to seeing her in other photographs. Looking at it carefully, I realized that she was pregnant at the time. Her hand rests on her growing stomach. Perhaps she is thinking of us, alone at home. Perhaps she is thinking of what she will do to make sure she never gets pregnant again.

Pilar, pregnant with her eighth child, Mycenae, Greece, 1963

## The Night Art Captivated Me

After he started working in alabaster, my father gave up printmaking—
that is, the darkness of ink—for a few years. Before that, he had made
etchings to illustrate André Frenaud's book of poems *Le chemin des
devins* (The Way of the Soothsayers). Curiously enough, it was that book
that cut through the darkness that had surrounded my relationship
with art since I started college. I had been angry at art for a number of
reasons that would be hard to explain. I didn't even want to hear the
word "artist." The whole topic was taboo for me, until one day . . .

"Eyes to look, eyes to laugh, eyes to cry—might they also be used to
see?" I had not yet heard those words of my father's in 1982, but what
I experienced that year made me understand them. I was twenty-four,
about to start out on my own. But that night, after a party, I went to my
parents' new house (I would live there for only a few months). I walked
in and saw the bookcase full of volumes; I soaked in the peace the place
emitted . . . and I felt inside that the time had come to give art a chance.
I invented on the spot what still seems like the perfect ritual for that
place, and I performed it according to intuition. I chose where to sit,
turned on a light, and decided to select one of the art books on the
shelves. The one thing I knew for sure was that the book would not be
about Chillida. The strange calm I felt was intensified by the night and
the silence of the house.

After browsing for a while, I selected a title that caught my
attention: *Le chemin des devins*, which I thought meant "The Way of
the Divine." I sat down with that large white book in my hands and
slowly perused the first pages, taking in the texture of the paper and
all the details of that collector's edition. Suddenly I was taken aback
when I found myself before an original print of my father's—a gor-
geous etching. There was no turning back. I have no idea how long I
spent looking at those black lines on white ground. I know it was a
long time. Each line, each tremor conveyed by their author's hand,
stirred me in a way I had never experienced before. Knowing that the
author, my father, was fast asleep just a few steps away only intensified
the experience; the expression of his struggles and doubts on the page

made me feel something akin to shame. As if I were looking at him naked.

It was not until years later—and in a completely different context—that I realized how important that experience had been for me. In a cognitive development class at Columbia University, my fellow students and I were asked to recount a watershed experience, something that marked a "before and after" in our lives. And that night in my parents' house immediately came to mind.

The words of the great Spanish poet Saint John of the Cross seem appropriate here: "On a dark night, Kindled in love with yearnings— oh, happy chance!—I went forth without being observed, My house being now at rest."[4] That going "forth without being observed" and "kindled in love with yearnings" was, in my case, an intentional and intimate act of reconciliation with art. For it to happen, I had to be ready to lower my defenses and open myself up to a new experience— something that only I could make myself do.

That was when I understood that looking in order to see is an act of will—indeed, that is one of the bases of my work educating viewers. I want to convey the idea that perception is everything, and that art cannot give you anything if you do not give something to it—your confidence, your time, your attention. Chillida said as much: "We see clearly with the eye full of what we're looking at." No less important, in my view, is understanding that what art has to offer is individual, intimate, and difficult to express in words. Though it makes you grow inside.

### Another Winning Team

I am startled by the full February moon looking down at me on one of my sleepless nights. Alone in the distant sky, the moon casts a light to read by. Down below, blackness and me. The yellow-white moonlight pierces branches and speaks to me. That vivid moment lives on—a cherished memory. Light and darkness on things, on memories. I will shed light on what's hidden: the role women have played in the success of men.

---

4  Opening lines of Saint John of the Cross's poem "Stanzas of the Soul," here in the translation of E. Allison Peers.

Guiguite Maeght, as my parents called her (née Marguerite Laurence Devaye), was crucial to Aimé Maeght's start as a gallerist. His relationship with the painter Pierre Bonnard began thanks to her. She was, according to my mother, a very sensitive, noble, and generous woman. Bonnard and Guiguite went to the same dentist—or rather I believe it was a dentist, but it doesn't really matter. The painter was often out of sorts when he arrived at the office. He and Guiguite started talking, and she found out how cold his studio was—apparently, his toes would freeze—hence his mood. One time when she went to the dentist—if it was the dentist—Guiguite took Bonnard some slippers she had knitted herself. He was touched. She also told him things about her life, for instance, that her husband was a lithographer who owned a press. Bonnard came up with the idea of giving Guiguite one of his works to exhibit in the front window of Aimé's press in Cannes. The three of them soon became friends. And, later, the Maeghts opened their gallery.

In 1947, the Maeghts organized an exhibition of all the Surrealists active at the time—artists, poets, and aesthetes. It was very controversial and gave the Maeghts visibility around the world. At that point, Bonnard entrusted all of his work to the gallery. Braque shortly did the same, and others followed suit. Little by little, the most acclaimed artists of the twentieth century joined the gallery, and the Maeghts went to great lengths to see to their needs. That was how the Galerie Maeght became one of the most important galleries in Europe.

Guiguite and Aimé could not have been more different. Aimé, according to my mother, was an innate fabulist. She often heard him tell entirely different versions of his life story, just because it amused him to do so. But what did either of their pasts matter when their present was so splendid and their future so promising?

### The Fondation Marguerite et Aimé Maeght, Saint-Paul-de-Vence
In 1964, the Fondation Marguerite et Aimé Maeght opened in Saint-Paul-de-Vence. The private institution was envisioned as a museum, a center for creative work, and a gathering place for the gallery's "family

of artists" and others. The modern building, designed by Catalan architect Josep Lluís Sert, whom the Maeghts had met through Miró, was a venue for exhibitions. The grounds also included sculpture gardens, featuring works donated by their artists; studios for producing sculpture, printmaking, and ceramics; a house for the artists-in-residence; and a larger house for the foundation's creators, Aimé and Marguerite Maeght, and their family.

That place on the French Riviera would prove important to my parents and their relationship. They would spend the month of August in the large house with Miró and the Maeghts. Though my father was working, for my mother those summers were the closest thing to a vacation she ever knew. Just imagine: a summer among friends with no family responsibilities. The hosts would organize large parties. The guest lists included not only artists but also musicians, writers, thinkers, and other cultural figures. I believe it was there that my parents met the composer Edgard Varèse, the architect Frank Lloyd Wright, and the photographer Henri Cartier-Bresson, to name a few.

Unfortunately, that was before my time. My older siblings, who did accompany my parents on some of those visits, were too little to understand where they were. They just played on the grounds with the other children. What we did enjoy for years were the wonderful Christmas gifts Guiguite would send us. Each of us kids would have a turn as the recipient of her tokens of affection. The second time my turn came around, I asked for a cassette player. That JVC was my faithful companion during my adolescence and into my twenties. I don't think I ever conveyed to Guiguite how much it meant to me.

Those Christmas gifts came with a holiday card made by one of the gallery's artists. They were works of art in their own right—my parents would often frame them.

When I checked the day of the foundation's opening, I saw it was July 28, 1964—my parents' fourteenth wedding anniversary. André Malraux, France's minister of culture at the time, gave a speech; Yves Montand and Ella Fitzgerald sang.

A photo taken that day shows the directors of the Galerie Maeght along with some of the artists and their wives. My father is standing between Pilar Juncosa (Miró's wife) and Louis Clayeux, the artistic director of the Galerie Maeght from 1948 to 1965, who is resting a hand on my father's shoulder. Clayeux resigned after the Fondation Maeght was founded, because he thought it should have been established in a less remote location. He was replaced by the poet and writer Jacques Dupin, who stands on the extreme left in the photo, next to Aimé Maeght (in the white outfit), and by Daniel Lelong, who is sitting next to Palazuelo, also on the left in the photo. In the shadows next to Aimé is Giacometti, and on the other side of the column stands Marguerite Maeght. My mother is at my father's feet, with Miró on her left. It is charming, I think, that the "family photo" included three Giacometti sculptures—and it is also appropriate, considering that the foundation is a living exhibition of twentieth-century art. My father's *Iru harri* (Three Stones, 1968) is on display there.

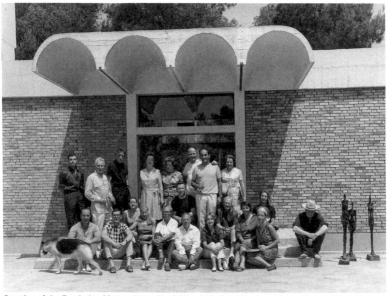

Opening of the Fondation Marguerite et Aimé Maeght in Saint-Paul-de-Vence, France, 1964

## Pili: A Woman among Men

While writing this book, I have had a chance to discuss some of its contents with friends. Every single one of them has been most interested in the figure of my mother. Seeing photos of her as a young woman, my friends doubted she would have gone unnoticed by the men she came into contact with. In one of these, Pili, looking serious, is flanked by two companions who both stare intently at her. I once heard her say how much she liked pleasing whomever it was she was talking to. If she was with a horse breeder, say, she would ask about the taming process and the horse's mane, the gestation period . . . anything that would give the other person a chance to talk about their passion. She must have been good at that.

At other tables, people seem to be conversing and enjoying themselves. The dinner was undoubtedly followed by music. But—unless things were very different by the time I came along—before the stroke of midnight, like in Cinderella, Eduardo would come by to collect Pili. She would leave her potential admirers and dance partners behind, and my parents would head home. My father did not like staying out late or messing around with things as important and serious as their love.

Chillida undoubtedly could have had other women to love and other bodies to inspire him. And there may have been many other people willing to take on all the tasks necessary to free him up to pursue his talent. But all those roles were played by Pili. Some say Chillida is who he is today because he had Pili behind him. But that takes things too far, I think. Every time I hear someone say that, something stirs inside. What if my mother, powerful and adaptable as she was, had been with another sculptor. That would not, of course, have guaranteed that that sculptor's work would have reached the heights that Chillida's did, or that he would have produced art as groundbreaking as my father's. Of course not. My parents were just a good team who devoted their life to art.

No one but Chillida can take credit for who he is—and that includes credit for the decision to take Pilar Belzunce as his wife,

Pilar, in white at the table in the foreground, during a dinner at the Fondation Maeght, 1964

to love and protect and honor her. It's hard to imagine a man more serene and faithful than my father. At my mother's funeral, the gallerist Elvira González said that she had never seen a woman as sure of her man's love as my mother. She told us how women were drawn to our dad. She mentioned, in particular, the singer and actress Juliette Gréco, who had trouble believing that a man as remarkable as Chillida paid her no mind simply because he was married. And it's true—my mother was as self-assured as she was discreet. At social gatherings, exhibitions, cocktail parties, and so forth, she would move among the people, smiling and talking to everyone. And then she would find a place to sit, often off to one side, because she didn't like standing still at all.

My father's love and attraction for her lasted a lifetime. Even in their final years, I remember my dad looking at her and saying, "I really don't know how I can love you so much." And I think she could have said the same. My father was as inept at doing mundane tasks as he was extraordinary at making art. He could be frustrating. "Pili,

where's my pipe?" "Come on, Pili . . . we'll be late!" No matter where they were, if he saw her slouching, he would tap her tailbone and say, "Pili, lower back!" She would straighten right up to please him.

### Granite: Alone in the United States

My mother's life was rife with challenges and feats, both mundane and extraordinary. None of them fazed her. I said that only on a handful of occasions did she fail to accompany our father to his openings—only if dramatic circumstances intervened—and that is true. I will recount one of those highly unusual situations now. My mother was always fast on her feet. She knew how to come out of the shadows when necessary.

How strange it was for me to find a picture of my mother, alone, in the middle of a work process that normally belonged to my father! The sculpture they are unloading is made of granite: *Abesti gogorra V* (Rough Chant V, 1966). This is a very important work for me because of all the stories surrounding it. This work was to be Chillida's first large-scale public monument. It was installed on the grounds of the Museum of Fine Arts, Houston in 1966, on the occasion of my father's first retrospective in the United States. That show, which would later travel to museums in Utica in New York and St. Louis in Missouri, featured fifty sculptures and thirty-one drawings and collages.

I would often see my mother, smiling in an elegant outfit—a Balenciaga dress, perhaps —at major events. On the occasion that this other photograph documents, Chillida was not the one being applauded; he was not the one saying a few words at the microphone. It was her, Pilar Belzunce. Our father was either about to undergo or had recently undergone surgery. I'm not sure whether the operation was on his kidney, stomach, or back—that information was kept from us kids at the time. And when I finally learned of that trip my mother took to the United States on her own, there were things that interested me much more than my father's afflictions.

As an emissary, Pili had a triple function: receive the parts of the granite sculpture that had been shipped from Spain; oversee the

Pilar posing in front of parts of the work *Abesti gogorra V* (Rough Chant V, 1966), which was to be installed in Houston, Texas, 1966

Pilar at the opening of the Chillida retrospective at the Museum of Fine Arts, Houston, Texas, 1966

work's assemblage and installation; and preside over the opening
at the museum. The assemblage and installation processes brought
countless problems that Pili recounted in a long letter to Eduardo. The
foreman of the quarry where my father had made the piece traveled
with her. Pili thought he was a sexist brute. She had to put up with him,
and the shame he exposed her to on more than one occasion, all alone.
The letter is not only full of complaints; it also expresses my mother's
sorrow. Apparently, when they were assembling the monumental
granite work, my mother and the quarry worker had a difference of
opinion. My father—undoubtedly via telephone—sided with him
rather than her, without taking the time to ask for much information.
Alone in Texas, my mother, who had taken on so much, was annoyed.
How was Pili able to forgive Eduardo?

I later learned that in 1966, the Beatles, who were in nearby
Arkansas at that same time, were also going through hard times.
When I saw a documentary about those artists who revolutionized
not only music but also the attitudes of youth around the world, I was
struck by their proximity to my mom during those days in 1966. In an
unfortunate statement to the press, John Lennon said the Beatles
were more popular than Jesus. Apparently, that irked some Puritans.
They were so offended, it seems, that they banned the sale of Beatles'
albums; they even set up fourteen locations in Arkansas where people
could bring their copies of Beatles' records for public burning. When
I learned of the coincidence between those events and the installation
of my father's first monumental work in the United States, I felt that
its meaning exceeded his career. It was part of History, with a capital
*H*. And I understood more clearly than ever how important the arts
are to opening minds.

A photo shows James Johnson Sweeney, the director of the
Museum of Fine Arts, Houston at the time, in front of the installed
sculpture (previously Sweeney had been a curator at the Museum of
Modern Art and the Guggenheim Museum in New York, where
Chillida also exhibited). He was one of Chillida's champions in the
United States, as well as the author of a number of worthy texts on his

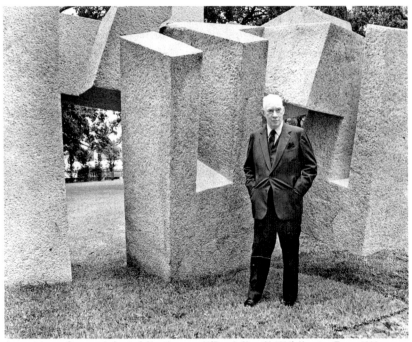

James Johnson Sweeney in front of *Abesti gogorra V* (Rough Chant V, 1966), Houston, Texas, 1966

A group of students at the Chillida retrospective at the Museum of Fine Arts, Houston, Texas, 1966

production. A few years ago, watching *Boyhood*, a movie filmed in real time by director Richard Linklater, I was amused by a scene where Ethan Hawke's character is playing hide-and-seek with his two children in Chillida's enormous sculptural forms. That was the first time I saw that sculpture being inhabited and enjoyed. I was delighted to see how Chillida's art continues to interest people.

That same year, 1966, Chillida was awarded the Wilhelm Lehmbruck Prize in Duisburg, Germany. Not long after, the first book of his aphorisms was published.

### Aphorisms

Chillida has been called a "heterodox geometer"—there is not a single right angle in his work. Though that is a fundamental characteristic of his art, it often goes undetected. "The right angle is narrow-minded: it only dialogues with other right angles," he would often say. "What is worthy lies near the right angle, not in it." His geometric intuition was informed by the Greek gnomon, which refers to the angle between a human figure and their shadow. That angle was assigned the value of ninety degrees in an act of simplification: in reality, how vertical a living person is varies with movement and time. To reflect that, Chillida's "right angles" range from eighty-seven to ninety-three degrees.

Let's take a moment and look at some of the pithy remarks that convey my father's philosophical thinking.

"Two in the bush are worth more than a bird in the hand." I soon came to understand this aphorism, which I initially saw as simply a humorous reversal of a common saying, meant a lot to my father. He did not like to play it safe. I think of the success he had in Paris with his first casts before he got married. He had a bird in his hand from which he could have made a lot of profit, but he felt that to do so would be to repeat himself. That's why he despaired for a year, looking for something else—for the two in the bush. That's why he took a risk, and already by 1951 created that novel work in iron that opened up new horizons yet to be explored.

"We ask questions when we don't know. If we already know the answer, it isn't an honest question." My father's thinking about space was particularly rich and included concepts from science, art, and even the spiritual world. The below are just some of his thoughts about space:

> "Isn't geometry only coherent when the point has no dimension? For everything to work out, the point must have no dimension but still occupy a place. Can you occupy a place without having dimension?"
>
> "Isn't it the non-dimension of the present that makes life possible, just as the non-dimension of the point makes geometry possible?"
>
> "The limit is the true protagonist of space, just as the present, another limit, is the true protagonist of time."
>
> "Are there any limits to the spirit?"
>
> "From space, with its brother time, under the persistent pull of gravity, feeling matter as a slower space, I ask myself, with wonder, what I do not know."

The art historian Kosme de Barañano contends that Chillida's way of understanding sculpture, with space as the primary quality, soon spread around the world. "He was among the first to realize that the landscape and the space around the pieces is key. In the end, even his drawings are always a play on the boundaries between what you have built and what is already there." In Chillida's words: "I knew that reason had limitations, and therefore there were spaces that reason couldn't reach. These spaces are accessible only to perception, intuition and faith, that beautiful and inexplicable madness."

And, finally, one of my father's sayings that I myself most identify with: "I have a lot of information about the work I live in, but I allow nothing to strip me of my freedom, of the action of the present." The work "I live in"! I know exactly what he is saying: I have spent years "living" in this book. The azaleas that my brothers-in-law gave me two springs ago are back in bloom.

**Martin Heidegger and Chillida, 1969**

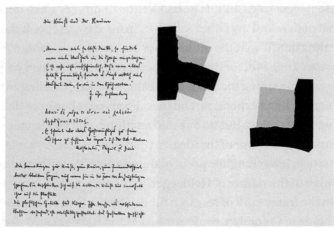

**First two pages of the Chillida-illustrated artist's edition of Martin Heidegger's**
*Die Kunst und der Raum* **(Art and Space), published by Erker Verlag, 1969**

## Art and Space: Heidegger and Chillida

In 1969, Chillida produced seven lithocollages for an artist's edition of Martin Heidegger's *Die Kunst und der Raum* (Art and Space), published by Erker Verlag in St. Gallen, Switzerland. It took Heidegger quite some time to find a sculptor, someone with an intuitive understanding of space, to work with on the project. He chose my father after long conversations. My father had the philosopher write on the lithographic stone he used for the prints.

On more than one occasion I heard my father recount an anecdote from his time working with Heidegger and the book's editor, Franz Larese:

> At a certain point, I asked Heidegger point-blank, in front of everyone working on the book, what size paper he had used to write his opus [*Being and Time*]. A bit taken aback, he looked at me. "No one has ever asked me that before." I told him it was a logical question coming from me. I am a sculptor; space informs everything I do.

Heidegger told Chillida he had written it on very small quarto-format paper. And my father said that, in his view, the book should have the same format the philosopher had intuitively chosen for *Being and Time* and, for that matter, everything else he had written since he was a young man. For the editor, who was planning to make the biggest, most expensive, and most impressive book possible, this was a fatal blow. But no one said anything, and Heidegger was resoundingly in favor of the idea. "At play was Heidegger's relationship with space. It was tangible proof of the relationship with space of a thinker of the stature of Heidegger."

In the framework of research funded by the Universidad de Antioquía in Colombia, professor Ana María Rabe showed that the relationship between Chillida and Heidegger went beyond a project where one man illustrated the other's text. Her pioneering research demonstrated Chillida's considerable impact on Heidegger's thinking

Chillida before the opening of one of his solo exhibitions at the Galerie Maeght, Paris, 1964

about the relationship between art and space and the notions of emptiness and place. In 2015, the philosopher's grandchildren, Arnulf Heidegger, who administers his grandfather's estate, and his sister, Almuth, helped Rabe transcribe some of Heidegger's handwritten notes on Chillida (she had come across them in an archive in Germany).

Published in the journal *Pensamiento* in 2017, Rabe's research results aroused a great deal of interest among Hispanic scholars of Heidegger. And I know she has still unpublished material on their relationship, which she discovered after her book came out.

### The Risky Act of Exhibition

Looking at a photograph of Chillida's opening at Galerie Maeght in 1964. I see double meanings everywhere. The pane of glass my father is standing behind provides one image and blocks another. We see Paris with its black slate rooftops on its impressive buildings, a few old cars, and the intersection of two streets, one of them Rue de Téhéran, where the entrance to the Galerie Maeght was. My father is standing inside the gallery.

It must be the five vertical lines of the doors that irk me. Behind them, my father's combination of self-assurance and vulnerability is palpable. His apparent calm does not fool me for one second. He is standing in the gallery with works that he will soon show the world. It won't be long before viewers and critics arrive. And they will judge those works—and him. Because what Chillida is exhibiting[5] in there—in that interior hidden by the reflection of the street—is more than the works he has made. Much more. He is exhibiting his person, in all its intimacy. He is hemmed in like the bear in a cage that they will come to see—at least that is the sense I get from the photo.

The act of exhibition brings risks, and the more you exhibit, the more you risk. Courage was, for my father, directly tied to fear. "To be courageous is to confront danger despite fear, not to not see the danger; to not see the danger is to be foolish or reckless," he would say. How many times did Chillida exhibit his work? How many times did he take that risk before I reached the age of ten?

Those were my first impressions. But there is something else. I asked who had taken the photo, and nobody knew. I looked harder, and I think I see my mother reflected in the window. She was never far from him—sometimes behind him, but also in front of him; protecting him, and also understanding him. Filling him with confidence and courage. Her two legs are firmly planted on the sidewalk. My parents know that they are looking at one another, and at the heart of that shared glance is the workings of their winning team.

Chillida had Pili at his side. She was the safety net under the trapeze artist. She was there to cheer him on and catch him if he fell. She never impinged on the flight of the lone bird that was Eduardo. My mother respected him. She was his confidant and grounding, the one who saw him through sleepless nights.

"Pili, are you awake?" "I am now."

And Eduardo would then unload the ideas that came to him at that moment when dreaming was giving way to wakefulness and dark turning to light.

---

5  TN: The Spanish verb *exponer* can be translated as "to exhibit," as in artwork, or "to expose," as in danger.

### Follow Those High-Flying Birds

Follow the high-flying birds—that is the only option. Could you break your neck somewhere along the way? Could you lose your head over the course of this great adventure? Of course. But one writes, makes sculpture, or paints dangerously. Aim high—that is all that matters in art. Otherwise, you just stay within the world of more-or-less-worthy professionals, some of whom will make it into the history of literature and art. There are plenty of painters, but how many names are worth remembering? How many important figures are there in a century?

The poet José Ángel Valente asks these questions in a conversation with filmmaker Gonzalo Suárez that I shot for my second film. I wanted them to talk about what different art forms have in common—and I learned a lot from their discussion. I learned about "entering the realm of the inexplicable," about "the gift of lightness," about "being open to the new," about "the lone bird," and much more. In 2023, La Fábrica agreed to publish the conversation in full in a book titled *El gato y el pájaro: José Ángel Valente y Gonzalo Suárez con Eduardo*

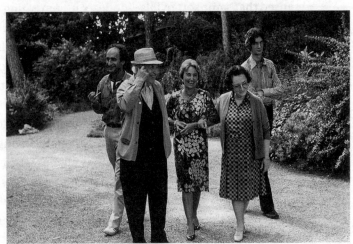

Chillida, Marc Chagall, Pilar, Marguerite Maeght, and her nephew, 1976

*Chillida de fondo* (The Cat and the Bird: José Ángel Valente and Gonzalo Suárez with Eduardo Chillida in the Background). It's a very personal book and, I hope, an important resource for scholars and lovers of art and culture.

If as a young woman I was dubious of art, it was because not all artists commit to their flight. Many—too many—fly in the tailwind of the "high-flying birds." They do not delve deep enough inside themselves to forge their own strong wings and take flight.

Another photo in my mother's personal archive shows my parents with Marc Chagall, Marguerite Maeght, and her nephew walking through the grounds of the Fondation Maeght. It seems that one day the two artists were sitting on a bench when a man came over and began showering Chagall with praise. Chagall was thrilled. At a certain point, the man called the painter *maitre*—the French word for "maestro," as in "great artist." The pronunciation of *maitre* is the same as the pronunciation of *métre*, which means "meter," as in the measurement. My father would often recall how, with head hanging down in what seemed like a well-rehearsed gesture of humility, Chagall answered, "*Pas métre . . . centimétre*" (Not a meter, just a centimeter). According to my father, Chagall in fact seemed to be thinking, "*Pas métre . . . kilométre*" (Not a meter, a kilometer).

I sensed that same sort of false modesty in something my father, at this point an old man, would say: "Chillida is no longer Chillida; Chillida is just your average Joe." He was well aware of all he had accomplished. What he really meant was that he was no longer the young sculptor with the *potential* to become great, but rather already one of the greats. Nonetheless, he was truly a simple man without an iota of snobbery or elitism. Although he undoubtedly enjoyed the recognition, he was also a bit embarrassed about receiving so many prizes and so much praise. Our culture may encourage vanity, competitiveness, and an inflated ego on the part of artists, but artists also need all those things to advance in their work. Accepting a prize but not attending the ceremony did not, to my father, seem ethical, but nor did refusing an award seem right to him.

Gonzalo Suárez would say, "Painting can, potentially, bring art to a picture, but not every painting is art—and that holds true for an abstract painting as well." Thinking now of the number of cities around the world where solo exhibitions of Chillida's work have been held, the texts that major twentieth-century art critics and thinkers wrote about his art, and the number of international awards he received, it seems crystal clear that no one makes it into the annals of history without hard work and sacrifice. My father's life was anything but carefree. He had to give up a lot, travel constantly, and face greater and greater challenges. The commitment his artwork required, the demands it made on him, is comparable in some senses to what we expect of professional athletes. For my father, his vocation was like a priest's.

Along these lines, Pili explained in my documentary *Chillida: el arte y los sueños* (Chillida: Art and Dreams) that, in her view, all artists are a bit naive. "Just think of someone willing to give their life, to give everything they've got, to do without everything and anything, for the sake of a color or an idea, to be able to render a line or shape. And you can't even be sure if, after all that, people will appreciate it or not ...!"

### Chillida and Sports

I have never, until now, stopped to think about how traumatic it must have been for my father to have to give up the life he had initially chosen for himself, that is, his career as a football player. My children, who are huge Real Sociedad fans, showed me an interview where he spoke of that. Pili, who was by his side in everything, would not have been able to support his career in sports. She never once went to see him play a game. They called him "the cat," because he seemed able to change direction in midair. For my mom, it was a big waste of time; she was actually glad when his injury put an end to his football career.

The posters my father was commissioned to make for the 1972 Olympic Games in Munich and the 1982 FIFA World Cup in Spain were prominently displayed in the house my husband and I lived in in San Sebastián. Though Chillida dedicated his life to art and thought, sports were a pillar of his existence. He was not one to stay out late with his pals

Eduardo giving up golf for good, 1964

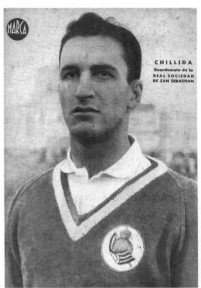

Cover of the sports magazine *Marca*, showing
Eduardo Chillida, goalkeeper of the Real Sociedad
de San Sebastián football club, 1943

in bars. He was at home with Pili and us kids, often watching major sporting events on television. We would watch not only the Olympics and football, but also tennis, boxing, cycling, motorcycle racing, Formula 1 . . . you name it! The spark of sports and competition caught on in all of us—although less in me than in my siblings—from a young age. In fact, sports were central to the lives of two of my siblings.

My sister, Carmen, was the fifth-ranked woman tennis player in Spain at a certain point. She recalls:

Sports were unquestionably where I bonded with *Aita*. He was thrilled that I played tennis, and when he heard me hitting a ball around the *el frontón* area after school, he would come out to give me some tips (he had played quite well as a young man). I started competing, and he liked to come to the matches. But having him there was too much pressure; I had to ask him not to come. One day I was playing at the San Sebastián Tennis Club when I spotted him watching the game from a hillside on the way up to Igueldo. I finally got over my nerves about having him there, and we would both enjoy it when he came to watch me play. Like all good parents, he was able to connect with me, and with all of us, through a shared interest. In his case, there was not all that much to give to anything other than his work, but what there was, was intense.

Carmen still competes in senior tournaments around the world. We are all so proud of her wins.

If having to give up that first dream of being a professional football player was hard for Chillida, giving up golf later in life was also a sacrifice. His attraction to golf was blinding. I'm not sure how he started playing—maybe when that golfer cousin came to visit from Argentina. In any case, in two years he was down to a handicap of four, which is no mean feat. When he had a herniated disk, he would stretch his back out with a French doctor in Hendaye to be able to keep playing. Who knows what challenge he invented for himself? My father was very competitive. My mother would often recall how

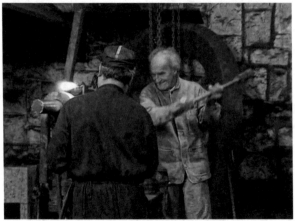

Still from *De Chillida a Hokusai: creación de una obra* (From Chillida to Hokusai: Birth of a Work of Art, 1993) showing Chillida working with a mallet in his San Sebastián workshop, 1992

Poster for the 1982 FIFA World Cup, Spain

Olympische Spiele München 1972

Poster for the Munich 1972 Olympic Games

beat up he would be when he came home from playing at the old course in Lasarte. The next morning, though, he would hop out of bed, rub his back, and say, "Pili, it's a miracle! I'm all better," and head back to the course. He started spending less time in his studio, and that led to some tension with Pili. "Eduardo, can't you see that golf is affecting your work?"

During those years, in the early 1960s, he was working in wood. I sometimes think he might have fantasized about slowing down a bit, traveling less, and so forth. But that was just a fantasy. When the club where he played was set to move to Hondarribia, he decided from one day to the next to give up golf. His friends were shocked to hear him say, "This is my last swing." He gave his whole golf bag to the caddy. Years later, he gifted the new club—where he never once played—a stela in honor of his departed friend, the architect Rafael Elósegui; they used to golf together.

In one of my films, Chillida discusses what he learned about speed, space, and time as a goalkeeper, and how that later served him as a sculptor. He explains that, whereas the football field is two-dimensional, the space contained between the goalposts and the goal box is three-dimensional. It is in that space that football reaches the highest levels of intensity. As the goalkeeper, occupying this specific individual demarcation, he had to develop very sharp and quick space-time intuitions to save his team from losing a goal, and those intuitions later helped him in his work with red-hot materials. My father's assistants were impressed by his strong and precise blows—undoubtedly the same blow he used when striking a golf ball. Perhaps he also learned something from the nearly impossible pivot of the back that golf requires? Did that come to inform how he positioned himself before the iron in the forge? Blow, twist, contract, extend . . . Sheer inner tension released to a specific end.

The body was Chillida's material not only as an athlete but also as a sculptor. His diet was simple, he went for a walk every day, and he did moderate physical exercise in the morning. When we were kids living at Villa Paz, he enjoyed playing paddleball with us out front, in

the middle of a patch of daisies reached by a tree-lined staircase. At my older siblings' birthday parties, he would intentionally hit the ball over the fence into the neighbor's lot to give him time to catch his breath while they went after it. He clearly liked playing—and winning. He installed an iron structure with an exercise bar, rings, and two swings in the *el frontón* area. After finishing up at the studio, he would be out there with us, doing somersaults, jumping around. My mother, lying in the sun, would look on. She would undoubtedly have liked to have a pool back there, but it was so close to the studio that she worried we would make a lot of noise and distract our father. She did indulge us by getting a simple blue-plastic pool supported by a round metal structure to put on the grass—it can't have been more than a meter deep. It was enough to keep us entertained, but not for long.

# Challenges and Hardships

Waking up when the day is new and looking out the window at the mountains helps me orient my being on this Earth. I breathe deep. The light changes as I write, reminding me of the passing hours. For my father, and for me, art and nature were everything.

### Harvard, 1971

Chillida did not believe in artistic instruction. Only minor things, like how to grip a pencil or use a tool, can be passed down, he maintained. That being said, he agreed to give a course at Harvard University in 1971. When the school first reached out to my father, a staunch autodidact, he told Harvard the same thing he had told so many other universities: "I don't believe in art education." But Harvard insisted, countering that it was precisely for that reason they wanted him. And he liked the challenge. The offer meant being away from home for a semester, but he knew Pili would be there by his side. From the beginning, it was clear that the curriculum would consist of no curriculum—an open and responsive approach. The only thing he intended to teach his graduate students was his own learning process. He would have them look out the classroom window—the building had housed Frank Lloyd Wright's studio—or show them the things that had caught his attention on his way to school in the morning: the path that each person left through the snow-covered campus; the scale of bodies seen from a distance. Everyone walking by looked like a Giacometti sculpture to my father, just as used to happen to him when visiting St. Mark's Square in Venice. I remember how my father told me that he had once asked Giacometti: "Alberto, how come you make such small figures?" And he simply answered: "So that the space look bigger!" And so he told his students. My father asked not to have to give grades, and Harvard agreed. He had the students grade themselves at the end of the term. Interestingly, a few of them failed themselves because they felt they had not risen to

the occasion and really taken advantage of the freedom that Chillida had given them. Later, a good many of them would come to San Sebastián to visit him. Including those who had failed themselves.

### Chillida and Jorge Guillén

During his stay in the United States, my father and the poet Jorge Guillén, who also taught at Harvard, became close friends. Despite their intimacy, they treated one another with the utmost respect, even using the formal *usted* rather than the informal *tu* in conversation. One day, my father told Guillén about the project he had done with Heidegger, proudly mentioning that he had gotten the philosopher to write on the lithographic stone. Before saying goodbye that day, Guillén became very serious and said to my father, "Chillida, I also have very good handwriting." My father got the hint—of course— and two years later they also worked together on a limited-edition book. *Más allá* (Beyond, 1973) features a text by Guillén and sixteen block prints by Chillida. Apparently, Guillén was a very kind, as well as amusing, person. I'm sorry I never met him.

In 1981, my father made *Homenaje a Jorge Guillén I* (Homage to Jorge Guillén I), a work in concrete that presided over the entrance to Intzenea, the second and final house my parents inhabited in San Sebastián. My children grew up around that sculpture, and as a young woman I photographed my nieces and nephews having a great time playing on it. It saddened me that, when my father died, someone decided to move that work to Chillida Leku. It was as if my mother and all of us who had lived in that house didn't matter at all. For years, I felt the piece's absence whenever I went to San Sebastián.

### The Chillida Belzunces at Harvard

Getting through those months at Harvard was, for Pili, the greatest challenge in her domestic life. She was wise enough to take with her my older sister, Guiomar, who had finished high school, and Luis and Eduardo, the two youngest. My two older brothers were away at boarding school, so the only ones left back in San Sebastián were my

Chillida and Jorge Guillén working on the book *Más allá* (Beyond, 1973), 1973

Naiara and Luisa, Chillida's granddaughters, with *Homenaje a Jorge Guillén I* (Homage to Jorge Guillén I, 1981), 1980s

sisters Carmen and María, and me. Just a shell of the family. Carmen saw to everything, including keeping track of the cook's expenses, with the help of a somewhat zany uncle of ours. I can still picture myself going up the stairs to the post office to pick up a package with clothes or one of the long letters our mother would send us every so often.

For the Chillida contingency in Massachusetts, Teresa Guillén was a great help. A very kind woman who lived with her father, she gave my parents sound advice on how to handle the many tasks that were new to them. My mother knew plenty about making a home charming, neat, and clean, but she was wary of appliances and, for her, cooking was *terra incognita*. In their temporary home in Cambridge, she must have felt like she was at NASA. Guiomar recalls her childhood and those months there:

> My connection with *Aita* when I was small was very special. There were not many of us yet, and he would be endlessly amused by my daydreaming and love of painting, which he encouraged even though I was only four years old. He said I had a great sense of colors and how to combine them; I even won a prize once. That phase of glory lasted until I tried my hand at more realistic render-ings—that was when painting and I parted ways. When I was much older, I started making ties for him, in the style of one I knew he liked but that was very old. I would combine colors with similar intensities and values. The ties were narrower than most and had crochet trim on either side. He loved them, and after I gave them to him, they were the only ties he wore for the rest of his days. Too bad I had not yet made any when we were at Harvard.
>
> I was the only one of us who got to enjoy my parents the way I did during those months at Harvard. In San Sebastián, they traveled so much that we barely saw them. From one day to the next, I went from not being allowed in the kitchen at Villa Paz to becoming, to my parents' amazement, a budding cook, though they did help me out. *Aita*'s specialty was vegetable soup, and *Ama* saw to the salads. Everything went off without a hitch. Cooking

The "backup team" at Harvard: Guiomar, Eduardo (left), and Luis, 1971

together and doing the weekly laundry with *Ama* were magical. The clothes would come out of the washing machine and dryer in the basement perfectly clean and dry, and nearly wrinkle free. We loved smoothing them out with our hands and folding them.

It was a very enriching experience. From the get-go, we felt welcome, and we soon became friendly with other Spaniards living there, like Teresa Guillén and her father, and Moncha and Josep Lluís Sert, a close friend of Miró's and Le Corbusier's favorite collaborator. And, of course, there was the Polish couple that was so kind to us—Sabine and Joseph Zaleski, who was also an

architect. They would all invite us not only to their wonderful homes but also to spend weekends at their friends' places in the country. The buildings themselves were quite something, designed in the style of Mies van der Rohe.

As far as I know, the toughest challenge they faced was when my father needed an emergency kidney procedure. He and Pili went to a hospital in nearby Boston, and Guiomar stayed in Cambridge with Luis and Eduardo. Not yet twenty years old and in a foreign country, she handled things very well on her own. She even took the younger ones to visit our parents one day and see with their own eyes the delightful little stone my father had expelled. Guiomar had certainly proven her worth. Like so many other busy women, Pili had trained her oldest daughter to be a second mother to her siblings from the time she was small. My parents relied on her for a thousand things. She always had great taste. "She has a refined snout" was my father's funny way of saying she was very elegant and discerning. They also appreciated Guiomar's ability to bring the family together.

My brother Luis, a racing driver, tells an anecdote that has to do with a career in sports, to which he dedicated—and continues to dedicate—a great deal of time and effort. It seems that he got lost in a department store in Cambridge one day. Pili, upset, called the police to try to find him:

> I walked around the building a few times, but could not find my mother and siblings. So I decided to walk to our home, which was on campus. It was far away and I was little, but I managed to find my way to the Carpenter Center, which was where my dad's classes took place. When I told him I had gotten lost, he congratulated me. "You did not get lost," he said. "You knew just where you were and where you were headed." Since then, I have always been particularly mindful of just that—where I am and where I am headed. That was just one of the many bits of wisdom I received from my parents that have been key to my life.

Luis (left) with his race team's new car, Chillida Leku, 1997. Chillida (center) designed the logo in front of the steering wheel.

Luis has competed in the Dakar Rally three times, once on a motorcycle and twice in a car. Endurance and a sense of direction are very important to those races. I remember perfectly how Pili and Eduardo would wake up at dawn to follow his adventures through the desert on television. Whatever the vehicle, it always donned a decal with the Donosti Taldea (Team San Sebastián) logo that our father had designed for him. Apparently, my mother used to say to him: "Don't race, but win." Luis also participates in mountain and circuit competitions where what matters most is speed.

My brother goes on:

Whenever my father asked us to get something for him from his studio or anywhere else, he would time us, and the next time we would try to do it faster. I think he wanted to teach us the value of bettering yourself. It should come as no surprise that I love racing so much. My father was always testing limits—that was something we shared. The difference is that when I do that, I end up injured

or off the track. When he tested limits in his art, he would tune in to the present or embark on a new work.

### The Molino de los Vados

One of the prints I found in my mother's personal archive might look like a simple nature shot. But in it a diminutive female figure holding a camera stands out against the imposing natural landscape. I recognize my mother immediately thanks to her blonde hair, stature, posture, and clothing—practical but elegant, with a long necklace draped down her front. Unmistakable. It is as funny as it is telling that I try to enlarge the image with two fingers, as if it were on a smartphone screen. But a simple sheet of photographic paper is what holds this memory. The back reads, "Pili 1971, Molino de los Vados."

I cannot make out her shoes, but I suspect they would be a pair of what my father called her *zapatos de hombrecito*—her "little man's shoes." I can picture the two of them in San Sebastián on any rainy day of any year at the hour my father liked to take a walk—around eight at night. He would look out the window to see if it was clearing up, and my mother would sink into the couch to see if he would let her off the hook. It would always turn out the same: "Come on, Pili, don't be a wuss. Put on your *zapatos de hombrecito* and let's get out of here!" And she would get up, unenthused but still cheerful. Walks were a shared family activity. Any of us kids who wanted to would put on our gear and tag along.

Personally, I've always loved walking on the beach in the rain—but it seems Pili only did it for my dad. After he died, she never once went for a walk in the rain again. I have learned so much about my mom in recent years. I have had to revisit the versions of her in my mind—and even in my books—twice: once after my father's death, and again after she became ill. Things I once considered negative have become positive, and vice versa. Everything changes with new knowledge and perspective. Emotions, and even events, change each time we take another look.

I used to call my mother's total commitment to my father's cause, to his art, self-sacrifice. But, then again, wasn't my father's cause also

Pilar on the grounds of the Molino de los Vados,
Burgos province, 1971

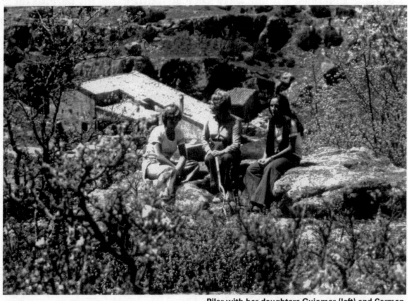

Pilar with her daughters Guiomar (left) and Carmen,
with the Molino de los Vados in the background, 1972

her cause? Submission was rarely what drove Pili to do the things she did for him; they were partners on the same mission, which she had taken on freely. Though I might, at some point, have seen their arrangement as sexist, I have not for a while now.

But let's get back to the mill, to the Molino de los Vados. Nature is center stage in the snapshot, as it was in my parents' life; what Pili is photographing is the house they built in Burgos province. It took them months, if not years, to find the calm place not too far from San Sebastián that they had their hearts set on. A place with a dry climate, good for their lungs and bones. We all helped with the search, and possible locations included the Yesa reservoir, the site of an abandoned village. The art critic José María Moreno Galván, who himself owned a mill in the area, was the one who, in 1971, first took them to the region. He showed them a simple watermill, under which the Arlanza River ran, that sat in the middle of a large meadow.

That was where, a number of kilometers from the nearest town, Castrillo de la Reina, my parents created their "Eden," which we all enjoyed in summer and winter alike. It had no electricity or running water. We used a marine cooler and water we carried in from a spring. Making that place a home was a great adventure that my parents tackled with enthusiasm and the help of their older children. A teenager at the time, I preferred to stay back in San Sebastián with my friends. I did help with planting trees, but I did not get involved in the search for the beautiful stones from abandoned shepherds' huts that would be lugged back to the mill to build its simple porch and the arched bridge over the river. These were the finishing touches on the house where, years later, I would get married, as did my sister Carmen.

My parents and younger siblings would spend the entire summer season there; the rest of us would visit every so often. Herds of sheep, cows, and horses, along with their friendly shepherds and those shepherds' dogs, would come by morning, noon, and night. We had oil and butane lamps, as well as candles—to say nothing of the enormous fireplace my father had made, a perfect place to gather. We also had the company of the vegetation, the rocks, the river with its "Roman" bridge,

Untitled paintings Chillida made while at the
Molino de los Vados, Burgos province, 1978

and the meadow. The sky at the Molino de los Vados was vast. We would go
for nighttime walks through the grass under a sky exploding with stars.

In the middle of nature, my father got to know us better—and we got
to know him better as well. He would read, go for walks, and sometimes
paint. The small and powerful paintings he made there were a simple
pastime, but they do preserve our memory of the mill. Years later, my
brother Ignacio organized a temporary exhibition, titled *Divertimento*
(Amusement), at Chillida Leku featuring this unknown facet of our
father's work.

The Molino de los Vados was an important place for Chillida. Only
his closest friends knew of its existence, and those friends would often
be invited to spend a few days there. We all loved exploring that region,
so rich in culture. Covarrubias, with its medieval buildings and the
Torreón de Doña Urraca, as well as the collegiate church where we
heard so many unforgettable concerts. The Monasterio de Santo
Domingo de Silos, its cloisters a Romanesque gem and its abbey
an ideal place to hear Gregorian chants. Many other small ancient

shrines lay scattered across the countryside, as do the extraordinary ruins of the San Pedro de Arlanza monastery. Chillida was one of the public figures who fought against plans that would have left the monastery under water. That effort was successful, but, as fate would have it, many years later his very own Molino de los Vados, isolated as it was, would be torn down and, later still, flooded, along with the lovely valley the whole family had enjoyed so much. Fortunately, our father did not live to see any of that.

### Calamity Jane

With the knowledge that comes with age, I now look at the photos my father took at the mill and I remember how hard it is to step into someone else's shoes when you are young. Was I able to get even a glimpse of how sad it was for him to give up his Leica, the one that would later be mine? He loved climbing up the crags and zooming in on us in the middle of whatever we were doing, until his worsening eyesight meant he could no longer focus the image.

I laugh now, as he must have laughed at the time, at the sight of my mother in pajamas under her unfailing white robe, pushing the grass she had just cut and gathered in a rickety old wheelbarrow. Beside her is the stone wall they built to separate the mill from the cows, horses, and sheep that roamed free. (My parents had been given permission to fence off a small parcel.) Something curious happened while they were building that wall with the help of my brothers and Mariano, the kind local man who looked after the house. A small tree was directly in the path of the construction. My parents did not want to chop it down, so they gave the wall a very Chillida-esque curve, leaving space for the tree to continue growing happily in the meadow. To make up for the lost space and round off its shape, they made an analogous curve, but in the other direction. One was concave and the other convex. In the concave space angled toward the house, they planted another tree and left it plenty of room to grow happily as well.

In another of my father's photographs of Pili, we see her in a summer hat, holding in her muscular arms one of the thickest water

Pilar doing chores at the Molino de los Vados,
Burgos province, 1974

hoses I have ever seen. The water rushing out paints a white arch in front of the stone wall.

Pili's do-it-yourself side came out in full bloom in all the houses they had. All of us remember her mowing the lawn at Villa Paz or removing the grime from the garden chairs before painting them, which she did whenever necessary. These might have been considered "men's chores," but she couldn't have cared less. She was up to any task! Eduardo would call her "Calamity Jane," and he thought she was capable of anything. He imagined her leading a long wagon train to conquer the Wild West and would paint her in her pajamas spurring horses.

An enlightening story from when we were small: Pili, still in pajamas, would take us to swimming classes at the San Sebastián Tennis Club early in the morning, and then meet up with us at the beach. Once, on the way home, she ran out of gas. She majestically strolled through half the city in her pajamas.

I wonder now about the little things she indulged in throughout her life. She liked reading every last section of the newspaper in bed in the morning and walking around the house—and even beyond, when required—in pajamas until well into the morning. However it may look, she was by no means lazy. Were pajamas a mark of her identity? A personal preference? A luxury? A statement of her freedom to act as she wished?

Pili's appearance and style were absolutely her own—she was not influenced by anyone or anything, not even Eduardo. And she passed that down to us kids. She believed that self-confidence was based, at least in part, on the freedom to choose, and she never allowed our father's criticism to affect us. He didn't have a shred of interest in fashion, but he cared about aesthetics and did not shy away from making a remark when he thought something didn't look good on us. The pointed-heel boots my brother Luis wore for a while irked him greatly, and he was unsatisfied when the parts in our hair didn't complement the oval shape of our faces or the cut of our clothes obscured the proportion between our torso and legs. Our mother would invariably jump to our defense: "You look amazing!" "A real stunner." I learned how to play those two off one another. I would not give in to my father's tastes, but I always knew what my father thought, even if he didn't say it outright. His favorite chair in Villa Paz was across from the stairs that led to the front entrance. He would be there reading before heading to the studio. If, when he heard one of us girls coming down, he looked up and smiled, he thought we looked pretty; if he only glanced up and looked right back down at his book, he did not. Sometimes my sister Maria would go back up and change. I don't think I ever did, though now when I see photos of myself in unflattering clothes, I have an idea of what he was getting at.

Pili was free and open-minded about everything, not only about clothing but also customs and habits. I'm thinking of the low necklines of the dresses my sisters and I wore, of how short my skirt was when riding my motorcycle, and of all the nights I did not sleep at home the year before I got married. My father, who was a bit prudish, would be

Still from *Chillida: el arte y los sueños* (Chillida: Art and Dreams, 1999) showing Chillida on top of a crag in Burgos province, 1998

scandalized. "Pili, have you said anything to that girl yet?" My mother told me that whenever he would say that, she'd shut him up with a simple: "But don't you see that *she* thinks what she's doing is okay?" My mother shunned convention, which might be why she never really fit in anywhere. Despite her charming personality, she was a bit of an outsider in Basque society, but also in Spanish and foreign societies. Pili and Eduardo were one; she was a *rara avis*—a rare bird—who compensated for everything my father lacked.

In another photo of my mother at the mill, she is sitting with her back to the porch, a hiking stick leaning against a wall. Her hair, pulled up into a high bun, reminds me of a very delicate drawing of her my father made. I can hear their voices in my mind, reciting a poem by Saint John of the Cross from memory. "By that one hair / Thou hast observed fluttering on my neck, / And on my neck regarded, / Thou wert captivated; / And wounded by one of my eyes." They were an adorable pair of hopeless romantics and mystics.

Each sentence about my father I have written, each image I have taken, stirs up hundreds of memories. Nothing I have recounted here about the mill made it into *Chillida: el arte y los sueños* (Chillida: Art and Dreams). But I wanted the sound of the cowbells to be heard, for

125

my father walking alongside the Arlanza River at night to be seen, for viewers to enjoy those solitary places that he too enjoyed. Personally, I love a still where his head peers above an enormous rock as he takes in the breathtaking landscape.

### A Collage for Calder: Paper

"It is thanks to space that the physical universe has boundaries, and I can be a sculptor. Are there boundaries for the spirit?," wrote my father.

There is a photo in which Alexander Calder seems to be showing Chillida the inside of his mouth—its cavity and void. Amused, my father takes in the sight. They were friends. Not long ago, I stumbled on a collage on a sheet of folded paper. It was for Calder, but never reached him. The handwritten dedication reads: *Voici cet espace pour mon ami Sandy Calder, afin qu'il l'occupe de toute son humanité. Chillida* (This space is for my friend, Sandy Calder. May he fill it with all his humanity). Written in pencil on the back are the words "ATTENTION ORIGINAL" and "TELEFONO" (TELEPHONE), though no number appears. Maybe that's what was missing: a number to notify his friend of the shipment. But I also see a small inkblot near the signature, which would be reason enough for my father to abandon the work and make a similar one that I am sure *did* reach his friend. Every detail about a work of art mattered to my father: the composition on the page, the format, the texture, the color of the paper . . .

I can imagine him carefully cutting out the two small black pieces of paper that make up the space his friend was to occupy. In friendship, Chillida was impulsive, and also generous. It is a simple and heartfelt collage. I am the one admiring it now. I wander in and out of the space intended for Calder. Nothing holds me back as I fly through the white space and, in the embrace of the black shapes, rest and reflect. "Art is not refuge, but open sky. It does not orient. Perhaps it disorients forward," my father wrote.

I think my father must have made this collage in his final days at his first studio at Villa Paz (he had outgrown it). That was an important

Alexander Calder and Chillida, Saint-Paul-de-Vence, France, 1970

A collage for Calder, undated

juncture. My mother bought the house next door and had a larger studio built there that replicated the same upstairs-downstairs studio structure. I think I remember him being a bit apprehensive about the change. But, as always, Pili saw him through the transition, and it worked out well. The only thing separating the old studio building from the new one was a bay tree, its scent enveloping everything.

My brother Pedro, who was a painter by this time, took over the upper level of the old studio for a spell. When the renovations began to turn that small house, with its slanted roof, into my home, he generously left. But a lot was left behind. Traces of our father lingered in the bookcase and in the chimney that my husband and I kept. Posters and other objects left behind in the move were kept by us as well. And among these remnants, for who knows what reason, was this collage. My mother let me hold on to it. I've thought about framing it, but so far I have not.

### *Lurras*: Chamotte Clay

Evening falls. The colors change and the northern mountains in the distance turn pale blue. Soon, what was pleasing and subtle—the mountains' forms against the sky and the land that separates me from them—becomes sad. The magic of light comes to an end before my window. I change position to look west. Shapes of other mountains still stand out against the orange of the fading evening sky. A cypress tree holds its ground in front of them.

I once heard that sculpture is, for viewers, one of the most demanding art forms. Personally, having grown up amid Eduardo Chillida's works, I find that a bit surprising. Of course, looking at sculpture means implicating yourself physically—just as the sculptor is implicated physically in the work's making—but to me that has always seemed perfectly normal. How can you possibly say you have seen a sculpture if you have not walked around it? "Sculpture must always face the consequences, must always be attentive to what moves around it, what makes it live," wrote my father. Walking around a sculpture with eyes glued to it is like dancing with it. The sculpture itself moves

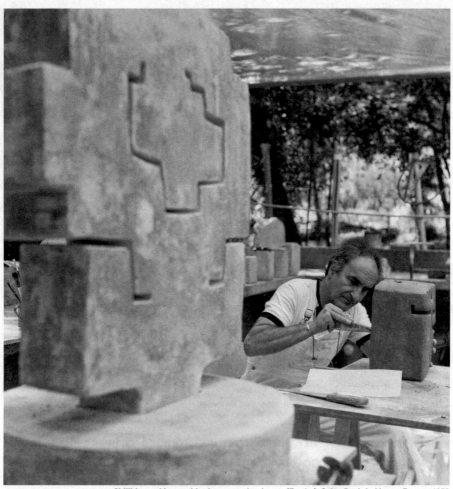

Chillida working on his chamotte clay *Lurras* (Earths), Saint-Paul-de-Vence, France, 1978

and changes with one's step. Some sculptures are very different depending on which side you view them from—which is why I have never understood how some museums install statues against the wall. Do they really think the chest is more important than the back? That's like saying that the north is more important than the south, or the east than the west.

Like all my siblings, I lived with sculptures from a very young age. I'm used to walking around them, touching them, and seeing them

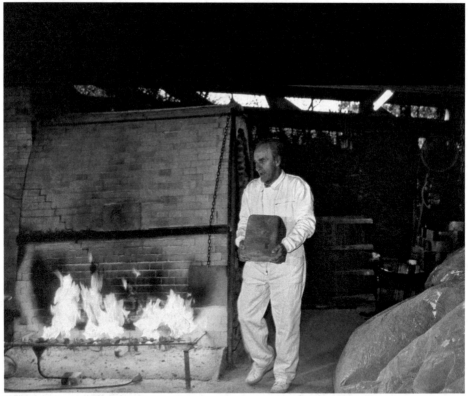

Chillida bringing a *Lurra* (Earth) to the oven, 1996

displayed in different exhibition settings—though it can be a bit of
a shock to come upon them if one is not prepared. I remember, for
instance, walking into the house of a friend whose mother had bought
one of my father's *Lurras* (Earths, 1973–98). That chamotte clay
sculpture set among different objects seemed, to me, to come from
a distant time. I experienced it as mysterious, almost prehistoric.

Chamotte is very different from the clay my father had so disliked
working with as a young man. He discovered it in the summer of 1973
while working in the print studio at the Fondation Maeght. It had
the largest etching press in the world at that time. Chillida, hard at
work in the studio, heard what he considered a beautiful sound. It
distracted him from what he was doing. *Bum, bum, bum.* He leaned
out the window to see where it was coming from, and he spotted the

ceramicist Hans Spinner, with whom he had never worked, preparing a block of clay for Miró. For my father, that sound was a siren call. Intuition and perception were what led him to it. He went down to where Spinner was working; my father asked him to let him touch the material that made such a beautiful noise. He also liked how it felt.

It was chamotte clay, that is, clay that has been fired, ground, and then mixed with water. That's what gives it the hard texture my father liked so much. Chillida began working with Hans Spinner. Once again, my father's way into the material was novel—in this case, listening to it. He was interested in the nature of this matter as such, especially the compactness of the "loaves of clay," each one the size of a large brick, that Spinner kept in his studio. I can imagine my father looking at them for a long while. He used to say that he worked following an "aroma" that helped guide him to the work he was going to make, even if he did not yet know its form. In this case, he knew enough: he knew that he was not going to model this earth; rather, it was precisely the compactness of this material what he would harness. He joined a number of loaves together until the size was right for the work he wanted to make. Then, making incisions and other interventions with an array of tools, he formulated his own dialogue with the material.

I heard my mother say that the maximum size of a *Lurra* depended on the reach of its maker's arms and his strength, since the clay had to be lifted and turned over during the production process. She added proudly that Eduardo could work with as many as four or five loaves.

The moment of truth was when the *Lurras* went into the kiln. Fire is a living and capricious element. No matter how careful you are, it might play dirty tricks on you and the color, perhaps, will not turn out the way you had hoped. I wonder where my father would have been without fire. Without that element, neither his iron nor his steel nor his clay works would have existed. Without fire, Chillida would have been all thumbs.

He enjoyed working on his *Lurras* outside in the Mediterranean climate, preferably with Pili nearby. Miró, who was also working with Hans, whom our father called "my German brother," often came by the

studio. And it was not unusual for Aimé and Guigitte Maeght to pop in during the artists' breaks. The atmosphere was familial and welcoming.

### *Le cimètiere Chillida*: Scenes and Recordings

Filmmaker Laurence Boulting was wise enough to shoot Chillida working on the *Lurras* in his 1985 film about the artist. One scene shows Spinner and his wife, Noëlle. It is night, and they are eating dinner with my parents beside the kiln, anxiously awaiting the final results. Film was in Larry's bones. Son of one of the "crazy Boulting brothers," his godparents were Laurence Olivier and Olivia de Havilland. Larry was mostly a documentarian. The first time he came to San Sebastián to talk to Chillida about the possibility of making the film, he introduced himself as a producer; that is to say, he was a messenger representing one of the directors he worked with. They spent a few days together, and before Larry left my father said, "Okay, let's make the film. But I want you to be the director." My father was able to see a person's essence; he knew how to give them confidence and strength. Considering the chemistry between them, it's no wonder that the film was a success and received a couple of awards.

Another of the scenes shows something important about my parents. A crane is positioning a sculpture in front of the Zabalaga *caserío* that would later become the Chillida Leku museum. My father is giving instructions on where and how it should be installed. Before the crane leaves, Pili tries to convince Eduardo to test out another position, one she thinks will favor the work. He doesn't want to try it; despite her insistence, he does not give in. They end up laughing, but I can imagine how frustrated Pili must have felt.

I eventually recorded an interview with Hans Spinner. He told me that my father was never satisfied with a work unless it was, in his view, truly excellent—and that, in Spinner's view, was not common among artists. Apparently in the back of his studio my father had what he called *le cimètiere Chillida*—the Chillida cemetery. That was where he put the unsatisfactory *Lurras* he would grind back down to raw material.

Had it been up to my father, a great many of his drawings would not have survived. He would make several, and then choose the ones he liked most and throw out the others, or have Pili throw them out. At least that was how it was until Louis Clayeux, the artistic director of the Galerie Maeght, suggested that my mother do otherwise. He explained to her that it's normal for artists to lose interest in what they've done before, but everything—even discarded drawings—forms part of their trajectory and, as such, must be kept. Pili followed his instructions.

### The Iglesia de Santa María

The aria playing on the radio brings back memories, voices in the choir my parents and I would hear on special occasions at the Iglesia de Santa María in San Sebastián. I have never used the material I shot there. With the tracking shot down the church's central aisle, I wanted to capture the place where Chillida went every single week, always sitting in the pew in the second row to the left of the altar. Memories keep flooding in, scenes that the high stained-glass windows also witnessed. At the altar, among all the sacred objects, is Father Elgarresta, whose humility Eduardo greatly admired. Though the son of a woman who could have been an opera singer, my father was nearly tone-deaf—as was Father Elgarresta. Every week, Eduardo would watch as the priest, despite his terrible singing voice, walked over to the microphone to sing along, as best he could, with the faithful. My father was moved by the embarrassment he must have felt, and how it did not deter him. It was something they had in common.

Who decides what facets of a person are and are not contradictory? Is it contradictory to be an active player in the avant-garde and to go to mass every Sunday? Maybe, but my father did it. That said, he was never sanctimonious or superior about his beliefs and practices. Beliefs—especially religious beliefs—are passed down to us at a young age, before we can stave them off or oppose them. They are served to us on a platter, along with love and fear. Later in life, my father studied other religions, but he found no reason to give up his own. Maybe he

was partly driven by fear. He also rationalized his religious practice: in response to my husband's surprise at Chillida's unfailing Sunday churchgoing ritual, my father replied that he was such a lucky man, a man who felt so free, that he needed to be tied down by something greater, namely, the communion of equals.

The Santa María church was, for me, a gathering place. I knew that every Sunday at one o'clock I could find my parents there. For that reason, I would go from time to time as an adult. Afterward, we would head down to the docks and buy shrimp and sea snails to eat together. One Sunday when I was not there, someone came over to my father after mass and said to him, cryptically, "Chillida, you owe me a trench coat." The implications held in that simple phrase ran deep in my family. The man was the son of the Basque Separatist *gudari* who had saved my grandfather's life by covering him with his trench coat, on that night when they executed so many captives at the prison in Bilbao. As I said, that story and the debt to the Basque Separatists that my father had inherited greatly affected his life.

### Will Eduardo Sign?

In 1974, during the tenth anniversary of the opening of the Fondation Marguerite et Aimé Maeght, another "family photo" was taken. The family had grown considerably, though Louis Clayeux and Alberto Giacometti were no longer around. Also missing were Marc Chagall, Valerio Adami, Anja Kandinsky, Antoni Tàpies—he started working with the gallery a bit later—Pierre Alechinsky, and a few others. I notice a detail. Here, and in the photo on the cover of this book, Pili is wearing around her neck one of the gold medallions my father made for her. He would often dedicate his romantic gifts to her with the simple phrase, "For Pili, my all-time friend." What stands out in a less formal photo taken that day are the smiles on the faces of Pili and Eduardo, of Pablo Palazuelo, and of Joan Miró and his wife Pilar Juncosa. My parents and the Mirós were close and trusted friends.

When making my documentaries, I asked my father how he had felt in the beginning about being around such important figures in

art—all the other artists represented by the gallery were at least twenty years his senior and very well known all over the world. I wanted to know whom he admired, and I remember he said Miró. My father thought Miró was an upstanding man; he was furious at the absurd criticism that called his work childish. Today, with the support of the gallery Hauser & Wirth, Chillida Leku welcomed Miró to share its space in 2022, just as it did with Tàpies the year before.

During the Franco years in Spain, the opinions of intellectuals carried a lot of weight. Artists would often champion statements and manifestos, and that might place them on the government's radar, with all the danger that implied. I remember, Pilar, Miró's wife, calling my mother to ask her if Chillida was going to sign one document or another. Usually, they both ended up signing.

One day when we went to the bakery we always shopped at, the owner informed us that, the night before, neighbors had kept watch on the entrance to Villa Paz in case Chillida's statements were met with retaliation. I heard someone say that my father was untouchable, but when, years later, he came out against terrorism within the Basque Country, we were somewhat afraid of reprisal from the other side of the separatist conflict.

During those tumultuous years in the early and mid-1970s, my father supported a number of causes: the right to the Basque language and flag, amnesty for the political prisoners, the opening of a university in the Basque Country. He also opposed the construction of a nuclear plant in Deva that nobody in the Basque Country wanted in our territory. The logos and graphic works he designed and donated came to form part of the Basque imaginary. People would put his designs on their clothes as pins or on their cars as bumper stickers; you still come across them now and again. Chillida's signature black and white soon became recognizable to everyone. The case of the design of the amnesty campaign for the Basque political prisoners in 1976 was very sad for my father. He had committed to that cause with the hope of bringing the violence to an end once and forever. They managed to secure the amnesty, but when my father saw that the armed struggle

Logo supporting amnesty for
Basque political prisoners, 1976

Logo in support of opening
a Basque university, 1975

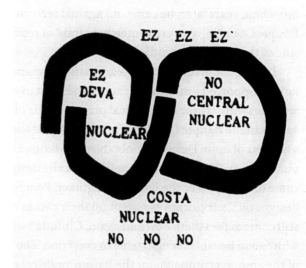

Logo protesting against the nuclear plant in Deva, 1975

136

continued afterward, he and many others gave up on that cause. The ends, for him, did not justify the means.

Though I know my father's commitment to all those causes came from the heart, it might have been, in part, a way of paying the son of the *gudari* back for the trench coat.

The political logos and graphic pieces from those years are rife with tension. I wonder if the exclusive use of black and white in Chillida's work was not in some way tied to the Basque-Spanish duality that ran through his life. For some, Chillida was too Basque; for others, he was too Spanish. For almost everyone, he was too international. A tough load to carry.

Rather than untouchable, my father was, in my view, unclassifiable. Like the poet of the present that he was, Chillida acted in response to what life put before him. He followed his conscience, unconcerned with toeing a constant line that made sense to others.

### Aimé's Kiss

One particular photograph is very dear to me, as it shows the affection that Aimé Maeght, by then an elderly man, had for my mother, warmly embracing Pili and kissing her cheek. It would have been easy enough for the photographer, the ceramicist Hans Spinner, to leave my father out of the image (he—partly—appears on the right-hand side). But he did not, and I understand why: everyone knew that Pili was an extension of Eduardo, and Aimé was, in a sense, kissing them both. My father's smiling face betrays how happy the kiss made him.

Around my father's neck are his ever-present glasses, and in his hands we find his no-less-ever-present bag of tobacco and one of his many pipes. A memory surfaces. When my father died, my siblings gave me a note they had found in his studio in which, as a birthday gift, I promise my father I will quit smoking. I can't remember whether I did or not—I have quit and started up again so many times—but I do remember how hard it was for my father, despite his considerable willpower, to give it up for good himself. He would trade cigarettes for a pipe, or swear not to smoke for a year and then take it up again

Pilar, Aimé Maeght, and Chillida, 1978

as soon as the year was over. His smoking once caused a lot of trouble at the home of a few collectors in New York. Craving a draw on his pipe, he slipped away from the gathering and lit up in an empty hallway. He had not taken even three drags when all the smoke alarms in the house went off. I can just picture the combination of naughty delight and shame on his face as he apologized. And then one day, at the age of sixty-something, he said, "This is the last cigarette I will ever smoke." And it was.

I take another look at the photograph. My father's torso is cut off, but I don't think anything is missing: his head, heart, and two hands are there—and that's everything an artist needs. A question he once asked me in his studio left me perplexed. "Which do you think would be worth more: a drawing formulated by Leonardo but rendered by a cab driver, or a drawing formulated by a cab driver but rendered by Leonardo?" I think he had noticed that when I started making my first

documentary, which was about the production of his *Homenaje a Hokuai* (Homage to Hokusai, 1994), I was overly concerned with the physical part of his process. I got the message and learned the lesson.

Aimé's kiss also shows how much he valued my mother. He had, over the years, come to know her many skills and how fiercely she upheld Eduardo's interests and the interests of her children. The way my mother leans her laughing face into the gallerist's hand speaks of how close they were, thanks, undoubtedly, to the many adventures they had shared.

### La sirena varada: Madrid

If San Sebastián and Paris were important places for my father, so was Madrid. That was the city where Chillida had studied as a young man. He and Pili would often meet up with friends and see exhibitions when they passed through on their way to other places. That city is, for me, associated not only with people I know personally but also with names often mentioned at the house: the civil engineer José Antonio Fernández Ordoñez; the neurologist Alberto Portera; gallerists Juana Mordó, Luisa Iolas-Velasco, Nieves Fernández, and Elvira González; and artists Eusebio Sempere, Paco Muñoz, and Antonio López García, to name a few. I know that there were countless people and places in Madrid that my parents held dear; I hesitate to try and list them because my inevitable omissions would be unfair.

For both my parents, Madrid meant, of course, the Museo del Prado, which they visited often, and the Museo Nacional Centro de Arte Reina Sofía. In fact, my father did the Reina Sofía's first logo. Its inaugural exhibition, organized by Carmen Giménez in 1986, was a joint show featuring the work of Chillida, Saura, and Tàpies, along with Baselitz, Twombly, and Serra. Madrid was also home to many galleries where Chillida exhibited and bought work. It was the city where he was named a member of the Real Academia de Bellas Artes de San Fernando, and the one where a number of his public sculptures were installed. The truth is, my father was always comfortable being Basque and being Spanish. From the time he was a boy, he had found

sustenance in Spanish culture; without its literature, painting, and music, Chillida would probably not have been who he was.

In 1973, Sempere, along with Fernández Ordoñez, created the Museo de Escultura al Aire Libre, which connects the Paseo de la Castellana to Serrano Street, near the Juan Bravo bridge. Sempere is the author of one of the works in the open-air sculpture park, as well as its beautiful waterfall, the railings alongside the stairs that connect the streets, and the small benches where passersby can rest and look at the works.

*Lugar de Encuentros III* (Meeting Place III, 1972), a sculpture in concrete by Chillida, was to be suspended from the Juan Bravo bridge, which shelters the museum's works. But the Madrid City Council objected at the last minute. They claimed that the work's weight might compromise the bridge's safety, even though the engineers consulted resoundingly denied that possibility. The sculpture had nowhere to go for a time, which is how it came to be called *La sirena varada* (The Stranded Siren). Many suspected that, with Franco still in power, the fact that Chillida was Basque was actually the dangerous "weight" that kept the sculpture from being installed. Of course, no one would say as much publicly at the time.

Defying all logic, Aimé Maeght proposed hanging the work in his gallery at 13 Rue de Téhéran in Paris. At the meeting where he first voiced the idea, someone on his staff said that it would be necessary to consult an architect, to which Aimé replied, "*Surtout pas!*" (No way!). My mother would have said the same thing. To everyone's glee, the work was exhibited at the Galerie Maeght despite every imaginable difficulty. In fact, it was one of the shows my father enjoyed most. Just imagine, a six-and-a-half-ton work in concrete hanging in the middle of the gallery in defiance of architecture and gravity.

The story of that sculpture was long and complex. To apply some pressure to have it finally installed in its original intended location, Miró offered the City of Madrid a gift of one of his works, also to be displayed at the Museo de Escultura al Aire Libre, if they would install the Chillida as the artist wanted. But the offer was declined. Instead,

the two artists did a trade: *Lugar de Encuentros III* was sent to the Fundació Joan Miró in Barcelona, where it was installed according to Chillida's wishes, and Miró gifted my father a large painting, with a dedication. When Franco died and democracy returned to Spain, the mayor of Madrid, who was a member of the Unión de Centro Democrático coalition, got in touch with my dad to say that they could finally install the work, suspended as he wished, in the sculpture park. My father answered that the work no longer belonged to him. Miró generously not only let the work leave his foundation but also renewed his initial offer and gladly donated his own work to Madrid. Chillida gifted to Miró a somewhat smaller concrete work. All's well that ends well.

### The Recognition of His Compatriots!

On September 7, 1974, at the San Telmo Museoa in San Sebastián, Chillida, fifty years old at the time, received his first award in his native Basque Country. Rarely have I seen photographs where my father looks as radiant. My eyes lap up the details in all the snapshots of the occasion in my mother's photo album. In all of them, I can sense Chillida's affection and how it is returned by the event's hosts. Why so overjoyed? Why that slightly naughty and slightly timid expression on his face? Am I mistaken that the shape formed by his arms and the arms of the man decorating him with the *txapela* is reminiscent of one of his *Peine del viento* (Comb of the Wind) works? They seem engaged in a friendly struggle, like kids wrestling. I cannot tell whether my father wants to take off the *txapela*—he never liked having anything on his head, for fear of losing still more hair—or if he wants to plant it more firmly on his crown. Is he checking out how tall it is or flattening it out in a gesture of humility? Is he taking an introspective look at the young man he once was or at the person he feels himself to be at that moment? His grinning face looks downward. His "opponent" tries to push his chin up.

His unfailing Pili, a smile on her face, is sitting at the table. Both my parents are wearing white, whereas the tie-wearing hosts are in

black. Informality versus formality. Is Chillida communing with the other attendees who are not being awarded? Does he want them to see him for what, in his heart, he knows himself to be—a Basque—even if he does not speak the language? I see so much joy in the photo.

In my first documentary, *De Chillida a Hokusai: creación de una obra* (From Chillida to Hokusai: Birth of a Work of Art, 1993), I show my father receiving the Praemium Imperiale from the Emperor of Japan. My grinning father, in a tuxedo with a red cummerbund amid a sea of kimonos, leans forward respectfully. I also remember watching him in 1987 stand alongside fellow recipients of the Wolf Prize for the arts in Israel under a few enormous paintings by Chagall. These are just a few of the moments of recognition he enjoyed over the course of his life. But none of those images move me as much as the one of him receiving the *txapela*, that large Basque beret, with his name sewn onto it. I am undoubtedly moved because he clearly is. The recognition of his compatriots!

In any case, his first exhibition in the Basque Country would not take place until 1981. Held at the Museo de Bellas Artes in Bilbao, it likewise brought my father great joy. The works included in that exhibition had been in a show at the Guggenheim in New York the year before.

My father did everything he could for our Basque Country, and it pains me that he did not live to see the end of the armed struggle—something he so longed for. He, who during a long month that saw many sad kidnappings, bravely proclaimed on the radio: "A man, any man, is worth more than a flag, any flag." Those words make me proud, as do other words he wrote out longhand on a poster supporting human rights, words of his that I embrace as my own: "A protest, an embrace, a cry, an echo, a refuge, a cross, a flower. . ."

Chillida receiving the Praemium Imperiale of Japan, 1991

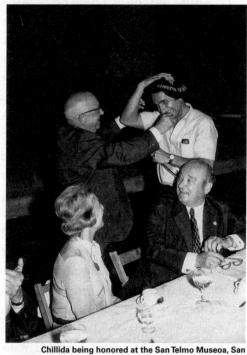

Chillida being honored at the San Telmo Museoa, San
Sebastián, 1974. Pilar watches on from her seat at the table.

Poster supporting human rights during
the Basque conflict, undated

**_Peine del viento XV_, Donostia-San Sebastián: An Epic Adventure**
The western end of the Bay of La Concha in San Sebastián is now
home to three weathering-steel pieces set deep in the rocks: the
units that make up _Peine del viento XV_ (Comb of the Wind XV). That
location saw my parents grow up and witnessed their love from their
first meeting at the ages of thirteen and fifteen. Back then, it was
a simple circular plaza at the end of the Paseo del Tenis. It might have
been where they said their goodbyes when Chillida decided to study
architecture in Madrid after injuring his knee. It was there that they
caught a glimpse of the uncertain future that awaited them when my
father decided to drop out of architecture school and go to Paris to
delve into sculpture.

After he returned from Paris for good, Chillida, now a married
man, forged many dreams that he shared with his wife. Of them, the
greatest was to install a work in "their place," to give a gift to San
Sebastián. His idea was to situate it on the beautiful rock, which is
visible in an old photograph from the 1970s. Over the course of
twenty-five years, Chillida made fourteen sculptures titled _Peine del_
_viento_, all the while cherishing that dream. When, in 1974, the time
came to make that dream come true, Chillida experienced his
beloved place as if he had never before laid eyes on it. And he realized
he needed not one, but three, sculptures—variations on a single form,
all alike in size—to emulate and accompany the horizon line. A Zen
spirit led my father to heed the present when the present arrived.

As the daughter of José María Elósegui, the engineer for the
Provincial Council of Gipuzkoa at the time, recounts in a book and
a documentary available online: it all began in 1973. A group of
Donostiarras—as those from San Sebastián are known in Basque—
wanted to pay tribute to Chillida for his outstanding international
career. They suggested an exhibition, but my father boldly said that
he would prefer something permanent. And he told them about
the dream he had harbored for so long. His project would turn that
neglected corner of the city, where its waste pipes emptied, into
a place where people could encounter the surrounding natural

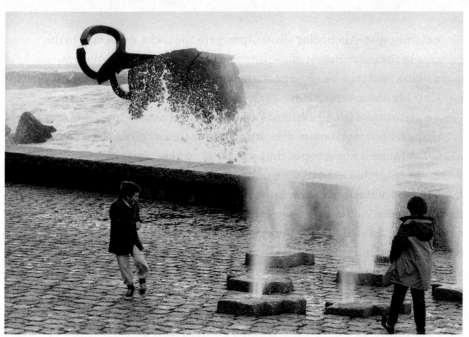

Children playing in the Plaza del Peine del viento (Comb of the Wind Plaza) in San Sebastián, ca. 1977

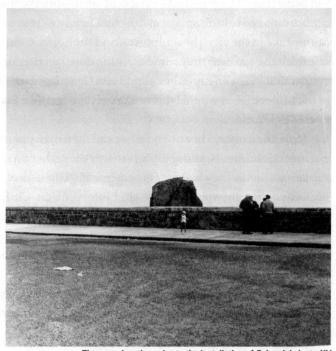

The same location prior to the installation of *Peine del viento XV*
(Comb of the Wind XV, 1976), 1970s

environment. Anchoring the sculptures in the rocks, especially in the case of the most distant of the three, was an engineering challenge—a titanic feat that Elósegui performed pro bono out of friendship with Chillida and love for his city.

Also out of friendship and love, Patricio Echeverría, owner of one of the largest steel companies in the Basque Country, made available to my father a workshop at the Gran Forja de Echeverría in Legazpi. He put together a team of ten of his best workers and donated twenty-five tons of steel so that my father could turn his long-held vision into reality.

*Peine del viento* had major reverberations both in and well beyond San Sebastián as a unique urban and public initiative. The work was soon incorporated into a broader project of the Donostia-San Sebastián city government. With Chillida's blessing, the city commissioned architect Luis Peña Ganchegui to reorganize the entrance and plaza that would accompany the trio of sculptures (my father had first taken an interest in Peña Ganchegui's work for the Plaza de la Trinidad in San Sebastián). The architect's intervention in pink Porriño granite is extraordinary. He built spaces at different heights, from which one can calmly take in the city, the sculptures, and the horizon out on the sea, safe from the waves as they come crashing down on the coast. The close connection between my father's and Peña Ganchegui's visions is patent in the project. They would later work together again on Plaza de los Fueros in Vitoria.

More than once, I heard my father call for urban planners, engineers, architects, and sculptors to work together on urban from the get-go, just as they had for *Peine del viento*. One aspect that escaped my father, though, would require later intervention. Chillida did not want to install artificial light at the installation site. It makes sense that the city council, urban planners, and architects would consider the need to light a public space. But what could be lovelier than leaving urban lighting behind and letting your eyes adjust to degrees of darkness—all the more so for a place like the Bay of La Concha? The dark entrance to the space sets it apart. Even though the sculptures on

the rocks are barely visible at night, it is thrilling to see the waves break on them, the white foam turning the works into what look like mysterious bursts of light.

By 1977, the year when the fabrication and installation of *Peine del viento* was finished, Chillida had created a number of sculptures for public settings. But this one was his first public-art dream come true: a work fully integrated into the landscape, just as he had envisioned it. Since the time they were young, Pili had urged him to make the wall that protects people from the sea wider so that lovers could sit there comfortably—and that came to pass. At this spot, everything changes with the tide, the weather, and the time of day. Individuals, couples, groups of friends, and families delight in the place. Whenever I go, I feel I'm sharing something profound with everyone else there; at the same time, my individuality is perfectly intact.

For my first film, I shot *Peine del viento XV* without any people around. When I started work on my second documentary, *Chillida: el arte y los sueños*, I was not sure whether to include it—I did not want to repeat myself! But that place was part of Chillida. So I decided to include the work, but to add new information. I shot people enjoying the place on a day when the sea was rough. Each film captures a different facet of the sculptural environment, the fruit of the joint efforts of an array of professionals. The seven holes punched into the ground act as geysers around which kids play; they make the sea breathe rather than pierce and break up the undersoil, as happens along other parts of the Basque coastline. Predictions at the time of the work's completion said that the sculptures would lose one millimeter every twenty-five years. So far, that has proven correct.

It is truly difficult for me imagining San Sebastián without such a place.

### Public and Private Figure

To look back at a stretch of one's life means to reconstruct it. Until now, I had never connected what would become my future vocation with a photograph, later published several times, that I took of my

father and my brothers Pedro and Eduardo playing in the snow in front of *Peine del viento*. Other pictures from my years as a photographer also attest to the pull my father's sculptures had on me. It would, however, be years until I began to take an interest in Chillida as a public figure.

At first, my father was, to me, just that—a loving dad, a man with warm hands I liked to squeeze. It was not long before he became a man with a name—Chillida, my own last name, though I disavowed it many times. I would often mutter it whenever I had to introduce myself. Why? Was it to protect myself? Or to protect him? It is not always easy to be the offspring of a well-known person.

An old and somewhat embarrassing memory surfaces. I see my twenty-something self, feeling a bit out of sorts from drinking, at the wedding of some friends. Suddenly, right in front of me in the hidden corner of the garden where I was quietly sitting, a would-be paparazzo appeared. I sensed his thirst for sensationalism and suspected he wanted to use my image to disparage my father in some way. From then on, I was constantly hiding my name to avoid incidents like that one, and it had the effect of reducing my freedom.

When I returned to Spain after almost four years studying education and film in New York, something had shifted, perhaps thanks to the many different kinds of experiences I had had with the arts. Intrigued, my mother asked me why I was no longer ashamed of my name. It was not long after that that Pili, in a crafty fashion, managed to get a film project about my dad sent my way. Rather than ask me outright, she figured out how to have a production company get in touch with me. I was flattered, since it was a professional proposal and I could not say no. Later I learned the whole story.

### Pedro Txillida Belzunce, My Oldest Brother

Looking at that old photograph, I can still see myself that day enveloped by the silence of the snowy city, walking to *Peine del viento* with my father's Leica hanging around my neck. I happened upon my two artist brothers, Pedro and Eduardo, and my dad playing; they were

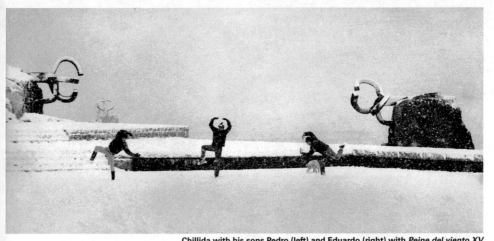

Chillida with his sons Pedro (left) and Eduardo (right) with *Peine del viento XV* (Comb of the Wind XV, 1976) in the background, 1984

assuming postures that imitated the forms of the sculptures. I found my position, clicked the shutter, and took this photo that I later developed. Now, I think of them.

Pedro and I shared an apartment in Madrid—we went to college back before the University of the Basque Country had been established. He was studying geography and history. He had always been a big reader; he liked to write and to share everything he knew. But art already had a pull on him. He was most interested in painting, and he pursued it—perhaps to do what grandfather Pedro had always dreamed of. I was at his side when he painted his first works in that small apartment we shared as students.

What a blessing it would have been to write this book, or parts of it, with Pedro by my side. I sometimes see in myself his desire to be part of, and also not be part of, our family, to be able to step in and out at will. As a teenager, when the family would go for walks along the bay, he would stay either a few steps in front or behind the group. In that, the two of us were different. I loved walking next to my father and coordinating my steps with his. I was always able to feel independent and free inside. That seems to have held true for him, the oldest of the boys, as well. For his whole life, he has kept some distance from the

Susana Chillida, Collage of solarized photographs, 1984

family pack, but also been right there whenever necessary. Like all families, ours has its points of light and of darkness. Maybe that's why he altered his last name a little to sign his works.

When Pedro returned to San Sebastián, he became much closer with our father. Whenever Chillida had to write something, he would call Pedro and they would work on the idea together. My brother would say that, in the end, our father's approach to text was the same as to sculpture: trim and trim until you are left with the essence. Pedro considered our father someone who took time to mull everything over.

Two more photos taken on that same snowy day show an athletic and playful Chillida. As a photographer just getting her start, I had trouble capturing the texture of the snow when it came time to make the print. That's why I used a simple solarization process to highlight what most interested me: the sense of movement when my father threw a punch and Edu, my youngest brother, dodged it while Pedro laughed at them.

## Looking for Common Ground: *Homenajes*

In a sense, all the work I have been doing about our parents is an homage to them, a celebration of both their lives and their love of art. My father often made works in honor of artists and others he admired: he titled them *Homenajes* (Homages). His main goal was to find common ground between the work of the one being honored and his own production—a self-imposed challenge he enjoyed tackling. When he collaborated with poets, artists, and thinkers, illustrating their work in collector's editions, his aim was the same. Most of the time, but not always, the approach that was needed came to him quickly.

In making my films, I also looked for common ground with my dad. To start with, I was determined to be as authentic in my art as he was in his. To that end, I needed specific images that would represent the two of us—I would have been satisfied with nothing else. I found those images in nature: the ocean, the waves, the rising sun, the moon, the horizon, the mountains, and the open air, as well as special places we had experienced together, like the beach at night. It was in those settings that I felt his spirituality and discovered the extent to which my own was enmeshed in it. I can see the two of us one night when he kept me company as I tried to record the sound of the waves. I had to do some tests that entailed holding the microphone as close to the water as possible, and he was game. There was a little danger at times, and we got a bit wet, but we had so much fun! Nothing that did not resonate deep within me was included in my films—and that ethic is our common ground.

Hanging in my parents' bedroom, set between two small windows that opened up onto the Cantabrian horizon, was the sculpture *Estudio para el Homenaje a Calder* (Study for Homage to Calder, 1979). The work, the size of a hand, was held up by a barely visible piece of fishing line. If you touched it—and everyone wanted to—it would rotate gently and show all its sides. The room was starkly white, and there was no other furniture besides the bed.

Eventually the full-size sculpture *Homenaje a Calder* (Homage to Calder) was produced in 1979. Despite its enormous weight, the

sculpture, like its model, rotates when touched. It is, then, a mobile—a favorite medium of the friend my father honors. That is the point of connection. In Calder's mobile sculptures, the pieces move in relation to one another, whereas in Chillida's, the entire piece moves so that the viewer can see it in its entirety, from all sides.

*Homenaje a Miró* (Homage to Miró, 1985) may have been the tribute that my father had the most trouble conceptualizing. Hard though he tried, he could not find the common ground between his production and Miró's. I remember him telling my husband and me one summer about how he was struggling with it. He didn't understand what the problem was until he once again looked closely at Miró's work and discovered something: his friend's curves were convex and his, concave. My father knew, of course, that all curves are both concave and convex, but—as he explained to us that day—the strength of Miró's work lay in how it expanded outward, whereas the strength of his lay in how it embraced and enfolded.

For *Homenaje a Braque* (Homage to Braque, 1990), my father considered leaving a simple space in the center of the sculpture. He wanted to lighten the material to emulate Braque's birds. But something unexpected happened during the production process—and that was by no means unusual. Indeed, so that he could freely include in a work whatever chance might bring about, my father liked to be present for all phases of fabrication. While the forge workers were preparing the block of steel that my father was going to work with, he noticed that in the lower portion something was taking shape that reminded him of the legs of a bird resting on the ground. He preserved that unexpected shape and included it in the final work. My father would call such things that appeared unplanned during the process "gifts."

I know a good deal about those "gifts"; I received a number of them during the making of my two films about my father. I think, for example, of the recordings of my parents in Paris. They show us a young Chillida taking everything in, enveloped in the sounds of people and police whistles as he sails down the Seine on a barge.

Eduardo and Pilar in their bedroom with *Estudio para el Homenaje a Calder* (Study for Homage to Calder, 1979), Intzenea, 1984

Mari Tere, one of Pili's sisters, had gone to visit them for a few days with her husband, Quico Letamendía, who filmed them. My cousins gave me those recordings when they found out I was making a documentary about my dad.

### Adventures with Pili, the Art Patron

The rising sun, the way its light hits things, tells me once again that art is truth. Half of the painting hanging in my bedroom is sheathed in darkness, the other half bathed in light. The work is by Carlos Añíbarro, a Donostiarra painter my parents knew. He lived in dire

Chillida in Larrañaga's studio with *Homenaje a Calder* (Homage to Calder, 1979), 1979

poverty, supported by a family that ran a bar in San Sebastián's Old Town. They would provide him with food, shelter, and drink—something essential to him—in exchange for paintings. Green is a prominent presence in his intense palette. His stylized figures are rendered with a remarkably free and bold hand. On one occasion Pili saw an exhibition of his paintings in the choir of the Iglesia de Santa María and, that same day, she decided to help him with his art career. My mother entered his life like a gale, unleashing all her might on a new project, without anyone having called her to do it.

What did my father think of the strange relationship Pili developed with that painter? For a few years, Añíbarro was around the house a lot, sharing meals with us. Pili had made herself entirely available to him: she took him and his materials everywhere, encouraging him to paint, especially outdoors. In the morning, she would pick him up in the car and drive him wherever he wanted. If Añíbarro wanted to go up a mountain, my mother would take him there and wait patiently until he decided exactly what it was he wanted to paint. My mother would tell us how he would walk around the setting, paintbrush in hand—he would even give it the occasional suck—until he decided on a spot. Once he had made up his mind, she would set up his easel and all his supplies, though he would often have a change of heart and the process would start over again. But Pili did not care. She had complete faith in him. What an odd pair they made!

At some point we learned that, when he was young, Añíbarro had been infatuated with our mother. Now that they had reconnected, he asked if he could paint her portrait (my sister María now has it). "How should I pose?" Pili had asked. "Just stand as you always have." "And how is that?" "With your hands on your hips."

Some days, Añíbarro would call in the morning to say he had a cough, which in his language meant he had a terrible hangover. When he was up to it, he would paint in remote places, as well as at friends' houses, the Molino de los Vados, and Villa Paz. We loved having him around. There is no question that my painter brothers, and Pili, too, learned a lot from him.

Carlos Añíbarro painting a portrait of his patron Pilar Belzunce, ca. 1978

One fine day, my mother thought the time had come for him to have a show. She got in touch with a gallerist from San Sebastián and the conversation got underway. "How much for this painting?" Pili would ask. "Three million pesetas," Añíbarro would say. "And this one?" "Fifty million." It was hard to make him see that no matter how much his paintings were worth to him and to us, it is the market that sets the price, and that price is directly related to prior exhibitions and sales.

When he finally understood that, everything went smoothly. But things going smoothly was not what Añíbarro was interested in. Unfortunately, he did not make Pili understand that soon enough or clearly enough. My mother convinced him to open a bank account with the money he had made from his painting sales. He sold more and more paintings, had more and more exhibitions, and put more and more money in the bank. Pili encouraged him to buy a house; she found him a nice garret apartment in the Old Town. Everything was set, and the day came to close the sale. The owner of the apartment

and my mother waited for Añíbarro for a long time, but he did not show up. He must have had a "bad cough." My mother signed for him and made the down payment. When, quite angry, she called him and told him what she had had to do for him, obviously expecting him to step up and take care of things as they had agreed, he came back with, "You like the place, don't you? Do you want it? No? Well, I don't either!" And that was the sad end of their friendship. My mother was not one to hold grudges—she proved that to be true with other incidents even more serious than this one. Had there been enough time, they might have made up. But he died before she was ready to take that step.

Añíbarro, whom I would meet up with as a friend in the Old Town, also painted my portrait. I thought I looked so old in it that I didn't want to keep it. Pili agreed with me, though I imagine its painter was not amused. I wonder where that work ended up, and who is looking at me, most likely not knowing it is me. All I have left of it is a photo of my mother holding the painting up from behind, before letting it go.

### Another Look at Pili: A Woman of Action

I find myself thinking about Pili as I settle into my hotel room in New York, the city where I have felt most complete and happy. Had I not sensed, when I finished my dissertation, that my parents needed me, I would have stayed on here with my husband and two children. When I told Pili as much, something unprecedented happened. For the first time in her life, my mother did not encourage me to follow my dream. I went home.

Now, buried under so much junk in my luggage, I sense my mother looking at me lovingly as I stumble. I am sure she even casts an adoring eye on my laziness. I never wanted to be exactly like her, but I do long for her qualities. I wish I had learned more from her. As kids, we would go with her on errands. She would double-park and leave us in the car while she popped into a store for something, or went to the bank or the post office, the shoemaker's or the customs

office . . . Her life seemed so tedious to me; I thought she *liked* taking care of all that—how innocent I was!

I photograph the imperceptibly flowing Hudson River, its surface twinkling with the city's lights. I wonder what she would have been thinking all the times she and my father stayed in a hotel far from home. I confess that it occurs to me that she didn't really think about any of it at all. I can see her in my mind's eye arranging their clothes in the closet and making the room look nice; I see her making and receiving calls, cheering Eduardo on before an important appointment, or dressing up to go out with him. But I cannot imagine her *thinking* about how to spruce herself up, how to cheer Eduardo on, or how to tidy the room. Pili was unquestionably a woman of action. And yet, she must have had her moments of sadness or even of guilt at having left her children behind, and not always in the most qualified of hands.

My father's death or, rather, my mother's behavior after it, led me to a series of startling discoveries about her. Our mother was a veritable poster child of the "strong woman," and she kept that up, undoubtedly for the sake of cognitive coherence. She would often say that Eduardo needed her more than we did, and that might have been true. But who thought about what *she* needed or wanted? Her calm tenderness toward her grandson Migui, the pleasure she took in spending time with him after our father was no longer around, brought home to me how much she had sacrificed over the course of her life. I now understand that if Pili had stayed home with her kids, Eduardo might not have spent so much time away, even if she had asked him to. He would not have had so many exhibitions or attended all those openings. And that means his career would not have been what it was—after all, showing up is crucial to an artist's career. And I know it occurred to her that if she had not gone along to all those openings, another woman might have caught the great sculptor's eye. And what would that have meant for her and her eight children, left without a father?

Today I realize everything Pili and I have in common simply because we are women. I can still remember the day I spotted my

mother's muddy nails under her everlasting pink nail polish bought in Paris. I was small and felt somewhat disappointed. With those same hands that my mother did her gardening, she would show off her rings, comb our hair, sand the rust off chairs, make appointments on the telephone, sign checks, and also—on one occasion—hit my unruly older brothers with a belt. Her voice would crack when she got angry—it verged on frightening. Thanks god it was very rarely.

Pili never aspired to perfection. She was a bit chaotic, even sloppy at times. Bold and gutsy. And quick. Life was always pushing her on to the next thing. The multimedia artist Antoni Muntadas, whom I met in New York, told me a story. It was the day of the inauguration of my father's sculpture *Topos V* (1985) at the Plaça del Rei in Barcelona, and Muntadas was one of the people there with my parents. When they arrived, they were horrified to see some graffiti and a puddle of urine on the work's steel surface. No one was sure what to do—there was really no time! My mother walked away from the others and soon came back equipped with cleaning supplies that someone at a nearby bar had loaned her. To everyone's surprise, she got right down to it, skillfully cleaning the sculpture. She was like that. More about doing than about talking or thinking.

A thousand memories come pouring in as I keep photographing the bright downtown lights. I see the reflection of "my Eduardo" in the window as he mixes a few gin and tonics from the minibar. How different our working life is from my parents'—theirs laden with social and professional commitments, ours marked by relative freedom.

I can say with certainty, due to the various openings I attended with them, how physically exhausting those trips were. Any international artist knows as much. Everyone showering you with attention and praise—even that is tiring. Someone would pick them up at the airport and take them to the hotel; they would barely have time to drop off their things and take a shower before someone came back to get them for an activity. In addition to press interviews and the openings themselves, there were always enticing invitations that they would rarely decline: a private viewing of an interesting show with the

director of a local museum, a visit to a church outside the city with spectacular frescoes, and so on. I am certain that Pili and Eduardo deeply enjoyed seeing wonderful works of art together and meeting people with whom they shared interests. It was all very stimulating. But I'm also not surprised that their stays were always as short as possible. The longer they stayed, the more tempting invitations, flattery, conversations, and dinners came their way. For Chillida, the studio waiting at home was the place he found peace. For Pili, though, there was no reprieve from the daily battles of running a household, managing a major artist's career, and essentially holding our entire shared world together.

### Preserving History: My *Abuelis* Juanatxo's Hotel Niza

Speaking of hotels, I cannot fail to return to the two that my father's grandmother opened in San Sebastián in the early twentieth century. When Juanatxo died in the late 1960s, Eduardo let Pili handle every-thing with the estate. She and the other heirs agreed that the largest of the two, Hotel Biarritz, would remain in the hands of my father's cousins, the Juanteguis, and Hotel Niza in the hands of the Chillidas (meaning Eduardo and Gonzalo, his painter brother). In 1971, Pili bought out Gonzalo and divided up the property between the eight of us kids as well as Eduardo and herself. She must have taken out a loan.

My mother's way of loving her children was different from other mothers. She was not prone to snuggling or physical contact. She showed her love through acts both large and small that anticipated our needs, and she made it seem that these things just happened in the natural course of events. In 1979, my sister María announced she was going to marry her boyfriend, Alberto Essery; they had both been working at the hotel for over a year. Since my mother thought he was up to the task, she offered Alberto the job of hotel manager, which he performed successfully up until the day he retired. María, working behind the scenes and without a salary, saw to—and still sees to—the maintenance, renovations, and general upkeep of an old hotel. Not

an easy task. Thanks to all those people—my *abuelis* Juana Eguren, my mother, María, and Alberto—my husband and I, like the rest of my siblings and their spouses, have been free to lead our lives as we see fit since the time we were young. We have never had to swallow our pride to ask for anything or endure undue hardship.

# A Turning Point

### The Death of Aimé Maeght

The more I learn about the work of Aimé and Marguerite Maeght, the more I understand how important they were to the history of contemporary art in the twentieth century. They were likewise essential to the rise of the figure of Chillida, who started this decade with a big retrospective exhibition at the Solomon R. Guggenheim Museum of New York.

Aimé's death in 1981 brought with it many changes. The Galerie Maeght was divided in two. On one side, Daniel Lelong and Jacques Dupin, the artistic directors who had worked at the gallery during Aimé's lifetime, stayed on for a spell, running the venture as Galerie Maeght-Lelong; on the other, Adrien Maeght, Aimé and Marguerite's son who had always championed a different type of artistic production, carried on under the name Galerie Maeght. The ceramist Hans Spinner moved his studio to Grasse, a town not far from Saint-Paul-de-Vence, and our father continued to spend his summers working with him there.

My mother, who for many years had seen to Chillida's career on her own, now had a team of helpers, like her daughters-in-law Mamen and Cristina, alternately, and her son-in-law Gonzalo, my eldest sister's husband. He was a financial economist, as befitted the education he had received in his family. My mother made Gonzalo her representative and right-hand man—a role he would play until the end. With the support of her team, Pili felt free, after Aimé's death, to work with more than one gallery. She was able to choose without any restrictions which venue was best for each occasion.

My parents' relationship with Lelong—who after Aimé's death joined a branch of the Galerie Maeght in Switzerland, directed by Elisabeth Kubler—continued for years. First as Galerie Maeght-Lelong, and later as Galerie Lelong. But Chillida eventually began

working with other galleries as well. He received proposals for shows around Europe and beyond. My mother and Gonzalo would assess each offer, and Meyer-Ellinger, Beyeler, Forsblom, Tasende, Carandente, Sidney Janis, Elvira González, and Nieves Fernández were among the ones selected. The Chillida team had direct dealings with a good many museums, like the Kröller-Müller in the Netherlands and institutions in Münster and Yorkshire. They developed relationships with curators like Andrew Dempsey and Kosme de Barañano, and with collectors like Plácido Arango, Jacques Hachuel, Rolph Becker, Frank Ribelin, and a great many others whose names I do not know.

Despite these new adventures, Pili and Eduardo would greatly miss those summers at the Fondation Maeght and the chance to work with fellow artists represented by the gallery, to say nothing of the dinners, conversations, and parties with other eminent artists, thinkers, poets, and musicians.

### Hans Spinner and the Joy of Living: Mas-de-la-Tourlac

A new summer tradition arrived for my parents, and also the rest of our family, when Hans Spinner moved his ceramics studio from the Fondation Maeght in Saint-Paul-de-Vence to Grasse. Lelong bought a house, Mas-de-la-Tourlac, where the gallery's artists could continue working during summers, and Hans, with his own hands, undertook the renovations needed to turn the place into a home and studio. My father was overjoyed that his relationship with his "German brother" could continue uninterrupted, as was Pili, who not only relaxed during those summer visits but also enjoyed watching Eduardo work. She would paint some corners of the house and even make a few ceramic male and female torsos—we still have some of those works, testaments to our mother's artistic sensibility.

While I speak for myself and my own experience, I am quite certain that my siblings would agree that the home Hans and his charming wife, Noëlle, had made was a gathering place where everyone felt welcome. The energy was contagious! We were met with open arms there not only during summers with our parents but at any other time

Pilar working in the ceramic studio in Saint-Paul-de-Vence, France, 1976

Hans Spinner and Chillida in Saint-Paul-de-Vence, France, 1979

of year as well. Etched in my memory is Noëlle, at mealtimes, going out to pick the herbs that grew everywhere in Provence and adding them to the salads that she would dress with wine to the delight of my mother, my father, Hans, and everyone else. Seeing Pili and Eduardo tipsy and enveloped in the music, often opera, that Hans would serve as dessert was lovely. We all laughed; sometimes we would dance. Each of us who passed through Mas-de-la-Tourlac, sometimes en route to another destination, was a bit different from their regular self during those days with them. They were healthy and joyful company. Later, my parents would gift Hans and Noëlle a number of works so that they could raise funds to buy that house where we had all been so happy.

And, speaking of couples, Guiguite, Aimé Maeght's wife—the woman who was so kind when she met Bonnard, who was in dire need of some slippers—deserves another mention. Not long ago, I found out that she learned at some point that her husband had had a daughter with his mistress. Guiguite not only took the initiative to meet the child but would often visit her. And, in 1973, Aimé recognized her legally with his wife's blessing—yet another act that, in my eyes, proves her humanity and generosity of spirit.

### Intzenea

Life in San Sebastián went on as predictably and orderly as ever, until, out of nowhere, my parents left Villa Paz in 1982 to move to a house located on a piece of land above *Peine del viento* (Comb of the Wind). A realtor friend of Pili's had been insisting that they see a house that, she said, was perfect for them. My mother finally agreed. She was so enthralled that the very next day she took my father there. As soon as they opened the gates to drive up to the house and Eduardo saw the view of the sea, the city, and the mountains, he asked Pili, "Can we swing it?" And so it was meant to be. It's amusing to remember what my father did with a few pieces of paper he found hanging from a nail next to the toilet in the bathroom on the upper level, where the domestic helpers had lived until my parents moved in. My father loved the paper's texture; he did not hesitate to tear the sheets from the nail

and keep them. They would later be used for many of his drawings of hands—hence the unusual cut-off corner in so many of those works. *Esku*, hand; *eskuak*, hands.

That house was enormous. My mother divided it up to make room for the first apartments of two of her married children, Pedro and María, and there was still space left over for the three of us who still lived with them as well as to host guests. Later, when the youngest, Eduardo, got married, she also made room for his family to move in. Pili was unquestionably an artist with space, a master at changing it to meet many different needs. And the architect Joaquín Montero made a good ally. He was the one we would also work with to change my dad's old studio into mine and my husband's first home.

Intzenea, which means "place of dew" in Euskera, was named for the *caserío* where our *abuelis* Juanatxo was born. For all of us, that home meant a constant relationship with the sea. From Intzenea, we could make out not only the entire Bay of La Concha but also the wide sea horizon, with nothing blocking the view. Looking at the sea, asking himself about it, had, since the time he was small, forged so many of Chillida's ideas about space, time, and form. And from Intzenea he continued to examine it. "The sea is my teacher," he would say. "We can never know enough; in the known, we discover the unknown," he wrote.

*Esku* (Hand, 1984)

## A Twenty-Year-Old Baby

The move to Intzenea came with a serious blow: my youngest brother Eduardo's first serious motorcycle accident, which was followed, the next year, by another accident, that one even more serious. All of our lives were put on hold for months.

It happened in the Ondarreta tunnel when my brother was on his way to buy paint. My brother-in-law Alberto saw that there had been an accident. He recognized the motorcycle. Everyone at the scene took Eduardo for dead, but Alberto insisted that they take him to the Red Cross, which was close by. The family was called. My parents were not in San Sebastián. María and Pedro had to decide whether to have Eduardo transferred to a hospital for a brain scan. Moving him was dangerous, but necessary. I can still see myself sitting in the emergency room holding my brother's helmet in my hands during those agonizing minutes before they told us he was in a coma. Dark thoughts crossed my mind as I remembered that our father, as a young man, had had to identify the body of his younger brother.

Pili turned into the very image of mother courage. She would disregard the hospital rules as a matter of course. When nobody was looking, she would open the window that separated her from her son in the ICU and tell him what had happened; she would take his hand and keep his spirits up. My brother's body remained inert for a month; he lost so much weight he was little more than a feather. We all clung to hope, despite all the odds. We would gather in the waiting room every day, as if our presence in that place, and our faith, could make a difference. If we had let ourselves be guided by reason, we would have given up. But we did not. "Of death, reason tells me, it's final. Of reason, reason tells me, it's limited," wrote Chillida.

Our father changed his routine during that month. Distracted, he would come and go from the house to the clinic, from his studio to the Iglesia de Santa María, yet nevertheless with his characteristic calm and constancy. When they told us that Edu had finally opened his eyes, though still in coma vigil, I saw my father go through an utter transformation. I know I tend to exaggerate, but I remember

how our dad's eyes, which had been staring out blindly, filled with light. My feeling was that his feet lifted off the carpet—he seemed to be levitating.

My parents called their friend Alberto Portera, an eminent neurologist and surgeon who had gone through something similar with his own son. He immediately came to San Sebastián. That call turned out to be our salvation. He told us that the hospital could no longer do anything for Edu because they did not think he would recover. They believed he would remain in a vegetative state. We saw how he would communicate with us with his eyes and the slight grin he would muster to greet us before falling back into his abyss. Dr. Portera did a few tests that confirmed what we had detected. He understood the importance of emotional stimulation. He told us about the small daily acts that could help our brother and recommended that my mother take him home as soon as he no longer had a fever.

Pili did not even bother to put the thermometer under cold tap water but simply drove her son to Intzenea, taking full responsibility for the consequences. She had a corner terrace closed off with glass and turned it into light-filled hospital room. (It would later be used for other purposes, as the needs of those who lived in the house changed.)

Witnessing my brother Edu's long recovery was, for all of us, like witnessing a miracle. He had lost control of his body and the ability to speak. He had to go through all the developmental stages that a baby goes through, from being able to hold up his head and control his sphincter to regaining language through lullabies that gradually awakened his lost memory. My mother was a wonder with that twenty-year-old baby who got a little better every day. As soon as it seemed possible, she pushed a wheelchair in front of a canvas and tied his right arm, which was spastic and supposedly unusable for life, to his back. She then put a paintbrush in his left hand. Looking at the life going on outside the window, my brother painted the Ondarreta tunnel where he had nearly been killed. He was born an artist.

### The First Sculpture by My Brother, Eduardo Chillida Belzunce

The text that my brother Edu sent me is titled "Two Fond Memories of *Ama* and *Aita*." The first is of our father.

One of my first childhood memories is from when I was about five years old. I was, as usual, playing around and exploring the yard at Villa Paz, when I suddenly decided to do something different with my day, something that, though I did not know it at the time, might well have ushered in my passion for sculpture.

We were very respectful of *Aita*'s studio and would rarely stop by when he was working. But that day I stood beneath his window and started tossing pebbles at it so that he would open up; I wanted to ask him for a little piece of clay to make a sculpture. *Aita* came over and asked me what I was up to. He found my request amusing and threw a few pieces of terracotta through the window. His idea was probably to keep me entertained with something other than chasing lizards or one of my older brothers. He leaned out the window a few more times over the course of that day to see what I was making. Then he came outside. I don't remember his exact

Eduardo Chillida Belzunce, *Ama sentada*
(Mother Seated, 1969)

words, but I do remember that he liked what he saw. He let me know as much, without giving me any advice.

By that time, even though I did not realize it—I was still so small—I was feeling the call of art in my guts (that was how *Aita* put it). I made a female figure—*Ama*, of course—sitting in a chair in a position typical of her, that is, with her hands behind her head.

So that was how, without a second thought, I made my first sculpture. *Aita* kept it close at hand until my wedding day, when he decided—undoubtedly due to a romantic notion—that the time had come for it to live with my wife Susana and me.

Once in the twenty-two years that *Aita* kept that sculpture of mine alongside his own small-format works—mostly projects for large-scale sculptures—Joan Miró came for a visit. Apparently, my small figure captured Miró's attention, and he asked my father about it. "Who made that sculpture?" Miró asked my father with admiration. Laughing, *Aita* replied, "That one is by my youngest, Edu!" My father may not have considered the work important, but he did enjoy looking at it every day for years.

### Júliet's Loving Care

Júliet was our father's pet name for Pili. My brother Edu remembers how she took care of him after his terrible accident.

My *Ama*, who my father referred to as his Júliet, was entirely dedicated for a time to helping me get out of the terrible situation I found myself in (she had my father's blessing, of course). It is heartwarming to know that, according to her, every morning she would come up to the room she had set up in the house for my recovery. She would shower me in her amazing optimism and infectious strength—those are my words, she would never say such a thing about herself. She would make me get up and sit down countless times, and perform other exercises every single day without exception. With her innate wisdom and charm, she took me to three physical therapists without telling a single one

about the other two. That was not only good for my progress but also a way to make sure that all three were overjoyed and motivated by how quickly I was improving. Each one thought he was solely responsible for my impressive progress.

And I laugh when Luis reminds me that *Ama* would feed me a big steak every day—just for me, to help me regain muscle mass and weight. My siblings would have fish—they were green with envy!

I realize that these two memories, one of *Aita* and one of *Ama*, are connected. They are both about important beginnings that marked a turning point for me. Both of my parents were essential to who I am. It was thanks to *Aita* that I got my start in art so early on, and it was thanks to *Ama* that I kept my strength and hope up for my second life, my life after the accident.

### From Mother Courage to Team Player

The role of mother courage that Pili took on after Edu's accident fit perfectly with the *Ama* we all knew. But as Edu recovered, she understood that she had to take some distance. I personally admire her ability to delegate when necessary. She detected that she was being overprotective and that that was not good for anyone. It was not easy for her to do, but she let Edu go to Madrid with our brother Luis to spend some time with his friends from the university, who filled him with life and good cheer. Then, after a disheartening visit with a doctor in New York, she left him with me in the big city. I would study, my husband would write, and Edu would paint. We accompanied him to the Metropolitan Museum of Art a number of times, and then we encouraged him to cross Central Park to visit his "friends" (Van Gogh, for instance) by himself. He would come back full of energy. I introduced him to a painter friend of mine who had been a dancer, and he took Edu to the Art Students League, where the two of them would paint. I still remember the look of amazement on his face when I first asked him to take a photo of me with a very simple camera I had bought for that purpose. My husband and I treated him as perfectly self-capable, and—bolstered by our confidence in him—Eduardo acquired many skills that have served him well his whole life.

Today, my brother Eduardo, who signs Chillida Belzunce, is a great painter; nothing could matter less than which hand he paints with or why. My father, who admired his work, would spend a lot of time with his son. His story of rebirth is inspiring, and I have used it as an example in teaching on more than one occasion. Edu has formed a large family. My brother and his wife, Susana Álvarez, are happy; she works with him on all his projects and was a strong supporter when he decided to go back to working in sculpture—his first passion.

### Embedding Space in Matter

"How profound is the air" is a line our father took from the writings of Jorge Guillén. Indeed, that phrase was the title Chillida chose for a series of works in pink Indian granite that he began in 1983. When quarrying this stone in India, they place small wooden chocks in the cracks that appear naturally in the granite; the wood then expands and the cracks broaden. In this way, the rock is broken up like an apple that has been split by hand. Indeed, what attracted my father to that sort of granite was its natural texture. He would then "embed space" into the granite mass—it could weigh as much as five tons—by means of clean and deep cuts. The appearance of this material varies greatly according to how one works with it. Not only the texture but also the colors within the granite—which are particularly visible on smooth sections, and even more so when wet—transform according to how it's cut, chiseled, and polished.

My father liked bringing to light what is normally hidden, and in looking at these works I find myself particularly aware of what is hidden in the ground under our feet. The series *Lo profundo es el aire* (How Profound Is the Air, 1983–98) helped him to think about the interior space of his controversial project at Tindaya Mountain in the Canary Islands. It helped me address issues of perception, scale, and imagination with schoolchildren during the first educational program at Chillida Leku. Kids would identify with a small human figure—a doll—that I would put inside one of those pockets in the granite, and they'd quickly get a sense of how the work looked "from

inside." It was an easy trick to teach them how to look. The kids would notice that if the doll was larger, the space seemed smaller, and vice versa. I can say with confidence that in their imaginations they were each able to explore the granite forms from the space Chillida had embedded in the material. And that is a good way to look at all of my father's art.

*Lo profundo es el aire XVIII* (How Profound Is the Air XVIII, 1998)

### "Pili, you'll never believe what I've made": *Gravitaciones*

"*Aitona* only uses black and white, right?" my son Adi observed once when we left his grandfather's studio (he was only six years old). The floor was covered with *Gravitaciones* (Gravitations, 1985–2000), works on paper both large and small, that were heading for an upcoming show. "That's right," I said. "I know why," my son shot back. "Because that's enough."

Adi does not remember that, but I will never forget it.

The story of how, in 1985, Chillida started making *Gravitaciones* never ceases to interest me. By then, he had been awarded a great many prizes: the Kaiserring prize in Germany that same year, as well as the Grand prix national des Arts et des Lettres in France, and the Prix Europe pour les beaux-arts à Strasbourg in the two previous years— just to mention a few.

His graphic work dates back to 1959, early in his career. Following what he described as the "aroma" of the work—a sort of "pre-intuition"— he understood from the beginning that all he needed were two colors, black and white. Only once, in his collages, did Chillida experiment with pieces of beige paper with textures that stood out, as starkly as the color black, against the lighter background. While he liked making collages, he did not like the sticky glue he had to use to join the papers.

One day he went to the studio and, when he turned on the circuit breaker, the heater and the music turned on as well (with these fired up, he would get ready to get down to work). In just the same way—in a flash of energy and creativity—Chillida also received a new inspiration. No one will ever know what exactly lit that spark—maybe it was a piece of string my mother had used the day before to wrap up something they had to send somewhere—but with a bit of string, paper, and scissors, Chillida improvised a collage with no glue. And so the first *Gravitación* came into being.

When he came home, he was excited. "Pili, you'll never believe what I've made. It's a drawing, but I did not use a pencil; it's a collage, but it has no glue!" Knowing my mother, I'm sure she ventured a thousand guesses before giving up. After lunch, Eduardo took her with him to the studio—he worked every afternoon as well as every morning—and

showed her his "invention." He pointed out the scissors, the paper, and the string he had used. Pili was enchanted. What she saw was not only a drawing and a collage but also a sculpture. Indeed, that holds true for all *Gravitaciones*, since a third dimension is at play in the paper reliefs. Many of them are white, and only white.

My father was a poet of space. What most excited him about the *Gravitaciones* series was that, with these works, he was able to place space between the sheets of paper, which he would then tie up. He enjoyed making these smaller-scale works, where space replaced the glue he had used for his collages. For Chillida, making them was like playing chamber music on his own as opposed to conducting symphonies in his studio with his two or three assistants or with the large orchestra of operators in the industrial forges. At the end of one summer when my husband and I were heading back to New York, where we would see the Waintrob brothers, my father gave us his most recent *Gravitación* as a gift for them. He wrapped it up himself. The old photographers were overjoyed when they had the work in their hands. Another Chillida invention!

Sidney and Budd Waintrob considered my father *el número uno*—as they would say in Spanish, with heavy North American accents (it was charming). At least once a week, my husband and I would have a meal with them at the Metropolitan Museum after seeing a show. On one of those outings, we told them that filmmaker Larry Boulting had just made a movie about Chillida. We walked over to the museum shop to see if they had it, and ended up watching the whole film on a monitor set up in the store. Both nearing ninety years old, and they stood there for an hour, barely blinking! Art for them, like for my father, was their whole life and their dream.

Years later, I asked my father if he would let me film his hands cutting pieces of paper and tying them together on his large white table. I wanted to show his most intimate space and share the peace he felt in it. Seeing him calmly make the *Gravitaciones* was truly moving.

After this scene, we see him sitting in a chair looking at the various *Gravitaciones* tacked to the wall. His fingers are interlocked and his hands rest behind his head. I recently discovered that that hand posture

*Gravitación* (Gravitation, 1993)

*Gravitación* (Gravitation, 1993)

*Gravitación* (Gravitation, 1990)

**176**

is a mudra that represents enthusiasm; whether or not Chillida was aware of this connection, it is safe to say he received all the energy he needed throughout his career.

### Freedom to See and Feel

I am now looking at another simple *Gravitación* that happened into my hands. Am I right to see in that black shape that Chillida put on the paper the small bird he had spoken to me about one day? Apparently, in his encounter with Brâncuşi in Paris, back when my father was still an art student, the sculptor had spoken of the peculiar vertical position from which mother birds feed their chicks—the type of subtle observation of an artist my father admired greatly. But it is not a bird. Or, rather, I'm sure my father did not intend me to see a bird in that black shape. But memories and feelings come flooding in. I do see the bird, and I can almost feel its hunger, its voracity.

I remember lying on the floor in my father's studio as a girl, listening to the music he would play for us. In music, you have no choice but to grope around in the dark, with no safety net or scaffolding. Music is there and not there at the same time. It cannot be seen. "Listen," my dad would tell us, "and then tell me what you see." I would close my eyes and the sea would come to me. Was it always the sea? In my memory, it is. And now I ask myself how many times I had that experience in my father's studio. Many? Or was once enough to engrave it in my memory? A number of drawings of my siblings listening to music in my dad's studio verify that those precious moments did in fact occur throughout our childhood and adolescence.

Ignacio remembers:

It was not uncommon back then, in the late '60s, for us kids to parade through *Aita*'s studio so he could draw us. Drawings of our torsos, backs, arms . . . It was my turn to model one day. When he got to my hands, my dad said, "Iñaki, let Pedro take over. Your hands are too slender." What a jerk—I had such pretty hands!

Like the true aesthete he was, our father saw that not all of us children had the qualities he needed in his models. That said, each of us had a chance to be his beloved subject at one time or another. "What children need is to be loved." And our father not only loved us, but let us know he did.

More memories. My father would often take us fossil hunting in the Urbasa mountains. It was so exciting to come across stones that were so much more than stones because their matrix held the life of other beings and the passage of time. And my father made us understand that. Once again, my father's statement rings true: "We see clearly with the eye full of what we're looking at." And, on the contrary, we learned that you can also look and see nothing at all.

"Take a nice long look at the titles of the books on the shelves and then I'll ask you to find one of them. Let's see who finds it first," my father would challenge us in a game of perception, not unlike the one his father had played with him and his brothers. Some of those titles—*La nuit grandissante*, *Letters of James Joyce*—still linger on in my memory. Art in all its forms was an abiding presence in our home.

### Bulwarks against Dejection: Ignacio and Pedro

Chillida was a tireless worker. He must have gone through periods of crisis and dejection, but he seems to have had sound strategies to keep them at bay.

I am thinking, for instance, of how he would work with his son Ignacio in his Hatz printing studio, adjacent to his own forge on the grounds of Villa Paz. The familial atmosphere was conducive to Chillida's well-being. Ignacio, donning blue coveralls, would amuse himself by spinning my father in the air to show his strength. Ignacio's wife, Mónica, was also her husband's assistant. They lived on the premises, so sometimes the little ones would come down to say hello to their *aitona*. That close relationship between father and son gave rise to countless high-quality prints that have been exhibited the world over.

**Portrait of Eduardo and Luis, 1968**

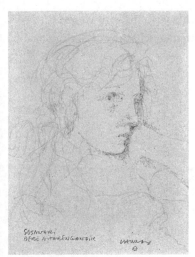

**Portrait of Susana, 1971**

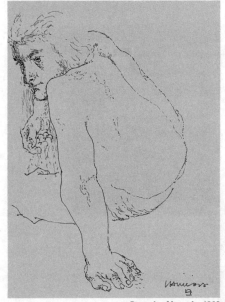

**Portrait of Ignacio, 1968**

179

My brother Pedro also had his painting studio in the same area. As he and my father lived at Intzenea, each morning they would go to work together. As soon as they arrived and greeted Ignacio, Pedro would continue on with Chillida to visit his studio and see what he was up to, before heading to his own space. Then, before going home for lunch, my father would visit Pedro's studio to see how his canvases were coming along. But things were not always easy. Apparently, my father wanted to show Pedro which parts of his paintings he considered second rate, and that bothered my brother. He needed the chance to learn from his own mistakes. Sometimes they would end up arguing, but they would also listen to music, share ideas, and discuss artistic questions that interested them both, just as they would on their frequent shared visits to museums.

I have no doubt that those intimate moments with his sons were important to Chillida and that they helped him deal with any crisis before it got too serious.

Chillida with his sons Ignacio (left) and Pedro (right) at the Hatz studio, San Sebastián, 1995

Something else that always calmed my father down was drawing. Indeed, he drew throughout his life.

**"In a line the world is united, by a line the world is divided"**
Horrified, I realize that in all my films about my father, as well as in my writings and even my conversations, I have referred to him as "Chillida," ignoring our familial tie. I wanted to keep a (false) distance for the sake of objectivity. This book is, among other things, a way to redeem myself and bring my father, with all his humanity, to life. I see his smiling face in a photo and I apologize for my misstep.

The only time I really delighted in calling him Chillida, and in introducing him as a great artist about whom I had made a documentary, was during an educational activity with a group of young adults in a Madrid prison. I tried to present him as the man he was, to foreground his thinking and life, without unveiling any family connection. My father considered the ability to draw essential to a visual artist. That is why, for the activity with this group, I began with Chillida's most accessible figurative drawings, to gradually and calmly work our way into his art's more complex facets. I wanted to make them understand that at play in Chillida's lines, which grew simpler over time, was not a lack of skill. On the contrary, they convey transcendence and that "gift of lightness" that the poet José Ángel Valente attributed to my father and all the other truly great artists in human history.

"In a line the world is united, by a line the world is divided, to draw is beautiful and terrible," my father wrote.

I showed the group photos of relatively unknown and early figurative drawings, images that experiment with shading, blurring, pointillism, and other techniques. We then turned to Chillida's more widely known drawings of hands. In some, my father, with a single stroke, would construct a total architecture of the hand, starting at the wrist. In others, the line of a finger vanishes into the folds of the palm, becoming lost among the undulations, as if they were mountains. In still others, the fingers dangle in an expressive and rich emptiness. My father's line drawings are simple and very realistic—therein lies their

Chillida with *Yunque de sueños XIII* (Anvil of Dreams XIII, 1962; left) and *Modulación del espacio I* (Modulation of Space I, 1963), 1960s

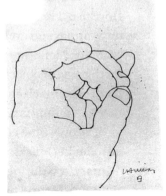

*Esku* (Hand, 1985)

virtue. On one of the first days I worked with the young people, I handed out a stack of laminated sheets with Chillida's drawings of hands. Written on one of them in my father's unique handwriting were the words, "This is the hand of your friend."

The hand is a very complex body part that my father engaged in his work in many ways, some of them rather unusual. He would often move his fingers into odd positions slowly and examine the resulting changes in space. Seen with his sculptor's eyes, his hands were universes useful for grappling with emptiness and form. Perhaps drawing them was also an active form of meditation, a sort of artistic and emotional warm-up. There is a relationship between those drawings of hands and his sculptures; though made of solid iron, the sculptures carry some of the lightness of the line on the page.

Since Chillida did not believe in artistic instruction, and as a result neither do I, most of my educational activities and exercises are geared at helping students understand what art is. I want them to delve into the artist figure and learn how to experience and look at the work, how to feel it—that, and not asking them to make something, is my priority.

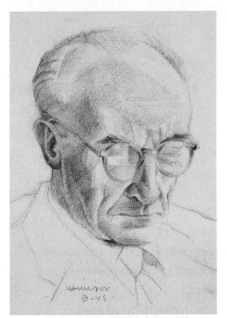

Portrait of Pedro Chillida, Chillida's father, 1945

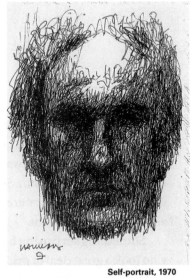

Self-portrait, 1970

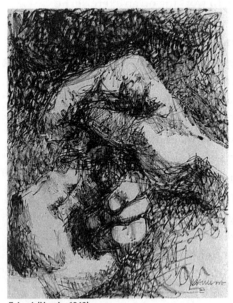

*Eskuak* (Hands, 1949)

183

*Esku* (Hand, 1985), rotated 90 degrees (left)
and in the correct orientation (right)

Recreating with one's own hand the position of the hand in one of Chillida's drawings, or examining the spaces created between the fingers and the palm, the way my father did—these are a means of communicating with him. Similarly, tracing each line of a drawing with one's finger as if it were a pencil is a way to get in touch with the artist's inner movement.

Something surprising happened with one group. A young man who took a great deal of pride in his drawing skill said he found Chillida's renderings very simple. In working on an exercise, he placed one of Chillida's hand drawings in the wrong position. When I saw it—proud daughter that I am—I was a bit annoyed; I placed it in the right position. The young man's response was immediate. "Oh, now I see! It's a hand for cupping water from a spring!"

Did this boy know that—in terms of art—more important than his skill at drawing was the sensitive perception he had just demonstrated? I'm sure my father would have liked that anecdote. If, from somewhere in the universe, he was watching, I know he would have laughed heartily about how I introduced the group to sculpture—and other art forms as well. From day one at the prison, we listened to classical music as we worked. The last day, I turned up the volume while a Schubert lied played. "Don't tell me that that is not beautiful," I exclaimed. "I don't know about beautiful," one of the kids said, "but it does put you at ease."

## The White Light of Menorca: Quatre Vents

Summertime, the *Lurras* (Earths), and the Mediterranean light—the origin of the Greek art Chillida so adored—were tightly bound for the artist. Indeed, he always made his *Lurras* on the French Riviera. The engineer José Antonio Fernández Ordoñez, a friend of my parents' who worked on some of my father's pieces, summered in Menorca, and it was thanks to him that my parents first visited the island in 1989. I imagine that Pili immediately began hatching a plan. She loved the sunshine and was adept at coaxing Eduardo to agree to her ideas. She suggested that he work on his *Lurras* there. Hans Spinner would take the chamotte clay to Menorca early in the summer and pick up the works at the end of the season to bake them in his kilns in Grasse. Pili had always given in to Eduardo's impulses and needs, and this time he gave in to hers. My mother traveled to the island to find the right place for them, and the next thing you know, they bought Quatre Vents, a large seafront house open to the four winds.

With the help of a number of my siblings and their spouses, Pili renovated the house so that all of us—children and grandchildren—could stay there. She also left a few spaces where our father could be by himself. One of those spaces was the "upstairs studio," where—as his poet friend Celaya used to say about the Villa Paz studio—he "engineered dreams" through the drawings and *Gravitaciones* that he tacked to the wall. The "downstairs studio," though it was really more of an "outdoor studio," was on a sunken terrace in the backyard. Under a lush fig tree, Pili had two concrete slabs put in as an L-shaped table where Eduardo could work on his *Lurras*.

Against all predictions, our father was happy in Menorca. He not only enjoyed working there but also began to love the sun and the dips he would take in the isolated open sea in front of the house. He could even be seen completely relaxed, book in hand, while floating in an inner tube in the round pool under two old olive trees. The white Mediterranean light did him good. He would take long walks—as was his habit—invite friends over on occasion, and, along with whichever members of the family happened to be around, follow the Olympic Games or any other

major sporting event. At sunset, he would often take us to the pre-historic taula and talaiot ruins; steeped in mystery, they can be found throughout the island amid stone walls and weeds. My father would often see his friend Fernández Ordoñez—in fact, he socialized more in Menorca than in San Sebastián. At Quatre Vents, like all the houses where they lived, my parents built a large, long, monastic wooden table with benches along either side (they were quite uncomfortable, actually, and more than one eminent dinner guest fell to the floor).

I remember one distant summer. Many of my siblings and their families had passed through the house that season. My husband and I liked overlapping with them for a few days and then staying on alone with my parents. We relished the intimacy, the calm, the conversations between artists, the walks—the simple pleasure of being together.

That summer, my father was struggling with a commission to illustrate Parmenides's poem *On Nature*, published as the artist's edition *Le poème*. That does not mean he was not enjoying the process. On the contrary, such challenges filled him with emotion and kept him alive. One morning, "my Eduardo" and I went over to the pool where, to no one's surprise, dad was floating on his enormous inner tube with the Parmenides book in hand. When he saw us, he put the book down and started telling us about some of his recent discoveries. The Chillida who was talking to us that morning was neither the famous sculptor nor the father but rather the young man who had been a seaman at prow in the regattas in San Sebastián, the one who knew how oars act in the water. "Look, by just moving my big toe I can change course." And we saw him maneuver his toes to steer the vessel— that is, the inner tube—on which he was floating. Happy as a lark.

The catalogue for the exhibition *Terres et Gravitations* (Earths and Gravitations), held at Galerie Lelong in Paris in 1995, includes a photo of my father with my eldest son alongside the *Gravitaciones* he had just made in the background. One of the catalogue texts was written by the poet Jacques Dupin and the other by Eduardo Iglesias, my husband. Pili asked my husband to write it. He was reluctant at first, but finally agreed. As a novelist, the approach he took was to come up with a short

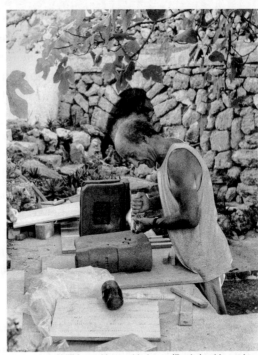

Chillida working on his *Lurras* (Earths) at his outdoor
studio in Menorca, 1996

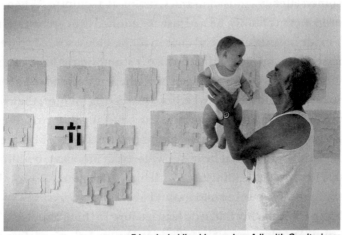

Eduardo, holding his grandson Adi, with *Gravitaciones*
(Gravitations) in the background, in Chillida's studio, Menorca, 1993

187

story. In it, a character shrinks down enough to be able to get between the sheets of paper in the *Gravitaciones* and the empty spaces in the *Lurras*. He called the story "Invitation au voyage : mouvement de l'imagination" (Invitation to a Journey of the Imagination in Motion), and my parents loved its simple depth. It was later also published in the original Spanish for a show in Burgos in 1996 organized by Nieves Fernández.

In my documentaries, the white Mediterranean light of Menorca paints a potent contrast with the black light of our Cantabrian Sea. The island is also a reminder that art has been essential to the human species since the beginning of time. For that reason, the first images in the film show Chillida at night, standing in silent contemplation as he takes in a prehistoric taula, astonished by the efforts his ancestors made to reach the unreachable.

### Between Pre-Socratic Artists

The relationship between my husband and my father was very deep. They shared not only a love of sports but also a knowledge of art, something my Eduardo got in part from his siblings. When we met, he was the only one of his siblings who was not an artist; Alberto blossomed later as a musician and Cristina as a sculptor. When Eduardo met my family, he had just abandoned the career his father, a self-made businessman, had chosen for his eldest son. My parents witnessed from up close Eduardo's early stumbling as he tried to find his way, and they encouraged him when he decided to become a writer. For my husband, my father was a caring mentor; they would converse often, and my mother and I loved seeing them together and, occasionally, we would take part in their conversations. My parents saw my husband for what he was: a wide-eyed, innocent, budding artist. They loved spending time with him. "The Eduardos get along swimmingly," my mother and I would often say.

From Chillida, my Eduardo learned how to think about art. That said, he did not let himself be influenced by my father's preferences (Chillida was much more interested in poetry and philosophy than in

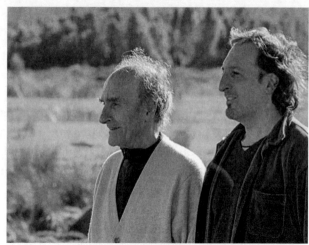

Eduardo and his novelist son-in-law Eduardo Iglesias at the
Molino de los Vados, Burgos province, 1998

fiction). He spent almost a year rereading the classics, and he became
a true pre-Socratic thinker, just like my father. Chillida's advice to him
was not to hurry to publish, and my husband listened. But who knows
how long it would have taken Eduardo Iglesias to launch his artistic
career if Pili had not encouraged him. He listened to her advice and
eventually published his first novel with a New York–based publisher
in 1989.

The experience of being at the side of artists, of sharing visions
of their progress from the very beginning, of being there in moments
of hope and of disappointment, is something that my mother and
I have in common. How much of what is at play in the work of each
of these Eduardos can be attributed to our influence? Neither of us is
characterized by reticence when it comes to saying what we think;
both of us acted as mirrors where our husbands saw their own work
reflected. I know my mother urged my father to make larger and
larger pieces, and he agreed. I have suggested that my husband's texts
be longer, but—ever the rebel—he has never given in. In his short and
profound novels with their original structures, he deals with pressing
topics; they always leave you wanting more.

# Born Twice

As I write, it occurs to me that, in relation to my parents, I was born twice. First was when I came into this world on May 2, 1958. The second time was in 1992, when I started filming Chillida. My relationship not only with my father, but also with my mother and the world they had built together, changed that year.

### "What belongs to one essentially belongs to no one"
By the time I began working on my documentaries, the bulk of my father's artworks consisted of public sculptures. He had decided that he would rather increase the number of "owners" of his individual works by making them public rather than by producing copies, a practice he had long rejected at that point. He loved the idea of making works for public settings where a larger audience could enjoy them. "What belongs to one essentially belongs to no one," he would say.

Me shooting footage of *Monumento a la tolerancia*
(Monument to Tolerance, 1992), Seville, 1992

The small deck where he did his morning exercises was open to the sea and the mountains that surround San Sebastián. He would often be up to see the sun rising between the Larrún, a mountain on the Basque-French side, and the Peñas de Aya, on the Basque-Spanish side. On that same deck, undoubtedly once again with the help of my brother Pedro, he wrote a heartfelt poem dedicated to his land:

*Bihotzean, zerupean, lurgainean, Aiako arriak lainoan.*
*Bihotzean, zerupean, lurgainean Larrún mendia lainoan.*
*Bihotzean, zerupean, lurgainean, Euskal Herria lainoan.*

(In my heart, under the sky, over the land, the Peñas de Aya
    in the mist.
In my heart, under the sky, over the land, the Larrún Mountain
    in the mist.
In my heart, under the sky, over the land, the Basque people
    in the mist.)

Chillida saw himself as a man rooted in the Basque Country with branches that stretched out into the world. As a pacifist, he was extremely distressed by the armed separatist struggle that gripped his land for so many years. "Is there any reason big enough to be superior to the smallest life?" he wrote. Raising awareness about human rights issues and the potential for more peaceable relationships between various groups was one of his obsessions in the final two decades of his life. It moves me to remember his unfailing presence in Gipuzkoa Plaza in San Sebastián every time another body was added to the horror. He would go with Pili, and any of us who wanted to come along, simply to be with others in a silent call for peace. We would barely speak on the way there or back.

What follows is the text Fernando Savater, a Basque philosopher also from San Sebastián, wrote in memory of my father for *Cien palabras para Chillida* (One Hundred Words for Chillida), a project organized on the tenth anniversary of his death:

I always imagine Eduardo Chillida standing—not haughty or defiant, but erect. I never see him sitting. In my mind's eye, he is never stooped over, but upright, attentive, and cordial from his impressive height. I see him standing a bit taller than the rest in the Gesto por la Paz peace demonstrations in Gipuzkoa Plaza; standing in the green hills of Chillida Leku, his works climbing up the landscape; standing before the iron spikes of *Peine del viento XV* (Comb of the Wind XV), stark against the sheltering and peaceful bay; and standing before the sea.

### Public Art: For Human Rights and Fraternity

A photograph of a work is just a photo; it is by no means the work itself. Similarly, a story we make up about that work is just a story—and that holds true even if the one making it up is the artist. What viewers have before them is the work, and all that matters is what that work wordlessly says to them. There are as many sculptures by Chillida as there are viewers who have communed with them.

*Zuhaitz V*, taking its name from the Euskera word for "tree," was installed in Grenoble in 1989. It consists of a solid block of iron that opens up into four branches that spread out into space. Chillida was commissioned to make the work in commemoration of the

The Bay of La Concha with Larrún and the Peñas de Aya in the distance, as seen from Chillida's deck, 2012

192

bicentennial of the French Revolution. Whereas all the other artists commissioned addressed the ideas of liberty and equality, my father engaged fraternity. On one side of the trunk, Chillida engraved words that he fervently believed: "*Cet arbre de fer né dans cette foret annonce que nous les hommes avons la même origine, il exige la fraternité*" (Born of the forest, this iron tree tells us that we men have a common origin; it demands fraternity).

Not long after, in 1993, he installed a public artwork in Germany. He titled it *Diálogo-Tolerancia* (Dialogue-Tolerance). When asked to make a sculpture for the city of Münster to commemorate the Peace of Westphalia, he reflected that there is nothing more important to making peace between people with differing stances than sitting down for a tolerant and open exchange. Back at Zabalaga, which was a sort of holding pen for my father's works until they went to their final homes, he kept a sculpture he called *Esertoki* (literally, "a place to sit down"). The work in Münster also consisted of two "seats," similar to one another but different, facing each another so as to foster dialogue.

Once my father became the topic of my own work, everything about him and his practice interested me. I remember, for instance, attending the 1992 retrospective exhibition held at the Martin-Gropius-Bau in Berlin with my husband and some of my siblings. The museum sat close to the Berlin Wall, which had fallen not long before our arrival; from this vantage point, we could feel the new winds that were finally blowing in Germany. When my parents arrived at the opening, a lone musician surprised them. He was playing the violin next to one of the main works, a *Peine del viento* that my mother had asked my father to make for her.

### Homenaje a Hokusai, Japan

In the early 1990s, Chillida was commissioned to make a public sculpture in Japan in honor of Hokusai, the great nineteenth-century Japanese painter and printmaker. At my mother's suggestion, the coordinator requested that the making of the work be filmed. Pili found the production company right for the job—an enterprise owned

by her nephew, Lorenzo, among others—and the condition she made to them was that I had to be the director. I don't know whether she did that to force me to get started in my career or to give me more freedom to make my decision—I never asked her—but that was how, from one day to the next, I found myself working on a project about my father.

*Homenaje a Hokusai* (Homage to Hokusai, 1992) had two parts: an 18-ton and 2.3-meter-tall central piece in weathering steel, and five enormous concrete pieces surrounding that central piece to frame a view of Mount Fuji. I learned from my father, during the first interview I did with him, that Hokusai was known as "an old man crazy for drawing" because he had made hundreds of drawings of that strato-volcano that is the symbol of Japan. He also told me that a full century before Kandinsky, an artist who provided so much inspiration for my father, Hokusai had sensed an art that might turn its back on figuration, an art that would be "alive" because it was born of a personal impulse. "That is what art is, what it has been since the end of the figurative age—when it is good art, valid art, I mean," he explained.

On the shoots, I would look hard and learn as much as I could in order to be able to successfully show it to audiences. The process by no means lacked emotion—on the contrary, it was an adventure that brought me and my parents together. The outcome? Two films, and many more stories, that depict an energetic, full-of-life, vivacious Chillida. On a number of occasions, I had heard my mother mentioning a very simple and—to her—moving film that showed Bonnard, by that time a very old man, sitting in a chair talking about his work (the Maeghts must have been the ones who showed her the film). For me it was clear what direction I hoped my film would take. I worked with director José María de Orbe on the screenplay. To get started, I shot conversations with my father about his work and life in general rather than focus exclusively on the making of the sculpture in question. I sensed that everything I was shooting had historical value—and that excited me. For that reason, instead of getting paid, I asked the company to shoot more than was necessary, and I also filmed for a few minutes before and after each interview. Later on, in order to maintain

My father and I preparing to shoot images for *De Chillida a Hokusai: creación de una obra* (From Chillida to Hokusai: Birth of a Work of Art, 1993), in Chillida's studio, San Sebastián, 1992

ownership of these materials, I set up my own company, La Bahía Centro Audiovisual (my father designed the logo).

My mother was extremely helpful throughout the process. It was thanks to her that I knew my father's plans—and changes of plan—beforehand, which gave me time to organize my team. Oddly enough, neither my mother nor my father was too concerned with how the film would turn out. Chillida's sole words of advice from the beginning were "follow your intuition." I remember him asking whether I was "getting what I was after." I have to confess that, even if it was an indication of trust, his lack of curiosity bothered me at times.

Our father-child relationship saw us through a number of rough times on the shoot, among them delays because of technical problems. All I had to do was briefly abandon my role as director and go to the other side of the camera to give him a kiss, and everything would be all right.

A few still photos capture the spirit of the shoots. I remember that day, my small team and I had been in my father's studio when we heard his car pull up. I ran to open the door for him—he was surprised, but seemed pleased to see me. I will always be grateful to him for giving me access to every facet of his life and for letting me shoot places no one else ever had.

Thanks to Pili's initiative and oversight of all aspects of Chillida's career, every filmmaker who has worked on Chillida after I did has had access to the wealth of audiovisual material that we produced during the filming of the *Hokusai* project. No one else could have gotten that kind of behind-the-scenes footage. My mother clearly knew what she was doing when she hatched her plan!

### "Let them be different": Weathering Steel

From the beginning, I saw that my father was interested in processes, not only results, and that he preferred experimentation to experience. The sculpture at the center of my first film is only one example of how he undertook his practice as a whole.

My father called his materials "matter"—something he got from Brâncuși during that early visit he and Palazuelo made to the Romanian artist's studio in Paris. They had been told that Brâncuși was aloof, but he was willing to receive them. My father was fascinated by how the artist's work and the man himself produced, at least for my father, the same sensation. He could tell how much Brâncuși respected life and matter. For him, the marble and wood he worked with, always with such love, were not just vehicles for his thoughts or ideas; he knew that they also had their own things to say.

My father would speak of "listening to matter" and "listening to the present moment"—and I have seen with my own eyes what that meant. I saw how, following the "aroma" of what he wanted to make—that pre-intuition I mentioned—he first rendered a small sculpture in honor of Hokusai. He then, with the help of his assistants, made a larger version to see the problems that arose with the change in scale. That was not only how Chillida prepared for making the full-scale piece at the industrial forge; it was also a way to experience, in the flesh, the different sensations before something as it grew larger and larger. What ultimately mattered most was finding the optimal scale vis-à-vis the human body for each public sculpture in its specific site.

I witnessed how Chillida would follow his intuition and sense of the present moment as he created a number of medium-sized variants of the same piece. "Let them be different," he would tell his assistants, Marcial Vidal and Fernando Mikelarena, as they worked. He explained to them that what the versions had in common was much more impor-tant than what might set them apart. That common ground was what mattered to him, even as he sought to let the differences blossom.

When my father finished making one of the variations, he would take it home to live with us as he mulled it over. He would often put

these smaller versions on the coffee table in front of the couch. Though he seemed to be watching television with us, I would have the distinct sensation that his mind often wandered elsewhere. My father, who was generally a bit absentminded, was always willing to talk to anyone and everyone who showed an interest in the latest work he had brought home.

As I mentioned, nothing was more important to him than tuning in to the present moment—and he suggested that I do the same. I remember one time I ran into him on the way out of his studio. I was hoping to record his reaction as I told him my overarching ideas about the documentary. He looked at me affectionately and said, "Do you really think this is the best time?" I knew he was willing to do it for me but, upon seeing his first reaction, I realized that it indeed was not the right moment. The right moment never came—but that was not what mattered. What did was mustering courage to, from then on, tune in to the present moment and hone my intuition.

At the forges where the large-scale versions of his works were produced, my father would find plenty of ways to get the workers excited about the project, among them conversations about poetics. He needed everyone to understand what he was after. Working in an artisanal fashion at an industrial forge was, after all, a true adventure. The work was guided not by precise instruction but rather by one of the smaller models. The workers on the morning shift often stayed on to see what their comrades on the afternoon shift would come up with, the means they would devise to keep twisting those enormous pieces of red-hot iron until the full-scale version resembled the model. In the locker rooms where they showered before heading home, the men would talk about "the moves" they had come up with over the course of the workday.

I remember in particular the interview I did with Arroyo, the process engineer at Aceros y Forjas de Reinosa in Santander. He told me how much fun they all had with Chillida from the get-go. Apparently, my father told the workers to "listen to the material." He explained that, when not forced into molds, the metal would express itself freely. At a certain point in the interview, Arroyo heard himself saying, "And that's true—the material does speak." He then became aware that the camera

was on; he blushed, undoubtedly at having said something so odd and deep.

Though I had, when I was young, gone to see my father work at Patricio Echeverría's industrial forge in Legazpi, I was not familiar with the steps that must be followed to allow the material to express itself. Any small piece of metal to be worked on one specific day had to be heated for twenty-four hours. Even then it still cooled down quickly. Time was of the essence in this process, and the tension was intense. Each part of any single curve required extensive planning, travel, and money. When the central steel piece in *Homenaje a Hokusai*—with its many curves—was finished, we all breathed a sigh of relief. The biggest of all was my father's. From there, the sculpture traveled to Zabalaga before being shipped to Japan.

My father sent all the major works produced at industrial forges to the fields of Zabalaga so that he could keep an eye out for rusting. Chillida did not consider a work in weathering steel finished until it had shed the outer layer that forms when the material first comes into contact with air and water. After a sculpture had faced enough exposure to the elements, he could assess its color. It was quite something to see how, when it failed to rain for a number of days, my parents would water a sculpture as if it were a plant or flower.

When the central steel piece of the *Hokusai* work was finished, it was time to begin production on the five concrete pieces that would surround it, each one nine meters high.

### Film, an Illusion

By the jai alai court at Villa Paz stood an enormous marble table with twelve rocks for chairs (we called it "the table of the apostles"). When it came time to film *Maqueta para Homenaje a Hokusai* (Maquette for Homage to Hokusai, 1991), I immediately knew that that table was the place to do it. We put the sculpture model on a turntable, and I climbed up on the large marble slab. From there, I used an endoscope to film the spaces between the sculpture's various pieces, all while checking the image on a monitor. I asked my father, who was close at hand in his

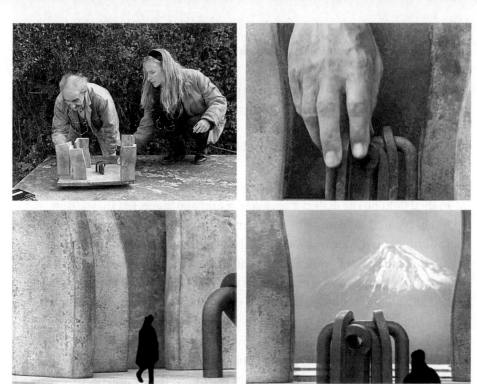

Film stills of *Maqueta para Homenaje a Hokusai* (Maquette for Homage to Hokusai, 1993) during the shoot for *De Chillida a Hokusai: creación de una obra* (From Chillida to Hokusai: Birth of a Work of Art, 1993)

studio, to come out for a minute and fiddle with the endoscope as well so that the film would capture how the author of the work saw it.

Shooting at such familiar locations meant not only that my father was at ease but also that we were on the same wavelength. Everything he did was at once habitual and novel.

Using a photo of Mount Fuji and the enlarged images of *Maqueta para Homenaje a Hokusai* we had taken with the endoscope, we created a "trick" sequence to convey what the work would look like at its final location. On the smooth wet sand of a beach, we achieved a simple chroma of me walking around and looking at my surroundings, as if I were actually in front of *Homenaje a Hokusai* as installed in Japan. In

film, any device, any artifice, is legitimate: film is an enormous and wonderful lie.

The sequence easily could have ended there, with the illusion of me in Japan with the sculpture. But I decided to put my father's hand in the frame and break the spell. Intuition told me that the film had to be coherent with a key characteristic of Chillida's art, namely, an utter lack of deception or trickery.

As my father explains in my films, each of his sculptures attempts to shed light on the dialectic between matter and space. For that reason, he always used solid material to contrast with the lightness of space. Everything that appears solid in Chillida's work is in fact solid, no matter its size or the cost of producing it. I sometimes ask myself what principles guide sculptors who make works that *look* like my father's but are actually hollow. I confess that when I come upon a work like that, I can't resist knocking on it to try to discern if it's hiding an empty space within.

In his final period, Chillida found a new way to grapple with volume and void, matter and space, and material and spirit, which for him were one and the same. The sudden onset of the illness that would be his demise did not give him time to experiment much along these lines. In works from series like *Consejo al espacio* (Advice to Space, 1953–2000) and *Elogio del vacío* (In Praise of the Void, 1975–2000), however, the appearance of total solidity is revealed to be just that—appearance—by showing their inner spaces. Chillida did not turn his back on his principles but rather put the "trick" in plain sight.

### A Tailor-Made Suit for Concrete

One of the many things that interested my father about concrete was that it had never before been used in fine art sculpture. Investigating the full potential of this modest material was a pleasure he shared with his frequent collaborator, the engineer José Antonio Fernández Ordóñez, who relished recounting all the unlikely ideas my father had come up with over the years to yield the specific texture he was after. Ordóñez also recognized how important his relationship with Chillida had been to his research into concrete.

It was decided that the five concrete pieces that would surround the steel piece in *Homenaje a Hokusai* would be made in Japan, as it would be logistically complicated to ship them from Spain. But my father was worried that the concrete pieces would come out "too perfect." The final texture was important, but perhaps more important still was the interpretation of the form. Of course, rendering a small model on a monumental scale is no mean feat. If not detected in time, a simple notch or speck of dust could result in a terrible deviation. That's why Carlos Lizariturry, an expert sculptor with whom my father had worked on granite pieces, was sent to Japan to carry out

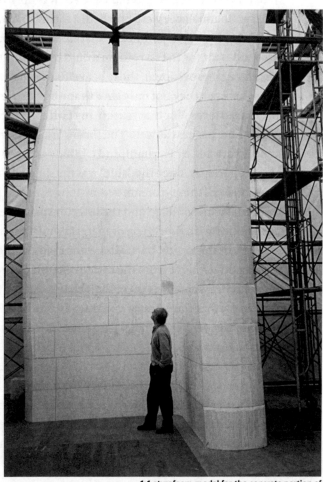

1:1 styrofoam model for the concrete portion of
*Homenaje a Hokusai* (Homage to Hokusai, 1992), ca. 1992

this work. Carlos rendered a 1:1 model in styrofoam of one of the five pieces—that is the essential first step when working with concrete. My father was pleased with the results.

I learned all of this from working on the documentary. It was a real shame I couldn't be present for the other phases of production—that was to be the topic of a second film. Every year, we were given a new date for the installation of the sculpture in Japan, until we were eventually informed that the Japanese company undertaking the project had gone bankrupt. My parents held on to the hope of seeing the project through to completion for longer than I did.

What no one ever got the chance to see was how, once the light-weight styrofoam pieces were finished, a formwork was constructed around them. For all of Chillida's concrete works, what was essentially a tailor-made suit for the styrofoam would be fashioned out of wooden boards. Though provisional, those beautiful wooden suits were essential, because they not only gave shape but also left traces on the sculptures' surfaces. For that reason, my father kept careful watch over that part of the process as well. The formwork usually was made in Arganda, Oiartzun, or Hernani, and Chillida enjoyed working with the experts. Apparently, once the "suit" was finished and each piece of wood numbered, the styrofoam was no longer needed. The formwork would then be reassembled and the interior space the styrofoam used to occupy filled with the different materials my father chose. Next came the most important part: all the materials would gradually start to set and gain strength from the inside out, until they met the wooden boards, which is what gives them their shape. I know that this was the moment my father found most exciting. The most critical step was happening, and yet he could not see it. Just as happened with the *Lurras* in the kiln.

### The Perfect Place

Chillida was very picky about where his works were installed. He was not shy about voicing his opinions, though that sometimes meant he himself would have to find the installation site or adapt it to his vision.

On a number of occasions, it was necessary to reroute traffic, whether pedestrian or vehicle, or to create an area that invited passersby to stop in for a look. My father tended to choose remote places that viewers had to seek out intentionally. That was certainly the case for *Puerta de música* (Music Door, 1993), installed on the hilly grounds of the Centro Gallego de Arte Contemporáneo in Santiago de Compostela, a museum designed by Álvaro Siza. My father wanted to formulate a direct visual relationship between the sculpture and the cathedral. Chillida always hoped that his work would create a new place or, at least, make a contribution to the existing space. I know, for instance, that they asked my father to install a sculpture at the entrance to the Guggenheim Bilbao, where for years Jeff Koons's *Puppy* (1992) has been, but he declined. He understood perfectly that his work had nothing to contribute there. Frank Gehry, the museum's architect, was one of the many people who had visited Zabalaga, though they were only acquaintances and not friends. Nevertheless, my father managed to get Gehry to understand his position.

### Full of Emptiness: *Elogio del horizonte IV*, Gijón

"A public work, for Chillida, more than just a sculpture, is a place; something that belongs to everyone or belongs to no one, like the waves or the sea." Those words, which I utter in my documentary *De Chillida a Hokusai: creación de una obra* (From Chillida to Hokusai: Birth of a Work of Art), are essential to understanding Chillida. Since there was no final piece in Japan to shoot for the film, I wanted to give the viewer a chance to see some of my father's other monumental works in concrete and to convey a sense of what is at play in Chillida's public sculptures. Along with *Peine del viento XV* in San Sebastián, *Elogio del horizonte IV* (In Praise of the Horizon IV, 1989) in Gijón was, of all the public sculptures he produced, particularly close to my father's heart.

Located in the hills that shelter the city, the sculpture seems to keep watch on the line the divides the sea from the sky. Indeed, the remains of a military fortification that are still visible there exist precisely because, from it, the army would look out on the horizon

to detect an enemy's approach. Chillida's work, meanwhile, pays tribute to the horizon, honoring its grandeur and ability to bring human beings together. "The horizon is the homeland of all men," my father would say. As soon as it was installed, the people of Gijón invented amusing names for the sculpture, like "*Eulogio*," finding comradery with the work by turning its title into a memorable man's name, and "King Kong's Toilet," which I believe is self-explanatory. Notwithstanding, the work—and the living, breathing place created around it—soon became a symbol of the city and part of its identity.

When multimedia artist Laurie Anderson was in Gijón, she asked to visit *Elogio del horizonte IV* and to be left alone with the work. My father told me that she said, after spending a long time with the sculpture, it was "full of emptiness."

My father was pleased when I suggested filming in Gijón. At daybreak, my small team and I set out to scout the location. All there was that early morning was the sea, the sky, and the sculpture along with the rising sun and the vast horizon. A little later, men and women walking their dogs began appearing. We spent the whole day shooting the life in that place. People passed from one side of the hill to the other, and many of them entered the elliptical space created by the work, in part because of an acoustic phenomenon that everyone likes to test out: the sound of the sea is louder in the middle of the sculpture than out toward the cliffs. My father loved recounting how he had not had that acoustic effect in mind: it was a gift given by chance. "Grass will not grow here," my father predicted, and he was right. The day of the filming was windy, and we shot kites in the air; we renamed *Elogio del horizonte IV* "The Uncomb of the Wind"—a pun on my father's famous *Peine del Viento XV*.

I asked my parents to wait until midafternoon to come join us at the sculpture. We had taken two small canvas chairs along so they would have a place to sit while we set up the camera. At a certain moment, Josep María Civit, the director of photography, caught sight of my father from behind. "Eduardo, I'm looking at your head and I can tell you are a *genio*—a genius." "Eugenio," responded my father,

who was never lacking in humor: his quick-witted pun played on one of the nicknames for the sculpture, *Eulogio*, transforming it into the common Spanish masculine name. Though we tried to be as discreet as possible, people recognized Eduardo and Pili. A newlywed couple came by and asked to have their picture taken with my father and the sculpture—and they were just two of the many people pleasantly surprised to find the artist and his wife in situ when they came by that day. They also wanted to have their picture taken with Chillida, and so they did.

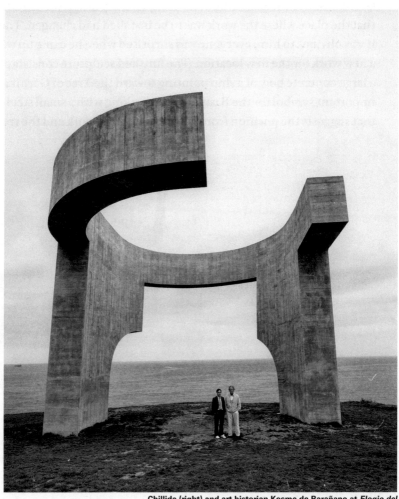

Chillida (right) and art historian Kosme de Barañano at *Elogio del horizonte IV* (In Praise of the Horizon IV, 1989), Gijón, ca. 1989

But the most felicitous encounter of all was between Chillida and his work. With arms held high and hair in the wind, he breathed in the fullness of the moment. He delighted in the ellipse that framed the sky before a horizon he described as nonexistent and beyond reach. "I understand hardly anything, but I share the blue, the yellow, the wind," he wrote.

### *Gure aitaren etxea*, Gernika

Only recently did I learn that a different location was originally planned for *Gure aitaren etxea* (Our Father's House, 1987), which lives in Gernika. Once the fabrication was complete, my father was informed that the place where the work was to be installed had changed. Though it was obvious to him, everyone was surprised when he came up with a new work for the new location. The finished sculpture consists of a large concrete bow of a ship pointing toward the Tree of Gernika—an important symbol for the Basque people—along with a small steel stele that suggests the position from which to view the work and the tree.

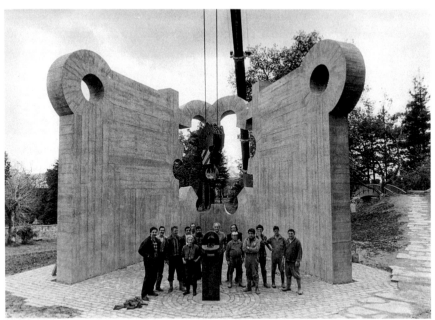

Chillida, Pilar, photographer Jesús Uriarte (second from the left), and the crew of workers at *Gure aitaren etxea* (Our Father's House, 1987), Gernika, 1988

In 1992, when his retrospective at the Palacio de Miramar in San Sebastián was drawing near, my father, as happy as a little boy, told me he had invited to the opening all the workers at the forges and workshops where he had made his sculptures over the years. My father's affection and gratitude for his collaborators was immense. When the time came, he was delighted to meet up with them in a new setting.

### *Monumento a la tolerancia,* Seville

Just after the retrospective in San Sebastián, the entire family attended the inauguration of *Monumento a la tolerancia* (Monument to Tolerance) in 1992. This work is located near the Triana Bridge in Seville. One of the forces behind its installation was the gallerist Juana de Aizpuru. She was always close to my parents, and at the time of the inauguration, her gallery was showing a Chillida exhibition. The work sits on the riverbank with its back intentionally turned to a castle that witnessed many horrors during the Inquisition. Its large concrete arms extend outward as if to embrace the viewer, but one stretches upward, like it's trying to include the cosmos in that same embrace.

Opening ceremonies are always attended by a great many journalists. They always come right on time and leave as soon as they have had a chance to take their photograph and record a few words. As a filmmaker, the opening did not hold much interest for me, but I did bring a small team to film the Waintrob brothers —our veteran photographer friends, who had decided to come to Spain for the event. On the calm day that followed the opening, they took pictures of the work. What I wanted to capture for my first film was their enthusiasm. Furthermore, they were a means to show our father's veneration for the wisdom of older people, just as the scenes with grandchildren in both my films attest to his admiration for the innocence of children—sentiments that I share.

On their way home from Seville, Sydney and Budd stopped in San Sebastián with their nephew David Stecker, who was also a photographer, and they did a session with my father in his studio. I have seen many portraits of Chillida taken by good photographers, but few of them convey as much affection. At a certain point, my mother and

Chillida at his exhibition at the Palacio de Miramar in San Sebastián with gallerist
Juana de Aizpuru and his daughters Susana (left) and Maria (right), 1992

Photographers Budd (left) and Sydney Waintrob with
Chillida, Villa Paz, San Sebastián, 1992

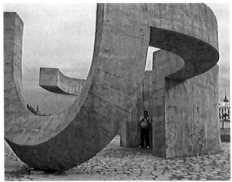

Still from *De Chillida a Hokusai: creación de una obra*
(From Chillida to Hokusai: Birth of a Work of Art, 1993):
Sydney Waintrob photographing *Monumento a la
tolerancia* (Monument to Tolerance, 1992), Seville, 1992

208

I, who were close by, were invited to participate. When, not long ago, I came upon the photo album of that trip—which the Waintrobs later sent to my parents—I was overtaken by joy but also by sadness; none of those four great friends is still among us. The cover of the album reads: *Eduardo Chillida, "el número uno," abril 1992* (Eduardo Chillida, "number one," April 1992).

Sydney was the first photographer to have a solo exhibition at the Metropolitan Museum in New York. He always said he wanted to live to be one hundred, and he died just four months short. In those four remaining months, my father died. Perhaps it's for the best, as I'm sure the photographer would have been devastated to have survived his younger friend.

### Imagination and Perception

A thousand memories crackle in the fire that burns in front of me. Something about this space will occasionally beckon me when it is time to write. My mother had a builder's impulse that some of us have inherited. That is why I saved the two chimneys my father made for Villa Paz, before it was demolished. Complicated though it was, I brought them with me when I moved to Madrid, and they have lit up my home ever since. When my siblings first came to my new home, we remembered together the shoes we would lay out for Three Kings' Day and the lengths my parents, mostly my father, would go to make the gifts appear each year in front of the granite chimney.

I snap out of my daydreams and notice an interesting space that has formed between two burning logs. I ask myself at what point I became capable of seeing my father's works as he did. I have the sense that I had to learn time and again everything he had to teach me before it really sunk in. In our first interview, we delved into the question of scale. I had trouble grasping what he was saying—and he had trouble explaining himself. He told me how he had trained himself to shrink in his mind's eye until he could "truly" see his sculptures, see them as if he were a little mouse-sized person circulating among their forms, looking up at them from that impossible perspective. It was through

those games of imagination and perception that my father tried to capture the human scale—something essential to determining the right size for *Homenaje a Hokusai*, among many other works.

One day, after all the shoots of my father had been completed—a process that took some eight years—I said, "*Aita*, it's too bad I never had a chance to shoot that thing you do with your fingers when you look at your sculptures." He had no idea what I was talking about. I explained, giving him an example. "When you look at *Lo profundo es el aire*"—a series known in English as How Profound Is the Air, from 1983–98, of which there were many at Zabalaga—"you use your index finger and thumb to calculate the size you would like to have in order to get inside the work's hollow spaces and look at it all 'from within.'" That strange exercise of my father's is key to looking at all of his works: there is no space within any of them, no hollow or void, that he did not first explore in his imagination by shrinking himself. But he preferred the word "perception" to "imagination"—that was something he discussed repeatedly in the interviews he did with my husband, Eduardo Iglesias.

I keep looking at the space between those two logs. Now, in my imagination, I also circulate through the embers, taking in the space between them from every angle. I am even capable of meddling in the folds of my hand, as he would. I lose myself, becoming all eyes with no body, and I discover the wonderful hidden spaces—spaces I explore through perception.

### Daring to Dream: Imagining a Space inside Tindaya Mountain

My brother Pedro tells me that it was at the quarry in Les Baux-de-Provence that our father first had the feeling he was inside one of his sculptures. Chillida was exhibiting work near Saint-Malo, and Pedro had a show in Toulouse. Both were visited by the ceramicist Hans Spinner, who took them to the quarry. The experience was unforgettable for everyone involved. Chillida was moved to make a sculpture in alabaster that he titled *Mendi huts I* (Empty Mountain I, 1984). This work has had space brought into it in multiple ways, so that the surrounding light engages with the material. Before Chillida made it,

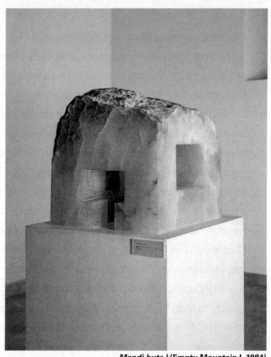

*Mendi huts I* (Empty Mountain I, 1984)

he had a dream where he worked with the quarry workers, instructing them on how to remove the stone. After all, what they wanted was the stone and what my father wanted was the space. I doubt he would have pursued that dream had it not been for his relationship with Fernández Ordoñez, the engineer. As a man of science, he could envision how to make that dream a reality. And so, not long before I started working on my films, the two friends began visiting mountains around the world together: they were taken to Finland by gallerist Kai Forsblom and they trekked in Italy before discovering Tindaya.

Tindaya is a beautiful mountain on one of the least populated islands in the Canary archipelago, Fuerteventura. At the time, it had two active mining operations on its slopes. Trachyte was very valuable in the United States and other places in the 1980s and 1990s, and so it was taken from the mountain, resulting in a loss of rock mass. My

father imagined that, with Fernández Ordoñez's supervision, it would be possible to extract stone without damaging the mountain, without changing its overall form, and without affecting the ancient footprints found toward its peak.

The idea was to create a space in the center of the mountain. Two small vertical hollows would be made in the top to allow sunlight and moonlight in, and a larger hollow midway up the slope would create an unobstructed space from which to take in the horizon over the sea. In studying the matter, Fernández Ordoñez learned that a number of great works in human history—the Pantheon in Rome, for instance—measured fifty meters by fifty meters. He and Chillida decided that that would be the size of the main hollow. Was the scale off? Was the plan too grandiose? Perhaps.

My father's intention with a project of such magnitude was to make human beings experience their insignificance before nature, a feeling from which we have so much to learn. He also hoped to incite a sense of connection and camaraderie between visitors. Anyone who entered such a vast space would feel tiny, and very much like the other people there at the same time, regardless of differences in religion, race, nationality, class, or stature, which, in other contexts, can seem so important. This project was, for my father, the culmination of his life's work: his examination of matter and space, of the void and the spirit, and his pursuit of human fellowship.

Engineers and astronomers had to study the *Proyecto Tindaya* (Tindaya Project, 1995) to determine if it was feasible. The one condition Chillida insisted on regarding any future development or tourist use of the site on the part of the local government—and it would certainly want to do something of the sort to get a return on the investment—was that the view of nature from within the work should remain totally unencumbered.

Fernández Ordoñez needed an architect who could explain the project clearly. He chose his son, Lorenzo, who had recently graduated from architecture school. Unfortunately, the project and its vision were attacked by environmentalists and special interest

groups—indeed, the project was riddled with disputes of all sorts—and so it never reached the design stage. Their accusations could not have been further from the reality of my father's art and person. To appreciate art, one must be prepared. I still believe society was not, by and large, ready for a project like that one.

I still remember visiting the 1997 edition of ARCO art fair in Madrid with my parents to see Fernández Ordoñez's installation model of the *Proyecto Tindaya*. What happened there broke my heart. We arrived in good spirits but were met by posters and banners that vilified my father in the most hurtful terms. I stayed outside while Pili and Eduardo went into the installation. The people behind the banners might never know the irreparable damage that their denigration of the project did to a sensitive man who loved nothing more than nature. My father learned something else at that time that also affected him greatly: a certain percentage of workers die in all major engineering projects. It is considered a normal part of the process. Knowing my father as I did, that information likely had greater impact on his commitment to the Tindaya project than he was able to admit. His health suffered, both mentally and physically.

But perhaps the wood model exhibited at ARCO confused people. It showed a cutaway of Tindaya Mountain to convey how small the hollowed-out space would be compared to the mountain's whole mass. But when you don't want to understand, you don't understand. Perhaps some people thought Chillida wanted to split the mountain in two. The fierce opposition from environmentalists continued for years. The Fuerteventura government and other institutions fought for the project, which was met with great enthusiasm from the art world, despite the controversy. The pressure from those against the project ultimately resulted in a law recognizing the mountain as a Natural Monument; it is still, some thirty years later, protected under this legislation. Though it's rarely said, it's worth remembering that if my father had not had that dream, Tindaya Mountain might well have been sold off one stone at a time without anyone ever paying attention to it.

Tindaya Mountain in Fuerteventura, Canary Islands

Detail of a model for Chillida's *Proyecto Tindaya* (Tindaya Project), 1995

Topographical model for Chillida's *Proyecto Tindaya*
(Tindaya Project), 1990s

214

Since that whole situation ensued while I was working on my documentaries, much of *Chillida: el arte y los sueños* (Chillida: Art and Dreams), my second film, is an attempt to help viewers understand that unfinished project from the sculptor's perspective. Oddly, *Homenaje a Hokusai* (Homage to Hokusai), the work at the center of my first documentary, was also never installed. I am pleased, though, that anyone interested in understanding either of those unfinished Chillida projects will find valuable information through my films. Indeed, if anyone ever attempts to finish either of the works, the documentaries will be useful in making sure the artist's original vision is respected.

### Pili's Frustrated Dream

As I have mentioned, Pili adored the sun and, during the long, rainy San Sebastián winters, she longed for it. My mother dreamed of spending part of the winter under the glorious skies of Castile. She designed and then had built a huge concrete structure on two levels on the outskirts of Madrid, where my sisters and I lived. The structure was large enough to contain a house, a study, and a large studio for her husband. My father acknowledged her desire to carry out the project, but he did not seem particularly interested in it. However, when the moment of truth came, he could not have been more frank. He said he had no intention of leaving San Sebastián—not then and not ever. Pili's plan did not prosper, and the concrete structure remained a skeleton for many years. The only thing included in the original design that ultimately had a chance to grow was a cypress tree, carefully integrated into one of the building's nooks and crannies.

That never-finished house seemed like the perfect location to shoot the final interviews for *Chillida: el arte y los sueños*, interviews with non–family members who were close to my father. The abandoned structure symbolized, in my mind, Chillida's decision to drop out of architecture school to pursue art, as well as Pili's frustrated dream of turning the place into a home for the two of them where his sculptures could continue to come into being.

I filmed my mother arranging a beautiful bouquet of flowers for the long table where, after three days of shooting, all the interviewers (except for one who had a professional commitment elsewhere) would dine with my parents under starlight and candlelight. In this second film, I wanted Pilar Belzunce to be more than a voiceless presence, as she had been in the first one. I asked the gallerist Nieves Fernández, who had grown to be one of my mother's closest friends, to interview her. Fernández had shown not only Chillida's work but also the work of his two artist sons, Pedro Txillida Belzunce and Eduardo Chillida Belzunce. The formal composition of the interview with my mother was identical to that of the interviews with my father: a shot of her alone, which ended up in the film, and a shot of the two women— Nieves and Pili—conversing, with Fernández reflected in a mirror. This other image of them both will appear in the film on my mother I'm currently working on.

No one else has delved into that interview the way I have. What stands out to me is the gallerist's opinion that Pili would not have been able to help Eduardo as she did if she had not had an artistic sensibility of her own. I fully agree. According to Fernández, that sensibility is what allowed my mother to understand and appreciate Chillida's work as deeply as she did, and what enabled her to be as generous with him as she was.

### The Dream of Zabalaga: The Origin of Chillida Leku

If my father learned from Brâncuşi, then he also learned from Picasso. He admired the Spanish artist's sculptural work at least as much as his painting. At the same time, he remembered how Picasso had stood up him and Palazuelo at the beginning of their careers. My father never again tried to meet him, but perhaps that unpleasant episode influenced Chillida's determination to be as accessible as possible.

When I started filming, I discovered that anyone who called Chillida to meet him would be invited to Zabalaga—a peaceful place where my father liked to spend time every day. Countless students, artists, gallerists, museum directors, and others have explored the

grounds of that old *caserío*, with my father as their guide, long before it was opened to the public. Chillida's availability was impressive; I can say without a doubt that my father viewed anyone and everyone interested in his work in the same welcoming and curious way. While that attitude makes me proud, I know it took a lot of time away from his practice.

Starting in 1983, when they bought that half-ruined farmhouse from the late fifteenth century, my father and Pili would spend most of their evenings there. It is in Hernani, just seven kilometers from downtown San Sebastián. Zabalaga was the place where my father's recently finished works would stay until the rusting process was complete. Every time my husband and I came back from New York

Framework of wooden beams and pillars in the
Zabalaga *caserío* at Chillida Leku, 2019

for a visit, my parents would show us the new parcel of nearby land they had purchased. They eventually acquired the eleven hectares on which the Chillida Leku museum now sits. My mother and their gardener would clear the fields of thorns and weeds while my father decided what he wanted to do with the *caserío*. He was in no rush. He never was. His choice of architect was spot on: Joaquín Montero worked closely with my father, following his lead throughout the ten-plus years of work on the house. In his contribution to the memorial project *Cien palabras para Chillida*, Montero provides an account of their long and multifaceted collaboration:

> His unique personality was in full force whenever anything captured his interest . . . His personal method subtly balanced prudence and daring, might and sensitivity, doubt and self-assurance, tolerance and rigor, knowledge and mystery—always deployed in pursuit of excellence. [. . .] My affection is matched by my gratitude for all the wisdom he silently passed on to me.

Because the sculpture *Homenaje a Hokusai* would be sent to Zabalaga when it was finished, I decided to film the reconstruction of the farmhouse. In particular, I wanted to film my parents inside the farmhouse before the renovations got underway. The partly collapsed roof let in light, as did the half-ruined entrance through which, in the film, my parents walk into the structure. In the scene, they try to walk up what remains of a small wooden staircase that leads to the likewise half-destroyed rooms on the upper level. Cautious, my mother turns back—climbing the stairs was a dangerous prospect. My father goes a bit farther and then stops. I don't know how long he stood there, completely still, but I do know what was going on. The camera captured perfectly the silent conversation that began between him and the *caserío*, an interchange evident only in his eyes. And that was enough for me. I had long heard my father speak of "listening to the present moment" and of "listening to the house." There I was, in the middle of that listening, in the middle of those questions Chillida

asked with his eyes. For him, perception was everything. And though I was not able to grasp what the farmhouse was saying to my father, I did learn other things that I would later be able to convey. I have been lucky enough to witness art, as it arises in the artist, unfold before my very eyes.

From beginning to end, Chillida treated the Zabalaga *caserío* like a work of art, one where the artist engaged the questions of light and space. The wood of the floors and partition walls on the upper level were almost rotted through; you could see the parts of the structure that held the entire house together. My father could not believe his eyes when he saw how much those oak pillars, and the way the pieces fit together, resembled the woodwork he had intuitively done in his *Abesti gogorra* (Rough Chant) series so long ago, in the 1960s. Truer than ever to his Basque origins, he decided to remove as much from the space as possible so that the structure would be open and visible. One of those more-than-ten-meter-high pillars was too rotted to keep. It took a number of years and a lot of effort to find a similar piece to replace it.

Meanwhile, new sculptures kept arriving at Zabalaga. The natural setting and the works combined perfectly—and so, little by little, my parents began to get the idea of turning the property into a place where people could walk among the sculptures, as if in a forest. Chillida wanted the world to know where his work came from.

I always had the sense that, with his attitude and his art, my father hoped to help the world form a broader—and more benevolent—image of the Basque Country than the one provided by the terrorism of ETA (Euskadi Ta Askatasuna; Basque Homeland and Liberty), which my father condemned openly and courageously. Perhaps that is why, of the many possible locations he could have chosen to establish his museum, he chose this remote corner of Hernani, the place where he had had his first studio and where people had traveled to see his work. He wanted both the larger Spanish and international communities to see other facets of the Basque Country. Perhaps that was also the reason why, in 1975, when he was awarded the Rembrandt

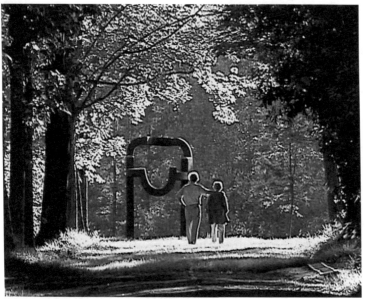

Still from *Chillida: el arte y los sueños* (Chillida: Art and Dreams, 1999) showing
Eduardo and Pilar together with *Arco de la libertad* (Arch of Freedom, 1993)

Chillida and groundskeeper Joakin Goikoetxea
at the Zabalaga *caserío*, 1991

Prize, he had the prize-granters travel to Villa Paz to give him the award in his studio.

From the moment my parents first began to envision "the Zabalaga dream"—which later became a reality as Chillida Leku—any sculpture my father made, no matter how large, had a place to go. So that site on the outskirts of San Sebastián is home to works originally conceived for public settings but that then lost their "places" for various reasons: *De música III* (Of Music III, 1989) was supposed to be installed next to the cathedral in Bonn, and *Arco de la libertad* (Arch of Freedom, 1993) in a park in Paris.

None of the forty-seven public sculptures by Chillida, found in seven countries around the world, had a simple production process. The life of a new public work would always begin with an expression of interest. A great many players—backers and advocates, business people, project managers, urban planners, mayors and other public officials—had to converge for the next phase. One delay would often follow another, and a great many difficulties might arise before the work came to fruition—and not all of them did, though that did not seem to trouble either of my parents very much. Once he was excited about a project, Eduardo would ask Pili, "Can we take this one on?" If she thought they could, he would embark on it wholeheartedly. They were both aware that, even if it never reached its final destination, they would enjoy having it with them at Zabalaga.

*Chillida: el arte y los sueños* shows the gradual reconstruction of the *caserío*, as well as the grounds and the sculptures that people it. Joakin Goikoetxea, who had worked with my parents since they had lived at Villa Paz, moved to Zabalaga with his family to be the groundskeeper. He collaborated closely with my father on the renovations of the farmhouse and with my mother on the gardens. The work of that distinguished Euskaldun, a man as sturdy as he was sensitive, a figure whom we all adored, makes itself felt in each bit of lawn won back from the weeds and each masterfully pruned tree, as well as in each and every corner of the *caserío*. "When I pass away, I would like you to put me next to Joakin," Eduardo would often say. But my father died

first, and Joakin dug his grave. Joakin was the next to go, and finally my mother. The ashes of all three lie together underneath a magnolia tree at Chillida Leku, the place to which each of them had dedicated so much time, effort, and enthusiasm, the place that filled them with such hope and joy.

Pili hated cemeteries. Knowing what the future inevitably held, she had asked Eduardo to make a cross that would mark the spot where they would rest together someday. After we placed her ashes underneath the cross beneath the magnolia tree, I heard Migui and Iñaki, her two smallest grandchildren, say, "Which would you like better—a headstone or a sculpture?" "For me, a sculpture, hands down!"

### The Number Three

Chillida considered three a magic number, and he based many of his works on it. *Homenaje a Luca Pacioli* (Homage to Luca Pacioli, 1986), for instance, is an imposing presence at Chillida Leku. It levitates above the ground horizontally, as if full of air. If you bend over and look underneath, you can see the three legs on which the beautiful, six-meter-long, wrought-iron slab rests. "If three legs are enough, why use four?" the sculptor seems to ask himself. Three: the number of the Trinity in which my father believed, as do I because of its rich and profound symbolism. When I asked my father about the number three in one of our interviews, he said, "Three is the most efficient of the numbers. One is all alone; two is like a ricochet; but three is a mature number capable of much more than the others. You can go further with the number three than with any other number."

A stirring noise in the trees by my window distracts me. Two turtledoves chase each other through the branches. I sense love in their fluttering. I remain pensive, and suddenly I understand once more that my mother, my father, and his works were three entities united in one: a single vital project.

## Marital Strife

Like all long-term relationships, my parents' went through rough spells. My mother-in-law would say that love takes brains, and I tend to agree.

We often fail to see how much information a simple gesture can convey. In a photograph taken in 1995 of the family lingering after a meal, my mother is having a cup of coffee. The look on my father's face seems to say, "What is this woman cooking up for me?" She looks calm, but she knows what he's thinking and avoids his glance. Her expression betrays that she's keeping something inside. Really, Pili kept so many things inside to avoid upsetting Eduardo! And as time went on, she kept more and more to herself. If she told Eduardo that they had a trip coming up, he would get so cross at the mere idea of it that he could barely work. So Pili would not tell him until the last minute, which would also make him fume. Pili would weather the storm as best she could.

When my father was perfectly healthy, my mother's strategy made sense to me, but that changed once he started getting sick. I would have liked Pili to let up a bit and think more about Eduardo than the gallerists, collectors, and general public. But she did not have that in her. She would put herself in the place of the person who had gone to such lengths to have a Chillida exhibition. Shipping my father's massive works—indeed, they often weighed more than a ton—unquestionably took a great deal of time, effort, and money, and she believed that the artist's presence at the opening was essential. No one seemed to care about the toll the travel, the interviews, and so forth took on him. Nor did anyone care about the effort required to sign all the prints and drawings he had amassed in his studio—he would sign them only when they were to be exhibited or sold, never before. I had the sense that the future of the works mattered more than the man himself—and, as his daughter, that was hard for me to stomach.

Now I think that perhaps I failed to grasp what my mother was going through when her husband started ailing. The artwork was, of course, an essential part in their shared life project.

## The Unimaginable

Pili had always feared going senile, which is what had happened to her mother. That was undoubtedly why she organized things so that, if that happened, neither my father nor his art would want for anything— another thing that I understand better now than I did at the time.

My mother knew how vital she was to the life of her husband, and she understood the importance of her children's spouses to their lives as well. That informed how, with characteristic intelligence, she organized a number of family rituals, like everyone going for lunch at the family house on Sundays, despite all the commotion that would bring. Such busy occasions were never easy for her to bear: medicine never came up with a remedy for the dizziness and headaches caused by the Ménière's disease that had afflicted her since she was young. I once suggested that instead of everyone going on Sunday, she could invite a different family every day of the week. But that was not what she had in mind. She wanted her children, daughters-in-law, sons-in-law, and grandchildren to spend time together and forge tight relationships. That would make things easier when, after her departure, it was up to us to take care of our father and his legacy.

## Family Trips

The Molino de los Vados in Burgos province was, while it lasted, an excellent place for everyone to get to know each other better. It is at the center of so many happy family memories. We would often get together there for an extended long weekend in October, which, for us, was even more special because October 12 is the day of Saint Pilar and October 13 is the day of Saint Eduardo—another coincidence that connected my parents. In addition to the long walks and fireside conversations we would all enjoy, my sister Carmen, a tennis player, and some others would organize tournaments. They would divide us into teams and come up with challenges and games. We would all play, including Eduardo and Pili. Once, carried away by the spirit of competition but also cooperation there was between us, my parents did something unusual for the pair of them—they cooked! Eduardo

made soup from the watercress we had gathered in the river, and Pili created a dish with fairy-ring mushrooms, the most common ones in the area. Everything was quite tasty, but Eduardo refused to eat the mushrooms with the excuse that someone would have to take us all to the hospital if we ended up getting poisoned. Maybe he sneaked a sandwich before dinner.

When my siblings and I got older, we would occasionally accompany our parents to openings or award ceremonies. My parents enjoyed having us around, but it caused problems for the gallerists and event organizers. Pili's place at Chillida's side was unquestioned—everyone knew that without her, he would not go anywhere—but making room for us was something else entirely. No matter how few of us went along, we were always too many. A number of my siblings and their partners had attended the award ceremony for the Order of Merit, given to my father by the German government. The protocol did not call for children to be invited to the dinner. My mother tried to find a solution, but when she could not, she indignantly left the dinner to accompany the rest of the family. Evidently, the minister of culture himself—or maybe it was the secretary of state—appeared at the restaurant where they ended up eating. He and my siblings convinced Pili to go back to Eduardo's side.

Maybe for that reason, we started to go on specially organized family trips. The first was in 1980 and the last 1999. They were a concession Eduardo made to Pili, an act of love, and a return of her total commitment to him throughout their lives. They were also a concession and an act of love from both of them to us kids. My father largely enjoyed them—we all did. That said, it was not always easy for all of us to be together 24/7; everyone felt the need, at times, to do their own thing. The eight of us kids with our partners, plus Pili and Eduardo, made up a large group that was not easy to categorize. Together, we visited the ruins of ancient civilizations, major works of architecture and artistic masterpieces, and places of natural wonder, taking in the world's sights and sounds, scents and flavors. Aztec, Mayan, Egyptian, and Greek civilizations; deserts, mountains, seas, rocky plains, and forests—with our parents right there at our side.

Guiomar Chillida, Jesús Uriarte, Gonzalo Calderón, and Pilar at the *Homenaje a Chillida* (Homage to Chillida) exhibition held at the Palazzo Ca' Pesaro, Venice, 1990

Eduardo and Pilar on a family trip to Egypt, 1985

The first family trip was to New York to attend the opening of Chillida's second show at the Guggenheim Museum. We went and came right back home. After that, a number of the family trips would begin with an award ceremony or exhibition, but from there we'd embark on a completely unrelated adventure. Chillida the artist would be left behind, and we'd head out with *Aita* and *Ama*. Those journeys, which some of my siblings organized and Pili happily paid for, were an oasis in the life of our parents. I think I can say that, for us kids, those trips were a sort of reparation for all the times we had been abandoned, if only briefly, when we were growing up.

In 1993, we went to Japan, where we were treated like royalty as our father was awarded the Praemium Imperiale. From there, we went to Chitwan National Park, a wildlife reserve in Nepal. We stayed in tents by a river that, we discovered, was full of crocodiles and hippopotamuses. A bunch of us were nearly killed during a charming "bird watching" expedition at dawn when we crossed paths with a male rhino looking for a mate. The only weapons our guides had were long sticks, but they sure knew how to use them in a pinch.

Another time we took a boat trip down the Nile, stopping at all the temples. We started out in Luxor and went almost as far as Cairo. We made unforgettable memories of nature and art, but also of the songs my brother-in-law José Mari would get us singing and the athletic competitions we would engage in, just as we had at the Molino or in the *el frontón* area at Villa Paz. Our father would laugh himself sick watching us, and Pili looked so happy.

I would bring along notebooks and pencils that I made available for the group. I still have some. While waiting at the airport, in the quiet of a hotel room or a tent, each of us had a chance to record a favorite image or what would live on as a cherished memory. In words or drawings. One of my best ones was never written down, though. I keep it in my heart. It happened in 1987, on our family trip to Greece and Turkey, which my sister Guiomar organized.

A number of us nearly fainted from the heat and the crowds when we visited the Temple of Aphrodite in Athens. In Turkey, we were able

to take in the wonders with greater calm than in Greece. We decided to rent a small boat to explore the coast, stopping at remote places still beyond the reach of the tourist industry. We went for a delicious swim. We were all young and we would dive from the highest point of the prow. This was after my brother Eduardo had had his motorcycle accident, so he could not join in. Under an umbrella by the helm, he smiled as he looked on, enjoying our enjoyment. I think seeing him so contented was why my parents decided to join in the fun. I find the memory so moving. My mom, who had been a good trampolinist when she was young, dove in, forgetting all about her age—and everything else. Then came my dad; he hated getting wet because he thought it would make him lose even more hair, but he got right into the spirit as well. I can still see them laughing, looking like wet chicks, so happy to be alongside their once terribly injured son, who no doubt appreciated their enthusiasm.

After our trip in 1989 to various national parks in the United States—we rented two vans—our father left in the travel notebook an odd work inspired by nature, and Pili contributed a drawing of our family. She also described in writing her feelings about the six Indigenous settlement sites and territories we visited—Zion Valley, Monument Valley, Colorado Canyon, Canyon de Chelly, Death Valley, and

Drawings by Eduardo and Pilar after a family trip to national parks in the United States, 1989

Yosemite. She evaluated them according to their living conditions: some seemed pleasant and well sheltered, others too rough for what she considered a comfortable life. At the end of her entry, Pili made up a seventh site she called "Family Valley." This is how she described it:

> It is home to the great Rock Mountain, a mountain solid and fairly rugged in configuration. It is rife with sharp edges, but also unexpected valleys that can be pleasant, cozy, and generous. The valleys are crisscrossed by gorges whose streams running down the mountain form Mother River. That river cuts through the whole valley, fertilizing it and trying—with its constancy—to make it warm and safe for its dwellers. Mother River is also fed by younger streams, their waters at times rich and abundant and at times scarce. Together, all this makes the valley a fairly harmonious and nourishing place for its inhabitants. They feel they form part of a whole whose most basic laws they respect. I found Family Valley quite moving, and I am so glad it exists.

The words and drawing my mother left in that notebook shed light on what she was after on those trips: she sought to strengthen the ties between us. And, since our parents' deaths—and even before then—that has proven truly important to being able to carry the weight of their legacy.

As I mentioned earlier, at a certain point Gonzalo Calderón, my mother's son-in-law, Guiomar's husband, became a central figure in Pili's life. She would discuss with him every decision she made, whether or not she ended up heeding his advice. His primary responsibilities were related to the sale of Chillida's works. It was, at least in part, his idea to safeguard the sculptures at Zabalaga, which would later make the creation of Chillida Leku possible. Gonzalo oversaw the venue's opening. My brother Luis, following an accident that could have killed him and some of the people in the crowd at one of his races, also started working for my parents. He first acted as a driver for them as he also began studying Chillida's work in depth. Little by little, he

took on more and more responsibilities. Luis is a good communicator, a people person, which comes in handy as the president of the Fundación Eduardo Chillida y Pilar Belzunce. My first contribution to the foundation was the recordings of my father's life, work, and thought. Later, in 1999, I joined the team professionally for a couple of years. I was in charge of organizing the foundation's guidelines and designing its first educational program. When the museum opened, I also used my film materials to create a video that let people meet the artist in the audiovisual room. My brother Ignacio got involved in the foundation after our father's death. I think he's the one who misses dad the most, since they worked together on a daily basis and collaborated on graphic work from the get-go. For that reason, we all deposited our trust in him to help steer the foundation. A calm and sensitive man, Ignacio also has a great deal of responsibility at the museum, as curator of Chillida Leku's ongoing exhibition program.

### Pilar Belzunce's Invisible Pillars

Through the same window where, on a sleepless night, I saw the moon trying to talk to me, I now see the low evening sun looking at me from between the branches. But the sun won't let me look at him—his might is lacerating. Giving in to his will, I close my eyes. Sitting silently before the computer, I think about gender inequality.

Weren't we a single entity in our mother's womb, a mass of still undifferentiated masculine and feminine forces? And when we come into this world, don't we, in our genes, carry both of those forces—the masculine and the feminine—within us? I remember my father saying that he did not know a single artist without a highly developed emotional side, and that quality is often associated with women. My father, of course, developed that facet of his personhood. My mother, meanwhile, developed the "masculine" facets of her being without compromising her femininity. It is thanks to her that "the things in the soul" of my father could express themselves in his art. But who took care of Pili so that she could take care of Eduardo? What invisible figures made possible the Eduardo Chillida–Pilar Belzunce team?

A few years ago, a filmmaker made a portrait of Eduardo Chillida on the basis of his children's accounts. In it, the sons' voices were given far more weight than the daughters'. Since I had given him almost four whole minutes of audiovisual material essential to the film, I figure prominently. Carmen, an athlete, is given some weight. The filmmaker had planned a single scene with the four daughters together in San Sebastián, but Carmen couldn't make it that day. At my request, he later filmed her alone. María, my younger sister, shared just one memory, and Guiomar, my older sister, was left out entirely. Here, today, I raise my voice against that injustice. Those two sisters were, if not the foundation, then at least the pillars that kept Pili standing. It was thanks to them—one in San Sebastián, the other in Madrid—that our mother could bear the weight she had taken on. And it was thanks to the three of them—Pili, Guiomar, and María—that Eduardo Chillida had the peace he needed to create the art so many of us admire and celebrate.

As the first born, Guiomar had a special place in Pili's life. She was the one who, during her first year of life, Pili could love unabashedly, without fear of making the others jealous. From the time Guiomar was a girl, Pili looked to her for support. Later, my sister and her husband Gonzalo became Pili's bedrock. Alongside her commitment to our mother, Guiomar was able to see to her family life and her children, as well as her career and hobbies—and that I admire greatly. The same holds true for María, who was crucial to our family first when our father got sick and then when our mother did. Without María's presence, their lives, as well as their deaths, would have been less colorful.

### The Opening of Chillida Leku

The greatest test that life put before Pilar was unquestionably the sudden illness that befell Eduardo. There's a photo where we see her with King Juan Carlos and Queen Sofía on the day of the opening of Chillida Leku. They are accompanied by the minister of culture Pilar del Castillo and the art historian and museum director Kosme de Barañano, who had curated a number of shows and coordinated publications and academic events around the figure of Chillida (they

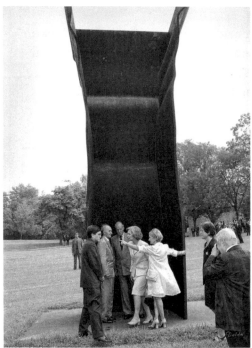

Chillida and Pilar Belzunce with the King and Queen of Spain
and art historian Kosme de Barañano (left) during the opening
of Chillida Leku, 2000

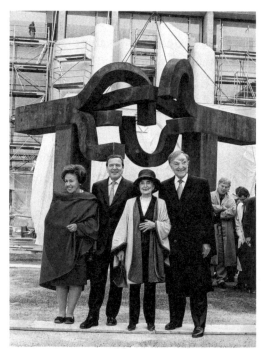

Arrival of *Berlín* (Berlin, 1999) in front of the new Chancellor's
Office in Germany: Pilar Belzunce with collector Rolf Becker (right),
his wife Anne Lore, and Chancellor Gerhard Schröder, 2000

also traveled together a good deal during my father's final years). My father seems elsewhere in the photo, whereas Pili appears full of vim and vigor as she tends to the guests. To me, she looks like a dancer, one hand pointing to something and the other grabbing onto the sculpture. If she had not had that work to lean on, I wonder where she would have found the strength she needed that day.

One of Chillida's final works, *Berlín* (Berlin, 1999), a commission from the German government to commemorate German reunification, was resting at Zabalaga at a time when my father had already retired from public engagements and Pili had taken over. There is something about that work that makes me think of the team my parents formed. The sculpture consists of two enormous steel pillars facing each other; from them emerge forms that stretch toward but never touch one another, just like each one of my parent's tasks in their shared life project. Not long after, that work was installed in a prominent place in front of the new Chancellor's Office. While delayed by Eduardo's illness, Pili still attended the unveiling in Berlin. The photograph taken at the event shows her with Rolf Becker, the German collector who donated the work, as well as his wife, Anne Lore, and Chancellor Gerhard Schröder.

The programming for the opening of Chillida Leku in 2000 began with an evening screening of my film *Chillida: el arte y los sueños* at the Kursaal in San Sebastián. When my parents walked into the venue, everyone rose to their feet, applauding. The following day, guests could visit the museum to see what art, as a universal language, is capable of. In addition to major cultural figures from around the world, guests included the King and Queen of Spain; Juan José Ibarretxe, president of the Basque Autonomous Community; Spanish Prime Minister José María Aznar; and German Chancellor Gerhard Schröder—gathering them all together was something of a miracle, considering their clashing political positions. Aznar and Schröder did not arrive until after the opening concert had started because of a meeting in Madrid. While listening to a Bach sonata, played by cellist Iagoba Fanlo, we watched through Zabalaga's large glass door as the

white helicopter with the two world leaders landed—quite a strange bird in that setting. Listening to its racket over the music and amid the sculptures, I felt that those of us attending the event were soaring higher than any machine could ever reach.

Our father was a liberal and tolerant person and totally focused on his duty as an artist. He had the good fortune—more like the gift— to know how to cope with postures different from his own without getting caught up in them, without getting pigeonholed or used. Our mother was also a person open to the world. She was a true art lover. With her innate charm, she honored that promise, the pact that seeded my parents' union: "If you follow me . . ."

### A Sort of Death

Ten years and 820,000 visits after its opening, Chillida Leku was forced to partly close in 2011. Many private museums found themselves in dire straits after the world financial crisis of 2008. Because I had been so involved in its creation and launch, it was, for me, a sort of death. I was filled with sorrow and rage. I quickly found ways to channel those feelings, however, and jumped back into action. I got in touch with Ana María Rabe and Ricardo Pinilla, philosophy professor friends of mine, specialized in art and aesthetics and both scholars of Chillida's work. Together, we developed collaborative activities between a number of European universities and Chillida Leku. The family kept the grounds in perfect shape, and visits for individuals and groups interested in Chillida never came to a complete standstill.

My mother, at that point, had withdrawn from the world and turned over all responsibilities to her children. Driven by our conviction and without any outside support, we siblings and our spouses continued to explore options for a full reopening. We eventually achieved this dream in 2017, when the gallery Hauser & Wirth started representing Eduardo Chillida, including seeing to the operation of Chillida Leku.

Grounds of Chillida Leku with *Arco de la libertad* (Arch of Freedom, 1993; left),
*Consejo al espacio IV* (Advice to Space IV, 1987), and other works, 2019

### The Chillida Legacy

It is not easy to go from being a child of Chillida to being his heir, from
being a family to being the custodians of a legacy. That legacy is heavy
in more ways than one. Chillida's work is literally heavy, but so are our
emotions. His tangible legacy is iron, stone, steel, paper—matter.
Questions, as well as obsessions and doubts, in the form of objects.
A silent and powerful world of his own that the artist forged with
reason and emotion, with his head, hands, and heart. But the Chillida
legacy also consists of archives, objects, photos, films, books, cata-
logues, letters, and newspaper and magazine articles—together they
hold the historical memory of a major twentieth-century figure. The
desire to further contribute to that legacy lives on in me. Chillida
made his work, and my work is him—that is, the man behind that
art—and the woman who dedicated her life to supporting him and
turning his dream into a reality with startling efficacy and *savoir faire*.
To a large degree, everything Eduardo Chillida gave the world is
indebted to the silent work of Pilar Belzunce. I feel such deep respect
for her work as part of the team they formed, and I want people to
know about it.

# Toward Absence

Sitting on a park bench amid the green and the passersby, I want to talk about their final days. In the face of disease and death, we are all alike. Only three springs came and went between my father becoming ill and his leaving this earth for a better place. Pili lived for thirteen long years without "her Eduardo." For me, and I suspect for the rest of the family, Chillida did not really die until she did.

### Pili's Farewell

I will never forget that July 4. It was 2015, and my brother Ignacio called me to tell me that, after a serious bout of pneumonia, our mother had begun to receive palliative care at home. I took the first plane to San Sebastián, where I found her lying in bed. Her body called out to my body. Her fragility aroused in me sadness and strength in equal measure. Surrounded by my siblings, I knew I did not have the right to monopolize the spot by her side, but none of the others moved toward her. Leaving that beloved body uncomforted and alone during her woeful wait was not, for me, an option. Her heat called out to my heat, her stillness to mine. I lay down beside her and took her hand. Attending to my mother at the time of her death was an exercise in calm and breathing that, strangely, reminded me of the exercise in calm and breathing that nursing my children required. I felt—I knew—that my body was a pulsating being that could convey sensations, emotions, and moods. Rhythm and pause, breath, pulsation, stillness. An intense heat from the tips of my fingers sent out the peace my mother needed. Lying by her side, present in my own body, I felt we were one. Pili had given birth to me. This was our farewell.

I will always be grateful to Miriam, a friend of my sister María. In 2002, María offered Miriam, who was recently separated and looking for a fresh start, a position spending a few hours a day as Pili's secretary and personal companion. Miriam was an upbeat, cultured, and

sensitive woman. While the specifics of her role varied, she stayed on until the time of my mom's death in 2015. How many of our mother's secrets are etched into her memory!

Miriam was the one who, that day, before the end, nudged us into an intimacy with Pili that was not our family's custom. Perhaps not all, but many, of my siblings spent some time alone with her. Renewed if bereft before her supine body, I wanted her to know things I had always kept from her. I needed to hear myself speak to her; I needed to tell her that my life had not always been easy, and that I knew hers had not been either, though we had always kept up appearances. I had always wanted to convey to her my joy and my warmth—never my tears. I did not want to burden her.

"How's it going, Susi?" she asked on the phone. I was in the hospital in Madrid, recovering from surgery. "Great," I said. "What about you? How's the surf?" When we hung up, after talking about the beauty of the sea and the cloudy sky she could see from her window, I burst into tears. I was in pain, broken inside. My husband made me see how much I kept to myself. And on that final day, when I did speak, I know that it did not burden her. We would be together forever more in our love, in our words and silences.

Pilar Belzunce left this world in peace and in the company of loved ones. We placed petals on the white sheet that lay over her body in the wooden box. María put rouge on her cheeks, and the two of us spent the whole night by her side, sleeping in the room that had been her office and painting studio. She looked lovely, and we were all at peace knowing that she would finally be reunited with her beloved Eduardo. The next day, loved ones, cousins, and a few friends arrived. They brought photo albums that showed her as a young woman. It was a precious farewell.

### Pili's Belongings and Photographs

I am struck by the simplicity and bareness of the large white space that had been my parents' bedroom. Outside there are mountains, and down below is the city and the roaring sea that works its way deep into every pore. Donostia is inside me.

I dive into my mother's belongings and find, among many other things, an old notebook in her handwriting. There are entries in different languages, and this reminds me of how my parents coached each other in foreign tongues. Since he spent part of the war in France, my father spoke French very well, and he helped Pili perfect her own grasp on the language. Pili, in turn, helped him with English. I have no trouble at all imagining them writing the letters I come upon. The first one, which is in French, is addressed to Dr. Werner Schmalenbach, a German art historian.

From what I can see, my parents were not particularly quick to get back to people (their letters often start with apologies for the delay). But you can also tell they were generous and empathetic. Artists are often asked not only to make statements about pressing social issues but also to donate works for important causes. My parents never refused to help out. Elsewhere in the notebook are remarks on pending errands: "Pick up photos at Bersans and put them away; pick up works at Muñoz y Cabrero and give them to the guys [my father's assistants]; write Guridi; watch the Príncipe de Asturias awards and drop off the things; leave the beach umbrella; leave money for Susana for April; present for Mari Tere . . ."

So many memories for each name and item on that list. I think of my mother's blue eyes—I would often describe them as little lanterns and watch as they lit up when called that. The power of words!

My mother's dressing table ended up in the house of one of my brothers. Four faint marks remain on the white carpet. Traces. And a growing emptiness that is gradually taking over the house. I find myself dancing and dancing around those spaces, taking in the moment. I dance out the sorrow, the rage, the fear. The tenderness I feel about being on her turf comes to melt away all of my masks. Music makes me feel better, as do movement and then rest.

I am overtaken by memories. To sharpen and intensify them, I delve into the photos she kept in an old printer's cabinet, lacking in order and abounding in memory. Without giving it too much thought, I choose a few. Simple photos that I see as treasures, making

me think about her and me. But can I think about us without the figure of the sculptor and his great work coming between us, whether to lift us up with their light or to crush us under their shadow?

### "There are no words for that pain": Motherhood Medallions

Photos from other times before my eyes. I see grandmothers, aunts, an array of ladies with pearls around their necks. My mother wears hers differently: a small knot sitting on her collarbone sets her apart. Then I see a photo of her nursing a baby; I know it might not be one of us. My mother also breastfed our cousin Silvia, the daughter of her older sister, who was not able to nurse. I am proud of my mother's act of generosity—but do I have a right to this pride? In another photo, I see the rounded forms of an early, now lost, semi-figurative work of my father's, bringing to mind the dividing embryonic cells that were implanted in the uterus of one of my nieces. She showed me a picture of the first ultrasound. Miracles of science.

I remember how much trouble I had becoming a mother. Getting pregnant was easy, but reaching my delivery date was not. Because of that situation, we discovered a genetic variant—a pericentric inversion of chromosome 9—that both Eduardo and Pili must have had. Not surprisingly, I inherited it, but I have what's called a double inversion. In technical terms, neither chromosome in that pair is compositionally abnormal, but their position varies from the standard placement. Nothing to stop me from having a healthy child, I was told, but "by chance" I miscarried three times.

"There are no words for that pain, Susi," my father told me one of the times I lost a pregnancy, "but listen to what Saint John of the Cross wrote: 'I continued in oblivion lost, / My head was resting on my love; / Lost to all things and myself, / And, amid the lilies forgotten, / Threw all my cares away.'"

To help with the grief over my third lost pregnancy, I grasped onto the medallion that I wore around my neck. I told my parents that what I needed was not a cross like the ones my father had made for all his children but a holy female presence to soothe this womanly sorrow.

Pilar nursing, 1950s

Eduardo, Pilar, and Guiomar, their first born, 1952

240

I was not making a specific request, but they—or my mother, anyway—understood it to be a commission. There are many amusing details in this story that have a lot to say about all three of us. My father fell behind and the medallion was not quick to appear, and Pili reminded him by leaving out in his studio an old mother-and-child drawing of his. And it worked.

When my father called me into his studio, he put a heap of maternity medallions on his table for me to choose from. I'm certain he was going to destroy the others. They were still in pink wax with his fingerprints fresh on them, just one step left in the process, namely to replace the wax with red-hot gold. He had already engraved the dedication on three or four of the ones he liked most, but he told me I could pick out others as well. I confess I was touched to see the words "for Susi from *Aita*" written out in longhand so many times. And then Pili came by. "Let's see now!" My mother told me to choose from the ones dedicated to me and suggested giving some of the others to the little ones in the household who did not yet have a cross. "But . . . !" I protested. That did not seem right. In the end, I chose only from the medallions dedicated to me, one of them roundish and the other squarish. That was how my father wanted it. The others were divided up between the other women in the household—but the children were not given any. The gold motherhood medallions that my father gifted to all the women in my family are dedicated to my unborn children and the pain of my parting with them.

When our first child was finally born, the umbilical cord slipped out of the doctor's hand when he cut it. A red liquid came gushing out like champagne. My baby was hot against my skin; he was light, his scent new, his cry subtle. But what did he taste like? Driven by sheer animal instinct, I stuck out my tongue and licked him.

### "Normalcy," Language, and Art

To speak of children, of photographs, and of motherhood medallions is to speak of works of creation. But what do we mean by "to speak"? And what about "to think"? Peter L. Berger and Thomas Luckmann

*Sin título (Maternidad)* (Untitled [Motherhood], 1947)

Recto and verso of the golden maternity medallion, with dedication, that my father made for me, 1990

study the process by which "everyday reality" is constructed and how the shared meanings foundational to our lives are built on the path toward socialization and awareness. How does language come to us? What does it add? What does it take away?

At birth, children have no words—they do not need them. For years, they make do with sound, touch, movement, affect. Their world is very large and only their own. But the onset of language changes all that. Each word fences in a specific reality, and what cannot be put into a pigeonhole cannot be named or thought. When language comes to us, we all become more equal; our worlds and selves contract, and we begin to forget. And the only thing that saves us from that existential shrinking is art—itself another language. Each artist delves into the dark matter of the universe with their own "arms." They are the ones scouting out the limits of "normalcy," the ones at the far end who lead us into new terrain. That which could barely be uttered or thought suddenly appears or reappears in a painting or a sculpture, in a piece of music, or in words themselves transformed by a poet or writer. To engage with art is to meet up again not only with our own past, but also with the pasts of others, to come up against that "not-understanding understanding" that takes us back to our earliest days.

Something else about art and words. Francisco Leiro, a sculptor friend of mine, told me how his son had grown up seeing him work in his studio every day while his mother worked in an office. From the time his son was born, everything that came out of his father's hands— mostly strange and large creatures rendered in wood—was perfectly natural for the child. When the time came for his father to have an exhibition, the doors that connected that studio to the outside world were opened. Strangers came in and began covering and wrapping up, and even taking away, what had, until then, been the stuff of the child's world. He grasped onto the legs of the sculptures, desperately shouting, "Daddy!" We attach our being to things. For that boy, those works *were* his father—that was what he called them. And he was neither right nor wrong.

Years later, I went to a show by that same sculptor. His mother was there. I spent some time chatting with her. She turned out to be a straightforward and sensitive older woman. "What a lovely show! You must be proud," I said. "I take it you like the work?" "Sister," she responded, "what can one say about the things of the soul?"

### Things of the Soul

Is the wind fluttering in the branches what makes me think about my father's soul?

His soul was large, and if I had to give it a shape, it would be a globe—and there, in plain sight, the cosmos, nature, life in all its forms, the human species. The morning paper and the evening news—both indispensable and both consumed in perfect silence—would inform him about what was going on in the world. Some time ago, I stopped consuming the news to protect myself from its darkness. The world pains me, and I think it pained him as well. But that pain, as well as the joy that the news might, on occasion, bring, was part of who he was. There were no debates or remarks, just a stillness that would seep into him and, sooner or later, turn into something tangible, something in another form—a wordless language, a deep inner desire to do better as a species. I believe that what he experienced regarding his beloved Basque Country, his small local world, and regarding us, his family, was largely the same. He worked with the pain and the heat that all of that conveyed to him—indeed, *all of that* was the stuff of his soul. If he can be accused of any "sin," it would be that he monopolized Pili, our mother, his love seizing her entirely.

### A Miraculous Beauty

I am still going through old photos when I notice something that amuses me. Both Pili and Eduardo would often turn their faces to the side for a profile shot in the hope that their countenances would take on the dignity characteristic of ancient Greek sculptures. A number of photos from different times in their life, all taken with the same

Polaroid camera, show them in that pose. I know their secret, and I smile at their innocence.

One snapshot of Pili with suggestively crossed legs takes me back to a painful and tender memory. When my father started going senile, Pili would help him shave. Flexible as she was, she would perch on the sink in her pajamas to get started. Eduardo could not hold back the attraction he felt. "A miraculous beauty," he would say, reaching out to touch her. My mother would tell us that his were the hands not only of a man, but also of an artist, of a sculptor caressing matter. And that was undoubtedly true. He had the hands, the eyes, and the heart of an artist right until the end. I confess that when our mother shared that anecdote with us, an idea came to me that, unfortunately, was never brought to fruition. I thought that perhaps Chillida would return to figuration and revisit Greek sculpture in a new way. What innovative twist would a Chillida whose life was largely behind him have given us? Nobody will know.

Profile shots of Pilar and Eduardo they took using the same Polaroid camera, late 1970s/early 1980s

## Painful Images

I once asked my father if he had ever thought of living anywhere other than San Sebastián. He spoke to me of the sea and said that he had never even considered it. Everything he had to do he could do from there. "I am never going to retire," he said. "But they will retire me." He added: "And if they can't find me one day, tell them to look for me by the sea." Today, those words, which proved ominous, take me to a difficult place. Painful images in the folds of my skin.

What follows might stir up memories in those who have had up-close experiences with Alzheimer's disease or other types of severe senility. This incident happened during our last family trip, to the Cyclades islands in Greece. Our father barely paid attention to the places we visited, and he did not seem to enjoy himself at all. He had the sense that he had seen it all before. He was like a fish out of water. The only thing that interested him—and a good deal—was what he called "loose-stone mountains." "We see clearly with the eye full of what we're looking at." Perhaps some of us had spotted worrying symptoms once or twice beforehand. In any case, after this trip, none of us could deny that he was now seriously ill.

One day he woke at dawn and wanted to see the mountain near where we had docked. The captain naturally put up the gangway, and Chillida disembarked. To one side was the mountain and to the other the nude beach we had passed by the day before. What memories were stirred in him by that deserted shore? Were they what confused him and caused him to quicken his pace? Was he actually trying to escape? I tend to think so. The day was just beginning. I can imagine him climbing the mountain rocks, bewildered by the unfamiliar setting, and suddenly realizing that Pili was not there. And then his "journey" turned into a nightmarish search. He became more and more lost with each step. He must have shouted her name to the wind many times before coming upon that house. He pounded on the door, shouting, "Pili! Pili!"

What ensued from there was like Don Quixote confronting the windmills he thought were giants. Chillida must have believed that

they were hiding his maiden in that "inn," and he started pounding harder. The people in the house were frightened by an older man yelling things they did not understand in a foreign language—we were in Greece—but they finally let him in. And since my father was in the grip of a sort of hallucination, he must have been anything but kind. He asked where they had taken Pili and demanded that they bring her back to him. He would not take no for an answer. Evidently, he grew so violent in his frustration that first the woman came after him with a broom and then her husband and son with whatever they could find. They managed to get him outside, though not without taking a few blows. My father had always been a strong man.

Then came the loneliness. Bloody and bruised, he eventually found the mountain and, like a wounded animal, he curled up among the loose rocks, facing the sea, waiting for who knows what. He was no longer shouting Pili's name. He must have tired himself out. He retreated in perfect silence.

As might be imagined, on the boat we were in a state of high alert until they told us he had been spotted from a boat. Words cannot describe how it felt to see him cross the gangway with what at first glance looked like his usual dignity. However, while he stood tall, his head was hanging down—a sight I will never forget. Titles for new *Don Quixote* chapters came to mind in the days after: "What happened to our noble knight when he left that cursed ship" and "Where the unfortunate adventure that our man encountered when he went after his beloved is told."

We laid our father down in the entrance hall of the ship. A doctor examined him and tended to his wounds. The captain briefly informed us of what had happened, which he knew because the Greek family had spread word of the incident among the community. After understanding what had ensued, we jumped into action. Whenever our father came to, he would sit up and look for Pili. We decided that our mother, or any of us daughters who look enough like her, would be in my father's line of vision at all times—far enough away so that he could not tell it was not her, but close enough at hand to keep him calm. The

trick worked. He would look up, see his beloved near, and close his eyes in peace. We divided into pairs and took turns keeping watch over him from the adjoining dining room. Thus, we could go about our days in his presence, happy to have him with us again. Our voices soothed him, as did our kisses. And for three days and three nights his wise body rested. A sad and heroic—to say nothing of romantic, in a Cervantine sense—episode was behind us.

That terrible memory leads me on to other times and places. I see the young and somewhat cocky Chillida, a strong man who felt the urge to go after any guy who so much as looked at Pili. "No, no, Eduardo . . . he didn't lay an eye on me," Pili would say to calm him down. It takes me to a story of that courageous young man who put his safety on the line when he confronted the entire Colegio de España in Paris because they wanted to do something that struck him as wrong. It takes me to that man, serene, if unwell, in his final days, remarking that "I would teach that one a lesson" when he did not like the way someone was behaving.

Chillida, as I said, had to rein in a character that was, at times, quite intense. He would transfer the tension contained in that effort to his sculptures. He sublimated it into his work, keeping control of that pressure by folding heavy pieces of iron or acting upon dense earth, making thick slabs of concrete gravitate or looking for light within alabaster.

### The Battle against Newton: *Lugar de encuentros III*

Chillida created spaces; I experience and depend on them. I am extremely sensitive to my surroundings and where I position myself in any setting. And since I happen to be in that neighborhood in Madrid, I decide to go to a café near the Museo de Escultura al Aire Libre de la Castellana. *Lugar de encuentros III* (Meeting Place III), a large concrete sculpture that weighs more than six tons, is an overpowering presence. This is *La sirena varada*, the work my father had such troubles with getting installed, the one he wanted to hang under the bridge between Juan Bravo and Eduardo Dato streets.

From the spot I have chosen—off to one side and away from the hustle and bustle of the city—I see my father's work as a serene presence. I think he achieved what he was after. His life's work was to focus our attention on space, and looking at this work today, I truly have the sense that the space under the sculpture is what is holding it up. My father needed that enormous mass of concrete to make the sculpture feel as light as air. Chillida was in a constant battle against Newton. Ironically, he needed to use weight in his battle against weight and gravity. If the form had been hollow and its weight merely an illusion, my experience of the work during the two hours I spent with it might have been different. People are, I suspect, more perceptive and harder to fool than we often give them credit for. My father's spiritual search was authentic, and that comes through loud and clear.

A young man touches the sculpture as he walks by. Are he and the work well acquainted? Does he give it a friendly tap every day on his way to work? Two workers with packs on their backs walk by and, to my fascination, one of them also has the impulse to touch the piece. Other passersby do as well. Is it the concrete that calls out to them? The work's

*Lugar de encuentros III* (Meeting Place III, 1972) at the Museo de Escultura al Aire Libre de la Castellana, Madrid, 1990s

manifest power? Its stillness? Or is it the work's defiance of gravity? Some walk around it, others stand right beneath it. I experience the place with them. The sculpture looks like a bird. I recall that the poet José Ángel Valente said the lone bird is "very important in the symbolism of creation." Then, to my surprise, I am witness to a full-blown photoshoot: a professional photographer and a young man—he appears to be a dancer—who wants to display his art next to Chillida's. He lifts his leg up to the sky as only someone who has dedicated his life to that feat could.

Soon an older couple approaches the work. Their steps are so coordinated that, were I to take a photo of them from where I sit, they would appear to have a single set of legs. Their agile and precise steps are like the ones that, as a girl, I took to keep pace with my father. I am swept up in memories of those final days he spent enshrouded in absence. Though, I wonder, might Alzheimer's actually be a resounding presence? One of the many things the disease changed about my father was the pace of his movements. While he had never been a jumpy or quick person, his motions grew slower and slower. At a certain point I felt that to connect with him—and, mostly, to avoid upsetting him—I too had to slow down. I would dash over to the room he was in and, when I got to the door, stop. I would take a few moments to slow my pulse and breathe deeply. I would walk in the room slowly, with an uncharacteristic calm that I am sure he enjoyed. I conveyed to my children how important it was to slow down with their grandfather. He had always been drawn to slowness—in music, in life, in everything. Indeed, he closed one interview he had with my husband by saying, "Slowness appeals to me much more than quickness. In fact, quickness does not appeal to me at all. It never holds the solution. Serenity, on the other hand . . ."

I cast my memories aside and, before leaving the Museo al Aire Libre, I say goodbye to Miró's *Madre Ubú* (Mother Ubú) and Julio González's *La petite faucille* (The Small Sickle). I can't remember when, but I do remember that my father once called González "the father of my iron."

Chillida and Frank Ribelin with *De música, Dallas XV* (On Music, Dallas XV, 1989), in front of the Dallas Symphony Orchestra concert hall, designed by I. M. Pei, 1989. Ribelin was the collector who donated the sculpture to the concert hall.

### The Rosa d'Oro Award: Concessions to Pili

Since Pili was preoccupied with Eduardo's health, she asked me to go to Palermo, Italy, in 2001 to give fashion designer Yves Saint Laurent the Rosa d'Oro Award in my father's name. Chillida had been the previous recipient, and he in turn had been selected for the prize by the architect I. M. Pei, creator of the glass pyramid outside the Louvre.

Granted every two or three years, the Rosa d'Oro Award is given to a living figure "who, through their work, has contributed to increasing humanity's knowledge, wisdom, and beauty." The novelist Jorge Luis Borges was the person who came up with the idea that each recipient should choose the next one. Borges was the first to be given the honor, and he chose the photographer Henri Cartier-Bresson. Later recipients include the publisher Giulio Einaudi, musician and composer Pierre Boulez, theater director Peter Stein, and—in 1998— sculptor Eduardo Chillida.

My father and his selector I. M. Pei had been close. They got to know each other during the installation of *De música, Dallas XV* (On Music, Dallas XV, 1989) in front of the hall that the Chinese American

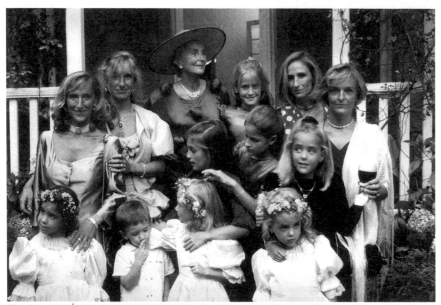

Pilar, dressed by Ágatha Ruiz de la Prada, with her daughters and grandchildren, at her son Eduardo's wedding, 1991

architect designed for the Dallas Symphony Orchestra. But what was the relationship between Chillida and the French fashion designer Yves Saint Laurent? I don't think I would be mistaken to say that my mother played a large part in that choice. My father had unquestionably enjoyed seeing Pili wear Saint Laurent's clothing throughout his life. I am certain Pili's penchant for designer fashion was another of Eduardo's concessions to his wife. Perhaps, though, for my mother the choice of a fashion designer for the award represented a way to honor the profession that her own mother and sister undertook to see the family through rough times—a thought I find endearing. I barely knew my grandmother María de Carlos, but I will never forget how despondent Pili looked when she came home from the funeral.

Ágatha Ruiz de la Prada was another fashion designer who captured my mother's interest because of how she broke the mold. That shared sense of daring was the basis of their friendship. Pili loved wearing her joyous and extravagant outfits to openings and weddings. According to Ágatha, Pili was the most intrepid

and adventurous of her clients. In 1989, she designed something especially for my mother based on a drawing by Chillida. In 1996, Ágatha paid tribute to our father by turning his sculptures into garments, a project captured in a book published by Ediciones Siruela. Many of the women in my family attended the book launch, held at the Museo Reina Sofía in Madrid, in those Chillida-based outfits. I was in New York at the time, but I can imagine my mother in the boldest outfit of all.

### A Strange Depth

When my father's illness first set in, I felt that all there was behind his disconnected words was just that—a temporal disconnection of sorts. If he was able to charm his way out of it, it was thanks to his upbringing and education, as well the social conventions he had learned over the course of his life. But then his communication grew more and more abstract. That said, I soon began to sense a strange and interesting depth in his words. I remember, for instance, when a gallerist friend came to visit. He talked nonstop to Pili and Gonzalo. My father looked on, but did not seem moved to participate. At a certain moment, he turned to me and said, commiserating, something like: "A lot of words, but not much light." For their entire lives, both he and my mother had kept their judgments of people to themselves, I imagine to give us, their children, the freedom to discover for ourselves what we found appealing or distasteful. Early in his illness, my father started to express himself more freely. He, of course, said things that bear light. I remember, for instance, one day when my kids and I were visiting Zabalaga. The oldest, who was still a child, took everything in, asking me an occasional question. My father observed him and, at a certain point, said proudly, "Your disciple is gathering a hefty load of doubts," which, in his language—the language of an artist afflicted with senility— meant: "That son of yours is on the right track." I laugh remembering it. Chillida always affirmed that astonishment, disorientation, and instability were the means to knowledge. Doubts and questions were, for him, the best path forward.

I remember how much he liked children. He would say that their bodies were full of water that would dry up with age. Though he might have lacked water in his body, he never lost his innocence. "I would rather be fooled than fool anyone," he would say—and I know that that was true. He was scandalized by the things he was accused of regarding Tindaya Mountain. I have the sense that he preferred losing his memory to bearing witness to the malice that he had been forced to confront. The world came crashing down on him. What a strange disease Alzheimer's is! To some, it affords protection. In the end, he had neither the strength nor the will to go on.

As his condition worsened, he did less and less both in the studio and outside it. All of his habits changed, except for his daily walk—that he wanted to keep up until the end. My brother Ignacio and his wife, Mónica, attended to his every need with unwavering commitment, as did my sister María. There were, of course, upsetting incidents during that time: he got into an inexplicable fight with the sink; he decided to leave his studio all on his own one day, only to be found, after much desperate searching, at the Hotel Niza, a place full of childhood memories. It was difficult for my father to adapt to his new situation, though he slowly—and resignedly—came to accept it.

I would go to San Sebastián often. When staying with my parents there, my siblings and I would walk with our father through the yard. I would walk backward, facing them, keeping the distance between us constant—something I knew a few of the priests from Azpeitia did on their walks through the cloisters. We would chat and tell stories while performing this somewhat bizarre choreography to get a smile out of our father. We all needed to see him smile.

My father's illness showed me once again how different each of us is—and that applies not only to patients but also to their caretakers and companions. Some people were totally lost in the presence of our father; no matter how they tried, they were unable to find any thread of meaning in his disconnected words, and hence became distant and silent. Others spoke just to fill the space. Some prayed. Others lost

their temper. And, unable to connect with an absent presence, some ignored him entirely, as if he were invisible. It was not easy.

My father's eyes were often closed, even when he was awake. I remember one day a friend came with me to spend a few days at my parents' house. It was sad to me that she was meeting Chillida for the first time in his current state, but none of us had anything to be ashamed of. We went to the living room and found him with his eyes closed. I loved my friend's reaction. She stood right in front of him, took his hand warmly, and introduced herself. "I am a friend of your daughter Susana. It is an honor to meet you." Dad did not budge. When we stopped by to give him a kiss before heading out to eat, we found him on his way to bed. My friend swears that she will never forget their encounter. She says he stood up to get a good look at us. After glancing over at me, he fixed his gaze on her and, perfectly composed, smiled. "You are beautiful," he said. He could see people inside and out. My friend had something special about her, and he picked up on it. He was pleased to see someone like her by my side. He gave us each a kiss, and we felt as if he had given us his blessing.

### "Let the little children come to me"

María, the sister I am closest to in spirit and in age, reminds me that, after her first child was born, our father was the one who asked to place a connecting door between the apartment where he and Pili lived and the one where she and her husband lived. "And that led to a close, everyday relationship between us that we all enjoyed. Always." Thanks to that door—which was like a cat flap—for years my parents enjoyed not only María's children from the time they were babies but also the children of the other siblings she would host at her place to spare our parents all the racket young children bring. María would give our mother a hand whenever she needed anything, and my father was so grateful. By chance—or perhaps it was a premonition—my father completed *Homenaje a María* (Homage to Maria), his only work in honor of a woman, in 1960, the year my sister was born. In 1983, he made *Homenaje a Jon* (Homage to Jon), her firstborn.

When our father's illness set in, and all the more so as it advanced, nothing was easy for my younger sister. She made sure my parents never wanted for anything and gave them cause for joy every single day. However, no matter how available she made herself, it was impossible, of course, for her to be there twenty-four hours a day—and she often felt frustrated that she could not do more. María recounts how Pili was available to Eduardo every single minute of the day:

> She was always with him and for him. I mean, from the time he got ill, she barely left his side. It was something incredible to witness. One day, our mother came back from running an errand. I was in the living room with our father, holding his hand, when something sad happened. Eduardo, who was always so tender and careful with words, who never wanted to hurt anyone, looked at our mother and said sweetly to her, "You are very nice, but she . . ." Though he was deeply senile by this point, he realized that he should not finish the sentence. *Ama* was devastated, and my heart skipped a beat. "*Ama*, don't take it badly," I said. "He is not saying that to me . . . He is only drawn to me because I remind him of you . . ." And that was true. Since we looked so much alike, he saw in me the young, vital, and happy Pili he had fallen in love with.

It was a rough day for both of them, but it seems that our mother understood, put it aside, and moved on. Unfortunately, this sort of behavior is common in people with Alzheimer's. An anecdote my brother Ignacio told me rounds out the image of those rough times:

> Even when he was ill, he left me precious memories. One day we were walking down the beach hand in hand when he had a flash of lucidity, which was not uncommon, despite his sickness. And he suddenly felt ashamed. As we approached others walking down the beach in the opposite direction, he said to me as gently as ever, "Iñaki, should we drop hands?"

## "Resurrection" and Death

And then one day in 2002 I got a call to tell me my father was dying. I
traveled with my sisters to San Sebastián, and the eight of us siblings
kept watch over him, and supported our mother, during a long night in
the hospital. I remember singing him a lullaby that my parents would
sing to us when we were small. I wanted Eduardo to understand that we
were giving him permission to rest in peace. I discussed it with my
siblings, who understood and joined in the song. He could barely
breathe. He had been given the last rites—and only had to breathe his
last breath—but Pili could not bear to see him die in the hospital. She
got a friend to come by and give him sessions of Reiki. Though
everyone laughed at the "witch doctor," three days later Eduardo's
chest had miraculously cleared and he was breathing easier. There is no
doubt in my mind that my father was perfectly aware of what was going
on when the stretcher came to take him home—he nearly jumped out of
bed! That experience makes me certain that Alzheimer's patients are
not entirely absent. I remember my mother walking around the living
room that day, a letter opener or some other odd object in her hand,
playing a sort of upbeat *tamborrada* drumbeat. She was overjoyed.

Once, when speaking intimately with her, my mother told me
something about that night at the hospital. "I don't remember who
had the idea that we had to give your father permission to die." She
told me that she could never have done that—it would have violated
the laws of their love. Neither of them would have accepted that
possibility, reason be damned. Later, I once heard her say—I still laugh
at the memory—something like, "No, it wasn't then . . . It was *before*
your father's resurrection." How could I do anything but laugh!

I was able to convey so many things to my father during those four
"bonus" months when he lived at home, and that fills me with joy.
I spoke not only for myself, but also for so many others who admired
and loved him. I thanked him for his decency and his exemplary life.
I would say things to him like, "Hey handsome! You are good inside
and out. Solid material, just like your sculptures!" I would often get
a smile out of him, and boy did I need it! One of the hardest moments

was a morning when I wanted to read to my father, who was in bed, something Father Antonio Beristain, SJ had written about him in the paper. His words moved me so deeply that, faced with my father's current state, my voice cracked. The article spoke of Chillida's "silent and eloquent figure."

Whatever his state, my father would get up in the morning and go out for a short walk. Until one day he did not want to get up from the couch. That was the only day he skipped his walk; the next, he died. And I, who was so afraid of death's cold and stillness, took his hand. It was still warm, and I was not afraid. I will never forget how we gathered around his inert body and, one last time, sang the Lord's Prayer in Euskera—the *Gure Aita* we had sung together so many times before—in his honor.

Nor will I forget something I heard my mother say. "Eduardo the Patient impressed me no less than Eduardo the Artist had before." I could not agree more.

### Grasping onto the Work

"In this one, Eduardo was already gone. I was no longer the Pili I had always been. Years go by and I don't know how to live," wrote my mother on the back of a photo. All she had left was his work—and she grasped onto it. On the back of another photo we read, "A very sad Pili. Eduardo—my friend, my love, my everything—was gone."

On the first New Year's Eve without Eduardo, we all called it a night at the stroke of midnight. Pili and I and the little ones stayed back at the house. María had left a video of beautiful boleros playing on the TV. Her daughter Sara and my kids joined the party, and then they headed to bed through the famous catflap door. Almost without realizing it, my mother and I found ourselves embracing and then dancing. She wanted to teach me how to dance the bolero, counting out "1-2-3-4, 1-2-3-4" with the astonishing patience she was known for. Lover of free dance that I am, I had trouble learning the steps. A little jumpy but happy, I was constantly stepping on her toes, though she hardly seemed to mind. I would have liked that night to last forever.

"Pili is so much Pili," our father would say. "The mother is the mother," Joakin, the groundskeeper, would say about her, using the masculine article *el*, undoubtedly in reference to her being the boss. I glance down at the cover of the book I am reading, *Woman to Woman*, a series of conversations between the writers Xavière Gauthier and Marguerite Duras. It contains a photograph of three women smiling from their seats at what appears to be a sidewalk café. There is no man with them. A mysterious expression on her face, one of them reaches for something that looks like a goblet. She appears modern and feminine in her floral shirt. Another woman in the photo covers her mouth, perhaps trying to hide her cigarette from the camera. A very young Duras sits in the center, her white teeth shining through red lips in a wide grin. The three look like allies, like partners in crime.

I could never imagine my mother in a scene like that! I cannot picture her sitting with women friends in a café, let alone having a drink with them at a bar—she never went out with friends without her Eduardo. I don't think Pili had a single true friend except the

Pilar holding onto a sculpture
after Eduardo's death, ca. 2002

people she met in her work with my father—gallerists, studio assistants, artists and their spouses—and none of them lived in San Sebastián.

I learned just how all alone she was when our father died. A long thirteen years began after his departure, an emptiness no one could fill. I did not want to follow in her footsteps. I began asking myself at that point if I truly took care of the friends I had. Did I even know what that meant? I started cultivating the art of friendship with more conviction. In her widowhood, a Pili unknown to us emerged, as did a new me, eager to learn new truths.

### What We Are and What We Could Have Been: The Story of the Piano

While I write, I hear one of my children humming a song in Euskera that I sang to them when they were small: "Txoria Txori" (The Bird's a Bird), by Mikel Laboa. My father taught it to us when he started learning Euskera, and I know my children will pass it down to their kids. It begins "*Hegoak ebaki banizkion...*" (If I had clipped its wings...). I suddenly find myself wondering about my parents. Did Pili clip Eduardo's wings? She most certainly did not. In fact, she stretched them so that he could fly higher. What about Eduardo? Did he clip Pili's wings?

Something I heard my mother as a widow say a number of times leads me to imagine what her life could have been. The flipside of Eduardo's "If you follow me ... " promise—those words he said to her before dropping out of architecture school to become a sculptor—was: "If you don't follow me, Pili, I just might end up following my father's dream, not my own." It also meant, "Pili, I want you by my side."

Let us picture for a moment a very young Pili at home in San Sebastián while Eduardo is in Paris. She misses him terribly but cannot even dream of visiting him—it would be years before women had even the most basic freedoms like traveling alone, opening a bank account in their own name, or getting a passport or driver's license without the permission of their father or husband. Pili is secretly learning how to play the piano as a way to feel closer to her artist beau; she and her father would argue over who got to spend time playing the instrument.

A young Pilar Belzunce painting in Hernani, 1952

Pili, moved by a pure spirit, surprises Eduardo when he returns by playing some of the simple classical pieces she has learned. He listens to her and, when she is through, asks her to play something of her own—a request that would change the course of her life.

My father's request had an innocent motivation, but also a cruel one. Had she ever once told him that she wanted to be a composer? In my father's defense, that request was in keeping with how he understood life. He lived for creativity and demanded a great deal of himself as an artist. From the beginning, he wanted to forge a world of his own, which is why even his first piece in plaster challenged established uses of that material. Rather than mold it, as was common practice—plaster is soft and malleable—he used it to cover a rock, forming a hard and dense block. Then, chipping away at the block with a burin, he gradually arrived at the shape he was after: that female torso titled *Forma* (Form).

What matters is not the things that happen to us but what we do with those things. And what Pili did was quit the piano for good. Our family life would have been different with a piano at home. Pili would have spent hours with us, delighting in music and, undoubtedly, in

dance. I am certain our mother would have been a bit closer to us. With our father, we shared not only art but also sports. With her, we had almost nothing in common—at least I didn't.

That phrase "Now play something of your own, Pili" could as well have emboldened her. There is no question that my mother loved the arts, that they moved her deeply, and so it's not hard to imagine that she may have fantasized about being an artist herself. Leaving the piano aside, what comes most strongly to mind is Pili's painting. All of us children knew the paintings she made during those very few moments of leisure she had over the course of her life. But none of us could have imagined that painting would be her salvation after Eduardo's death. She could spend hours on end at the easel. Had she chosen another path, she might have placed that passion at the center of her life. I can just picture my parents, a pair of young artists in love, sharing interests and dreams. But there would have been no room for children in that life. Back then, birth control was not available, and besides Eduardo was so religious. None of my mother's pregnancies was easy, perhaps because they meant giving up on all those other possible dreams.

### A Woman among Women

Delving into Pili's life and person means rummaging in the dark and forming new certainties. My mother had a number of different facets; she had shadows and doubts, many of them tied to being a woman. Indeed, that is why we have much more in common than, in my naivete, I tended to believe.

Giselle Michelin, Aimé Maeght's personal secretary, comes to mind immediately. Giselle was an efficient and independent person. Single and adventurous, she would often vacation in China and write long letters to my mother telling her everything she learned there. She would stay with us during her frequent studio visits with my father, and she and I became friends of a sort. She knew I was a big reader, and when I was a girl, and even into my youth, she would send me books she thought I'd be interested in. I now wonder what it was about Giselle

that my mother found unsettling—because I always felt Pili found the relationship with her troubling, even though she was also unquestionably fond of Giselle. Did she envy her independence? Her professional life, and the steady salary that came with it? The effect she had on us kids? Or maybe specifically on us girls? Maybe Giselle made Pili think about those other lives she could have lived. We all have moments when we think about who we are and who we might have been.

Eduardo was never expected to attend to any mundane task—Pili saw to everything. As I said, she even did what was considered man's work at the time, to say nothing of all the standard work reserved for women—except, that is, cooking, which she refused to do. She knew that, as a mother of eight, if she learned how to cook she would spend half her life in the kitchen. That said, not knowing how to cook made her overly dependent on the domestic helpers who worked in our home. They had her in the palm of their hand, because she needed them in order to be free to fly around the world with her Eduardo. Is that why she was at times a bit standoffish with them? Gregori, Nati, Pilar . . . so many women formed part of our lives, and we formed part of theirs. What did they think of our father? They probably thought he

Chillida, Pilar, and Giselle Michelin, Aimé Maeght's personal secretary, 1977

was a living saint, if a bit oblivious to them, just as he was to us and to everyone and everything that crossed his path. My father was benevolent but distant. And what did they have to say about Pili—if they dared to say anything at all, that is! Maybe they found her elegant and hardworking; at times sensitive and at times anything but; sometimes fair, but not always. Because my mother could be as hard as a rock. I'm not judging, just observing.

I'm pleased to say that, with the passage of time and after my father's death, Pili loosened up and became more grateful; many of her prejudices around class, appearance, ethnicity, and so forth disappeared entirely, which I found moving. Watching a person grow, regardless of age, is always thrilling. That said, I have trouble thinking of women whom she admired. A certain sexist atmosphere prevailed in my household growing up—I suspect my mother was more responsible for it than my father. My father admired, for instance, the Spanish philosopher and essayist María Zambrano—in fact, they had arranged to meet in person, though unfortunately she passed away before they had a chance to do so. He also appreciated the work of my sister-in-law, the installation artist and sculptor Cristina Iglesias. On more than one occasion I heard him describe her as "one of the best sculptors *(escultores)* in Spain today"—and his use of the male form of the word was an attempt to counter the prejudice faced by artists who are women.

I know my parents as a couple also came across prejudice in the art world. Pili's role was not an easy one—nothing is easy when money is involved, and she negotiated payments, discounts, returns, and other such matters. And then there was the issue of envy. I remember Nieves Fernández recounting that some gallerists and artists in Madrid would say, "Here come the *Chillidones*"—as though my parents thought themselves superior to others—when they came to visit. Apparently, some considered Pili a "shrew." In fact, one of the reasons Nieves wanted to write her memoir was to correct what she saw as an unfair image of my mother.

## "If you follow me . . ." Revisited

The afternoon breeze rocks the branches of the tree; I have moved my table under it to hide from the heat. Sheltered under the leaves, I keep thinking of the pact between Pili and Eduardo. Young as they were, they had little notion of what "following" an artist meant. They learned everything together. Life was their teacher.

A photo of the family with *Peine del viento XVII* (Comb of the Wind XVII, 1990) was taken in 1992, on the day Chillida was awarded the Gold Medal of San Sebastián in the context of his show at Palacio de Miramar. My father holds Pili close from behind. Next to them are my Eduardo and me—carrying our first child who would come to term in my belly—alongside all their other children and grandchildren who had been born at the time. Once again here, Pili is touching the sculpture. It's as if she wants to show that it, too, is part of the family—or even a part of herself. A necessary part.

For Eduardo to be able to work in peace, he entrusted every detail of his life to Pili. He rarely questioned her decisions. It cannot have been easy for a man at that time to let a woman oversee his life to that extent. Eduardo of course kept up his side of the deal, dedicating himself entirely to his art. And my mother kept up her end as well, though it was, at times, thankless.

There was a period, I remember, when my mother seemed disgruntled and angry. I recall hearing her say that she wanted to be "reckless" (she used the English word). Imagining another version of herself, someone other than the hardworking, responsible, and self-sacrificing woman she was, amused her. But she never went through with it. She continued to disregard her own wants—or maybe she did not even know what they were, thinking that life was a series of obligations, albeit obligations she had taken on freely. It was during this period that, having returned from New York, my husband and I decided to not settle in San Sebastián but rather move to Barcelona for my work. My Eduardo has always followed me given that, as a novelist, all he needed—at least at the beginning of his career—was a pencil and paper.

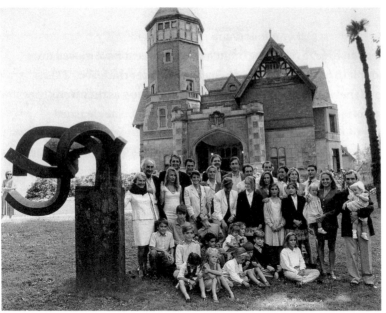

The Chillida Belzunce family with *Peine del viento XVII* (Comb of the Wind XVII, 1990),
Palacio de Miramar, San Sebastián, 1992

The Chillida Belzunce family in front of the Zabalaga *caserío* at Chillida Leku on
Eduardo and Pilar's golden wedding anniversary, July 28, 2000

Pili did, at times, have a sense of regret. What did the man whom she took care of with such commitment and devotion do for her? Did he listen to her needs? I once heard him call her a "sun-baked floozy" when he saw her lying in the sun for a much-needed rest. How much injustice did my mother endure at the hands of a man who, though good-natured and decent, was entirely focused on himself and his work? While I fight against the ghosts of my upbringing, I find myself repeating patterns of gender inequality, only gradually becoming aware of them. Women of my generation, at least, continue to be hounded by guilt for not giving more of ourselves for the good of others.

I can imagine at least one other point of tension between my parents: Chillida's studio was "his house," a place that belonged only to him. Might Pili have wanted to form part of that space rather than just clean it up? Would she have liked to have more impact on his work? At times, perhaps. But he couldn't allow that. Would she understand?

In any case, once Eduardo was gone and with him the possibility that he keep creating, Pili's own life came to an end as well, in a sense.

### Protecting Others from Pain

Although it may seem silly now, when I first started working on my documentaries, I felt a kind of shyness. As if I were "stealing" Chillida's presence. That's why I left so many things unrecorded that I now regret. I wish, for instance, that I had captured more images of his hands, those hands that not only worked but also loved and held. When I was little, I would sit on his lap and squeeze them—something he came to miss as I grew up. "Susi, don't you want to sit with me anymore?" When we were teenagers, if our father noticed that one of us looked troubled or was acting a little strange, he would always ask us if we were all right. He would then hold his hand, palm up, out to the troubled one and say, "We all love you very much." He knew that that—along with laughter and tears—would release the tension. Those moments were in the past, impossible to document now. But I could have recorded how he would make his fingers "come to life" in the

games he played with his grandchildren. He would walk his hand, using his thumb and ring finger, over to them, saying, "The itsy-bitsy elves are coming." He would then lift up one of them and have it greet the children.

I did once take a "stolen" snapshot of my father with my kids—the youngest must have been just two years old and the oldest four. I knew as I captured the image that one day it would no longer be possible—my kids would be all grown up and my father no longer with us. I wanted to show them together and document their love. My father adored my youngest, Kiti, a sensitive boy who always had a smile on his face. Thinking about that photo now, I hear words not spoken but seen. My older son, Adi, sees his grandfather looking at his younger brother and he looks up at me, taking the photograph. In his eyes I read the question, "And who are *you* looking at?" Father, mother, sons, jealousy . . . It is a timeless story.

Eduardo and Pili were strict parents. That said, I once caught my mother breaking the rules and picking up my baby, asleep in his bassinet, when she thought I was napping and no one would spot her. It saddens me to think that some of her grandchildren experienced her as a bit cold, though their bodies undoubtedly recall Pili's warm arms reveling in rocking them when no one was looking. She never wanted to hurt anyone. When her grandchildren were older, she feared unintentionally comparing them and generating rivalry over her love. And because she reined in her own emotions and contained her affection, she received less of it from others. That same pattern was at play with her own children, which is even sadder. The love of a father and a mother is distributed evenly, but sometimes frugally to protect one of the children. I know that both Pili and Eduardo missed out on a lot of pleasure for that reason—but maybe we all do.

That is partly why what happened after my brother Edu's accident gave me such joy. Life had given my mother another chance to show the full force of her affection, and this time she devoted herself to her son without reservation, placing him above her Eduardo, her seven other children, and her grandchildren. Guiltless, she did not worry

about making anyone jealous. My brother put it well: "*Ama* would feed me a big steak every day—just for me, to help me regain muscle mass and weight. My siblings would have fish—they were green with envy!"

### Pili's Dream Come True

Sitting in the lobby bar of a large hotel, I observe two different worlds. To my left are the people who come by to have a drink and people watch, and to my right are the ones who, dressed for a gala, want to be seen. Exuberant greetings and kisses—the world their stage ... In the background, a piano plays. A curious red-crested bird alights on a branch outside the window near me. Before I have a chance to take a good look, it flies away. Only the memory of its strange crest, and the fluttering of the branch, remain.

The sorrow my mother experienced after my father's passing was vast. The siblings who lived with her understood that better than anyone. We sometimes convinced her to come to Madrid. Before, when my parents would travel to Madrid together, they would always stay with my sister Guiomar. But now—undoubtedly to stave off memories—she preferred to stay with me. I would go with her to buy easels and oil paints—she had started painting again in San Sebastián

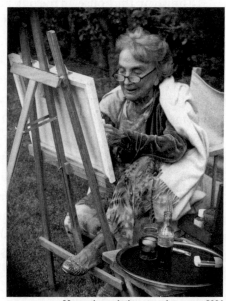

My mother painting at my house, ca. 2004

after my father died and her love for it was reignited. When she decided what she wanted to paint, I would get the place ready—just as she had done for Añíbarro all those years ago. The moments we shared were unforgettable.

My children would check out her things in the bathroom (comb, hairpins, silver mirror, lipstick, and so forth). "Those things belong to *Amatxi*, right? She really likes to look good!" they would say. And she did. But she was also a bit unkempt. When she painted, she would forget about everything. She wanted to finish every painting she started, and she would often end up hunched over, because she never took a break. I would stand by, often photographing her or, using my tripod, photograph myself at her side. If I saw she was getting paint on her nice clothes, I would toss a cloth over her; if the sun was strong, I would bring her a hat; if she seemed cold, I would bring her a sweater. I loved taking care of her, and she let me. She would sometimes end up in a motley combination of clothing, but it was worth it to be able to keep at her painting.

No matter how much she enjoyed being near her three daughters who did not live in San Sebastián, staying permanently in someone else's home was not an option for her. Guiomar wanted, at that time, to finish up the house on the outskirts of Madrid where our mother had dreamed of spending winters before the idea was dashed by my father. Guiomar was an expert at dealing with workers and choosing colors, furniture, and so forth. Pili let her take on the project, and my sister turned that abandoned concrete structure into a spacious home. But we soon realized that it was too late to make that dream come true. Pili missed the sea and the places she had shared with her Eduardo.

My sister's effort was not in vain, however. Once the house was a real house, my mother was free to decide where she wanted to be, and that gave her a great deal of peace. Otherwise, she might have felt that she had no choice but to stay at Intzenea. And so, Pilar Belzunce returned to San Sebastián, where she remained, in the company and care of those who loved her, for the rest of her days.

### Music and Painting and Pili

Pili understood better than anyone what dedicating oneself to art entails. Though she had always loved painting, she barely pursued it during Eduardo's lifetime. However, in the ten-plus years she lived after his death, she immersed herself in it. She could, at that juncture, have painted with the seriousness of a professional artist. Indeed, though not everyone in the family knows it, she did consider that pathway at a certain point. At the time my brother Edu started renovating his home in San Sebastián, she painted in her office, a glassed-in room adjacent to the living room. It afforded none of the privacy she knew creative work requires. Because there were already workers on the grounds doing the renovations, she actually considered building herself a separate studio. She imagined it in a distant corner of the garden, an out-of-the-way place near my brother's studio.

The place Pili planned was barely large enough to hold a ping pong table. How could someone so generous with others be so stingy with herself? It almost seemed like a joke, and no one encouraged her to pursue the idea. The mere thought of our eighty-year-old mother walking over there by herself was scary, and so the tiny studio was never built. Later, her own health faltered. What she had always feared came

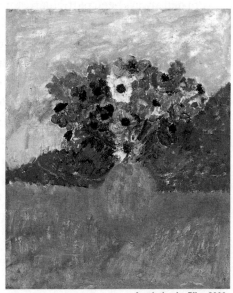

A painting by Pilar, 2000s

271

to pass, and the shadow of Alzheimer's was once again cast on our lives. Of course, her artistic skill was also affected. María, who is herself creatively talented, would encourage our mother by painting something on a canvas or board that Pili would then continue until she made that painting her own. She loved expressing herself with colors.

It is lovely to remember how, after a rough period immediately following the onset of the disease, music and dance once again became part of her daily life. The joy they gave her—a pleasure she had given up as a young woman—was now readily available. Any of us, her children but also her caretakers, was always pleased to help her play music or to dance. Someone gave her a small keyboard, and we would often hear her play "Für Elise" or another classical piece she still remembered. Regardless of how powerful, self-sufficient, and tough she had been, Pili the Patient was kind and grateful. She knew how to let herself be taken care of.

María directed the team of professional caretakers at Intzenea, and a backup team that lightened the load took shape there spontaneously as well. This second team included Idoia, Pedro's second wife, who would drop by every afternoon. We siblings would take turns covering the weekends, which is when Cecilia—a cousin of ours whom Pili had always been particularly fond of—took over from Miriam, Pili's main caregiver. The atmosphere was very good. A good-natured Armenian woman, also named Susana, was in charge of the kitchen. She would sing songs to Pili in her native tongue and, with a broad grin on her face, dance Pili to bed. My mother's face as she gazed upon the cook, who went to such lengths to please her, was a sight to see. No less important was the care provided so generously by my sister-in-law—yet another Susana. A "catflap" had been built connecting her house to my mother's as well. That way, Susana and Edu's kids also were able to have a direct connection with our parents and fill their days with joy. Migui, their youngest, was unquestionably Pili's best friend during her final years. They would dance together to the music prerecorded on that electric keyboard.

Having witnessed it up close, I can affirm in no uncertain terms

that art in all its forms is truth and that love is a necessary part of life. Family is something that, for better or for worse, all humans carry with us. Chillida was a careful custodian of his.

### Pili and Eduardo in Picos de Europa

How sweet, Pili, to stumble upon what you wrote late in your illness on the back of the photos I took of dad and you in 1985, the ones you had up in your office: "Newlyweds Pilar Belzunce and Eduardo Chillida in Panticosa." These words speak of how much you enjoyed the trip that my Eduardo and me—quite recently married—and you two took to Picos de Europa in a motorhome. You felt young and alive; you were still very much in love with your husband; and you must have felt like newlyweds. That is why you get confused about who is who and mix up the times and the names of the various places of natural wonder that have made you so happy.

Few parents of your age and means would, I imagine, be willing to embark on an adventure so lacking in creature comforts. But, for you two, neither comfort nor ease was a counselor worth heeding. I mean, why else would our father, in his beginnings as an artist, switch his pencil to his left hand even though he was right-handed?

On one of those days in Picos de Europa, my father wanted me to take his picture "in the style of a Caspar David Friedrich painting." He stood tall, taking in the landscape. Meanwhile, my mother gathered thistle to adorn our motorhome. I photographed her as well. I can still see the four of us walking, verse by verse, as Antonio Machado puts it in one of his poems, amid the Cantabrian green and the rocks. Until then, the poetry in our home had been the secular work of Machado. But now mysticism had found its place. Pili and Eduardo would recite from memory Saint John of the Cross. Art was always present in our trips together; I remember how surprised I was to discover the paintings of the monk Beato de Liébana, when my parents took us to the Monasterio de Santo Toribio de Liébana. Previously unknown sides of their personalities were revealed to us during that trip. They were excellent at cards, for instance, especially at escoba. They were willing

Eduardo, Picos de Europa, 1985

Pilar, Picos de Europa, 1985

to eat outside at any old spot in the mountains; we would stay up for hours chatting under the stars.

Would a calligrapher be able to tell the difference between my mother's stretched-out and pointy handwriting and the hand of so many women of her age and background? From the time she first arrived in San Sebastián at the age of thirteen, everyone felt she was peculiar. She attended the same type of Catholic school she had attended in the Philippines and had many friends, but the nuns soon found out that she did not have the "spirit" of the Asunción school.

The thing is, though, my mother was well mannered. She had a strong personality and a sense of dignity. I remember an altercation she had later on with my father's grandmother at the Hotel Biarritz. The two women professed their mutual affection and admiration, but they were by no means equals. Pili and Eduardo had accepted *abuelis* Juanatxo's financial help for years. That tough and hardworking woman organized weekly bridge games with women her age, and the only younger person invited to play was Pili. I don't remember the details, but my great-grandmother must have been losing one day when she took advantage of her asymmetrical relationship with Pili and tried to humiliate her for no good reason. But Pili stood her ground. My mother's courage, though she had so much to lose, only served to earn her my *abuelis*'s respect and bring them closer. That was just one more of the anecdotes my father could use to demonstrate the truth of one of his favorite phrases: "Man should hold his dignity over his fear." As we can see, in his generic "man," women are again included.

### The Past and Present of a Place

A twist of fate has made Pili's place in Menorca become my place. Quatre Vents is more than a house in front of the sea. It is an old terrain that my parents, as well as I, fell in love with. Keeping its spirit is not difficult. It only requires love for the land, for the centenary pines and holm oaks that become lost among the forest, for the palm trees and the native species that separate us from the ancient rocks and the blue of the sea.

Colors pour down with the autumn rains. Plants sown by someone else sprout and hidden bulbs will soon blossom. I refuse to learn their life cycles or the nuances of their colors; they startle me, an unexpected gift that arrives every year. An odd daisy stands erect on a slender stem, and the *Drimia maritima*, tall and upright, look like lanterns. There is no rivalry, only harmonic coexistence year after year.

Lying under the same shady holm oak where my mother would stretch out, I recall a scene from last summer that would have delighted my parents. It was late afternoon and my two sons, now adults, were kicking a ball around. Aware that what I wanted was peace and quiet, their movements gradually slowed down. The ball would fly through the air, and they would let it rest on their feet for a moment before giving it a light kick—a skillful and rhythmic back and forth. Not a word was spoken. Sheltered by the tree, I looked on and recorded on my phone the silent game played by the grandchildren I gave my parents, the ones they knew only as children. They take after their grandfather more than they know.

When my father died, I went out into the yard with my son Kiti. Looking up at the stars together, I told him that his grandfather was up there, watching over us. Before going back inside, I heard him begging while looking upward. "*Aitonita*, come back!" Pure childhood innocence! I will always hold some sorrow that Pili and Eduardo never had a chance to know them as men. Here is the inscription Pili wrote to my son in the book *Preguntas* (Questions), published on the occasion of Chillida's admission to the Real Academia de Bellas Artes de San Fernando in Madrid:

Kiti, this book is by your *Aitona* and godfather, who will be very pleased to see you reading and understanding it when you grow up. You two love each other very much already, and I am sure that as the years go by you will understand him better and love him even more. Remember the warm kisses you gave each other—that memory will delight you always. With all my love and a warm kiss, *Amatxi*.

## New as the Waves, Old as the Sea

In 1998, the Academia de Bellas Artes put up a small exhibition of drawings and prints by my father on the theme of music in general and Bach in particular, and I was going to film it. I arrived ahead of the camera operator I was working with, and the gallery was empty except for one woman. She worked her way through the show slowly, taking her time with each work, looking at every picture first from up close and then from farther away. I was fascinated by the attitude of this long-haired, white-headed woman. When my parents arrived, I saw how pleased they were to see her. I had not yet met her in person, but the woman was Clara Janés, the poet whose volume *La indetenible quietud* (The Unstoppable Stillness) my father had illustrated (it is a lovely book). As I have mentioned more than once, my father loved collaborating with poets and philosophers as much as he hated giving speeches and lectures. When he had to speak in public, he kept it short. He would only do so spontaneously, guided by his intuition. He had plenty of charisma, and that always proved more than enough.

The Academia required that any new member give a speech at the induction ceremony—and that was why it took him so long (perhaps even years) to decide to accept the honor. When the day finally came, he surprised everyone by asking a battery of questions—the concerns that motored his work. That was the origin of the slim volume *Preguntas*, written in his hand and illustrated with drawings made for the occasion.

Though I filmed a great deal that day, the only moment I included in my second film was Chillida's salutation to Bach, a major source of inspiration for my father: "Modern as the waves, ancient as the sea, always never different, never always the same." I feel the urge to dedicate those same words to my father, remembering his various series of sculptures and prints that are alike but different, the ones he would give the same name but increase in number until he felt the question behind the exploration had been settled. A sliver of the question always remained unresolved in the works he finished—hence the need to go on. "All the things that matter in this world are alike but different, like the leaves on this tree, like the waves, like men themselves."

## The House That Is Many Homes

I come upon an object that, in a sense, encapsulates my parents' life. It started out as an old black-and-white photo. My mother, ill by this point, stuck it to a board and transformed it with her brushes, adding color where there was none before. The image shows the two of them on their honeymoon in 1950, standing in front of the shelter where they stayed in the Parque Nacional de Ordesa y Monte Perdido. "Mom," Pili said to my grandmother, "don't worry about the Trousseau sheets and towels—we won't be needing them." Pili knew they were at the gates of adventure and challenge; they had no home to return to. Her father had warned her: "Child, that boyfriend of yours is not normal. He could turn out to be a genius—but he could turn out to be a train wreck." My father's father, in turn, had told Eduardo that "a married man has to earn a living." My father responded: "I am earning it, but they are not paying me."

The weight of this object, which is no longer a photo, comes from the few things in the image that my mother did not transform: the small part of the ground under their feet, and the two of them with jackets in their hands (it's hard to tell whose is whose). Pili's two legs form a single pillar, and in her smile I read her willingness to confront all the adventures that await her. He is the one who looks worried. His slightly bent legs in the foreground suggest tension, and the great leap in his career he had hoped for following the recognition that his early figurative works received in Paris.

Oddly, my parents are askew in the photograph. It seems as if one of them, undoubtedly Pili, had asked someone to take the photo, after having carefully chosen the spot. She clearly wanted the house, the shelter in the Parque de Ordesa—their first home—to be center stage.

What else was my mother drawn to? Windowsills, places from which to look out at and dream about what was on its way in. She even attached a ladder to the window of one of the rooms, perhaps the one where their first child was conceived. The ladder, in my view, was meant to be a way for them to enter the home or sneak outside with ease and privacy.

The House That Is Many Homes: black-and-white photo of
Eduardo and Pilar in the Parque de Ordesa shelter during their
*honeymoon*, colored by Pilar in her last days, 2015

In her final days, Pili turned that black-and-white photo into a
painting, the four corners of its frame bursting in a flower-like pattern.
It is a painting of a house. We might call it the "mother house," because
its details bring to mind many of the houses that my parents built and
inhabited over the years. The image holds time: days past, seen by her
now senile self; days to come, seen from the vigor of her youth. Houses
and more houses joined as one. A home.

Despite the transformations at Pili's hand, the home in my
mother's image is still discernible. It is undeniably the shelter in the
Parque de Ordesa. Also recognizable in the picture are her dreams
from those earlier years; many of them came true, and others she
passed down to her children and grandchildren, her heirs. Isn't that
house vaguely reminiscent of the Zabalaga *caserío*? I verify the
resemblance by looking at another photo of the farmhouse's facade,
full of windows enlarged slightly without altering their original
placement. The new painting *is* Zabalaga, with its pathway through
the grass. The large gate Pili added in her painting, in a shade of green
different from the one that dominates the rest of the image, speaks of
the sculptures that have to get in and out. It also speaks of the gate to

Chillida's first study at Villa Paz. That's right—the entire left side of the house *is* that first study. My mother added, in black, an extra slope to the roof—it was a small house with a gable roof and only two windows in the front.

On the right side of the house that is so many homes, she added, with blue pen, a small buttress; she also created two windows and a door. Maybe it is a small second house for one of her children. Taking another look, as a whole, the house *is* the Molino de los Vados as well. It has all of that home's simplicity, as well as its horizontal layout, central gate, and first-floor windows. Houses and more houses in which we shared precious moments, forever etched in our memories.

### One Last Day at the Molino de los Vados

As I approach the site where the mill stood before the area was transformed, I am not sure what I might feel. All I know is that the work needed to accommodate a large reservoir has been halted for a while.

The first stretch of the road, which was thick with mud on my wedding day (we all got bogged down in it), is still here. The makeshift door that a shepherd put up to keep his flock in is still here (his trick for opening it and the sound it made when he did are engraved in my memory). Slightly farther in, the changes are starting to become evident. Amid the low oak trees, a wider road has been paved over some parts of the original path, to allow trucks in. The landscape is dotted with electric power poles. When we parked the car, we saw that there was no way to get down to the house because . . . there is no house. It is now under meters and meters of soil. The trees we had planted are gone, and the enormous boulders above the mill look very small, though underground they obviously remain intact. The canal that ran under the mill has been diverted, and the river that divided the meadow from the mountains is now unpassable. The stones of what had been the old Romanic bridge lay abandoned along the riverbank.

It pains me to mention the enormous concrete sluice gate that now bars the original access to the spring. The view of the boulders is partly

blocked, though fortunately the peak where I filmed my father has escaped unscathed.

Nobody could know at that time whether the reservoir project would continue or not. What I do know is that it came as a relief to see the prehistoric graves still intact and in place. We climbed up the mountain and found a small *txoko* beside the spring, where water still emerged, safe from the destruction all around. It was Mother's Day and my birthday. I was there with "my Eduardo" and our children and, when I breathed in the air, I felt I had everything I could ever want. What was no longer with us lived on in me.

One final memory of my father. We were both in his studio. He had just given me *Les mères* (The Mothers) by Edmond Jabès, a poet he admired greatly. "I didn't know that Jabès has died," I said. "Yes, last year," he replied, and went on, not missing a beat. "Well . . . he died to the extent that any poet dies."

The time has come to bring this book to a close. A few flowers look at me from out in the yard. I know that there will be times, many times, when I will long to call out to my mom, who lived by the sea. She would speak to me often of the color of the waves, their size, their roar. Our conversations were pictures she would paint for me from far away. I will long, of course, for my dad's presence among us as well. How couldn't I. But he lives on in me—everything I have recounted here, the rich life we shared, does too. My father was also a poet, and his artworks linger among us—and they will forever more, as part of this world.

I would like to thank Hope Jensen Leichter, of Columbia University, for helping me discover, when working on my dissertation, the combined use of audiovisual media and writing that has been a cornerstone of my work ever since. You are my most important mentor.

To my husband Eduardo Iglesias and Ray Loriga, early readers who helped me find my voice. Your feedback, patience, and keen literary sensibility proved essential; I admire you both as writers.

To my children, Adi and Cristian Iglesias Chillida, and to María Lahoz, Adi's companion. Your interest in what I was doing and your questions opened up novel lines of inquiry about my parents. Gratitude goes to Pedro, my brother, for your enthusiastic encouragement, for the suggestions you made regarding the text, and for the information you provided. To my sister María: with characteristic sensibility, you pointed out a few details that required minor but important modifications. Thanks to my brother-in-law Gonzalo Calderón, and to all my siblings and their spouses, for your affection and testimony, as well as the photos and information you provided.

I give deepest thanks to Ricardo Pinilla and Ana María Rabe, for your friendship and trust in me. I have grown a great deal through our long-standing work together on academic projects related to Chillida. To Lucas Sarasibar, who urged me to keep at it in the middle of the process, when my project had come to a stop. To my friend Cristina Álvarez Puerto, a poet, educator, and practitioner of systemic therapy; you were at my side to cheer me on in moments of dejection and made me see values in my book that had gone unnoticed by me. To the memory of Alfredo Mateos Paramio, a source of vast support while he was among us, and to all the friends who have been so understanding of my long absence as I worked on this project.

My gratitude also goes to Mercedes Monmany, for sending me to Galaxia Gutenberg press as a first option. To Joan Tarrida, its director, for the enormous respect of my work you conveyed from the beginning, and to Zita Arenillas and Lidia Rey, for your careful review of the original Spanish manuscript.

To the teams at the Chillida Leku museum and Fundación Eduardo Chillida y Pilar Belzunce, thank you for your help locating specific pieces of information and photographs. Also crucial to this project has been your earlier work cataloguing and transcribing documentation from my parents' archives, including the letters between them. In particular, I thank Mikel Chillida, my beloved nephew: you made sure my requests ended up in the hands of the people who could give me what I need. And to you, Ixiar Iturzaeta—we both know the many occasions upon which I distracted you from your work.

Last but not least, I wish to thank Mireia Massagué, the director of the Chillida Leku museum, who was the first person to see the potential interest that Hauser & Wirth Publishers might have in an English edition of this book and who put me in touch with them. To Michaela Unterdörfer, its kind and sensitive director: it was a pleasure to meet you in person and I really appreciate the hardworking team you put together, whom I have worked alongside digitally—Maria Elena Garzoni, Jane Brody, and Jaclyn Arndt. All of you, with your infinite patience, have made the process of rendering my voice into another language—complicated in itself—easy and interesting. I especially appreciate how conscientious you were in pointing out cultural differences that made it necessary to change specific words that would have led to misunderstandings in my text.

I thank you all from the bottom of my heart.

—Susana Chillida

## Image Credits

Publisher: Michaela Unterdörfer
Managing editor: Maria Elena Garzoni
Editorial support: Florence Cobben, Ixiar Iturzaeta,
Mireia Massagué, Nausica Sánchez
Translation: Jane Brodie
Copyediting and proofreading: Jaclyn Arndt

Book design and typography: Studio Studio
(Arnar Freyr Guðmundsson, Birna Geirfinnsdóttir)
Production coordination: Christine Stäcker
Pre-press: Prints Professional, Berlin
Printing and binding: DZA Druckerei zu
Altenburg GmbH

Cover material: Lessebo Colours Sahara 2114, 300 gsm
Paper: Munken Pure Rough, 90 gsm
Typeface: Text and Univers LT Pro

*Eduardo Chillida and Pilar Belzunce: Memories
of a Daughter* © 2024 Hauser & Wirth Publishers
www.hauserwirth.com

Original Spanish edition published in 2024 under the
title *Una vida para el arte. Eduardo Chillida y Pilar
Belzunce, mis padres* © 2024 Galaxia Gutenberg,
Barcelona

Text © 2024 Susana Chillida

Cover image: Eduardo Chillida and Pilar Belzunce
with *Basoa III* (Forest III, 1989) at Zabalaga, Hernani, 1991
Inside flaps: Chillida with his sons Pedro (left) and
Eduardo (right) with *Peine del viento XV* (Comb of the
Wind XV, 1976) in the background, San Sebastián, 1984
Page 4: Eduardo and Pilar in the final frame of *Chillida:
el arte y los sueños* (Chillida: Art and Dreams, 1999)

Available through:

ARTBOOK | D.A.P.
75 Broad Street, Suite 630
New York, NY 10004
www.artbook.com

and

Buchhandlung Walther König
Ehrenstrasse 4
50672 Cologne, Germany
www.buchhandlung-walther-koenig.de

ISBN: 978-3-906915-95-1
Library of Congress Control
Number: 2024939837

Printed and bound in Germany